The Art *of* Figure Drawing

CLEM ROBINS

NORTH LIGHT BOOKS
CINCINNATI, OHIO

WWW.ARTISTSNETWORK.COM

For my father.

The Art of Figure Drawing. Copyright © 2003 by Clem Robins. Manufactured in China.
All rights reserved. No part of this book may be reproduced in any form or by any electronic
or mechanical means including information storage and retrieval systems without permission
in writing from the publisher, except by a reviewer who may quote brief passages in a review.
Published by North Light Books, an imprint of F&W Publications, Inc., 4700 East Galbraith
Road, Cincinnati, Ohio 45236. (800) 289-0963, First edition.

Other fine North Light Books are available from your local bookstore, art supply store or
direct from the publisher.

07 06 05 04 03 5 4 3 2 1

Library of Congress Cataloging in Publication Data
Robins, Clem
 The Art of Figure Drawing / Clem Robins.— 1st ed.
 p. cm
 Includes index.
 ISBN 1-58180-204-8 (hc. : alk. paper)
 1. Figure Drawing—Technique. I. Title.

NC765 .R585 2003
743.4—dc21 2002069598

Edited by Bethe Ferguson
Designed by Wendy Dunning
Production art by Matthew DeRhodes
Production coordinated by Mark Griffin

METRIC CONVERSION CHART

to convert	to	multiply by
Inches	Centimeters	2.54
Centimeters	Inches	0.4
Feet	Centimeters	30.5
Centimeters	Feet	0.03
Yards	Meters	0.9
Meters	Yards	1.1
Sq. Inches	Sq. Centimeters	6.45
Sq. Centimeters	Sq. Inches	0.16
Sq. Feet	Sq. Meters	0.09
Sq. Meters	Sq. Feet	10.8
Sq. Yards	Sq. Meters	0.8
Sq. Meters	Sq. Yards	1.2
Pounds	Kilograms	0.45
Kilograms	Pounds	2.2
Ounces	Grams	28.3
Grams	Ounces	0.035

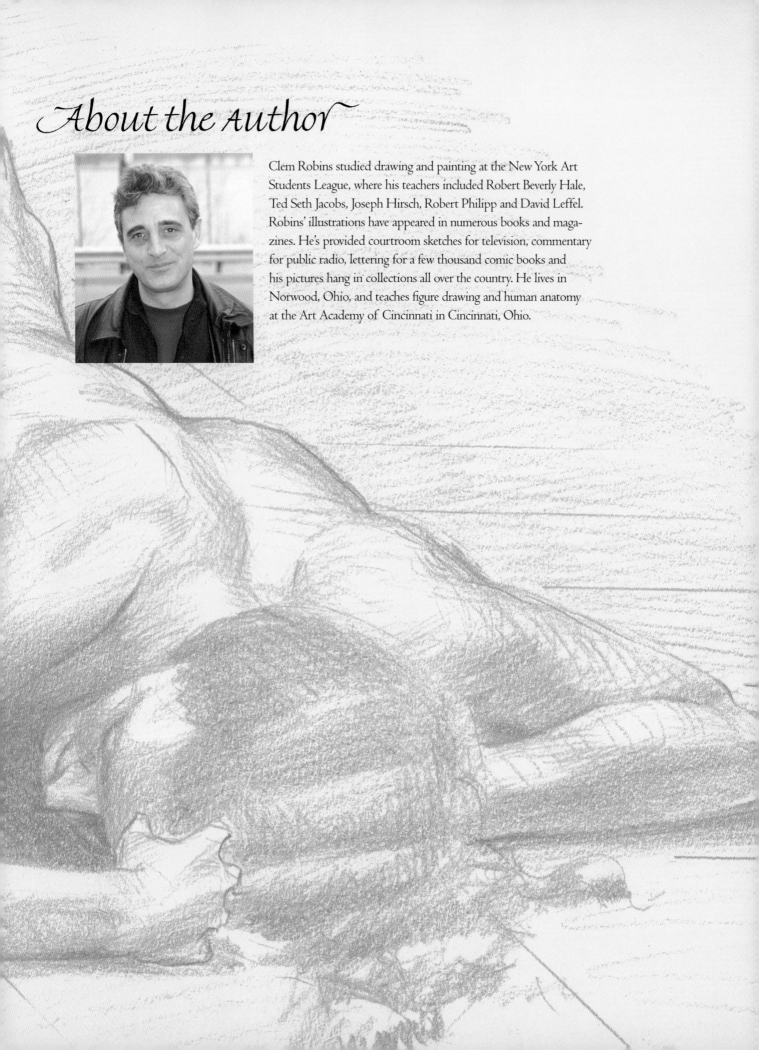

About the Author

Clem Robins studied drawing and painting at the New York Art Students League, where his teachers included Robert Beverly Hale, Ted Seth Jacobs, Joseph Hirsch, Robert Philipp and David Leffel. Robins' illustrations have appeared in numerous books and magazines. He's provided courtroom sketches for television, commentary for public radio, lettering for a few thousand comic books and his pictures hang in collections all over the country. He lives in Norwood, Ohio, and teaches figure drawing and human anatomy at the Art Academy of Cincinnati in Cincinnati, Ohio.

Table of Contents

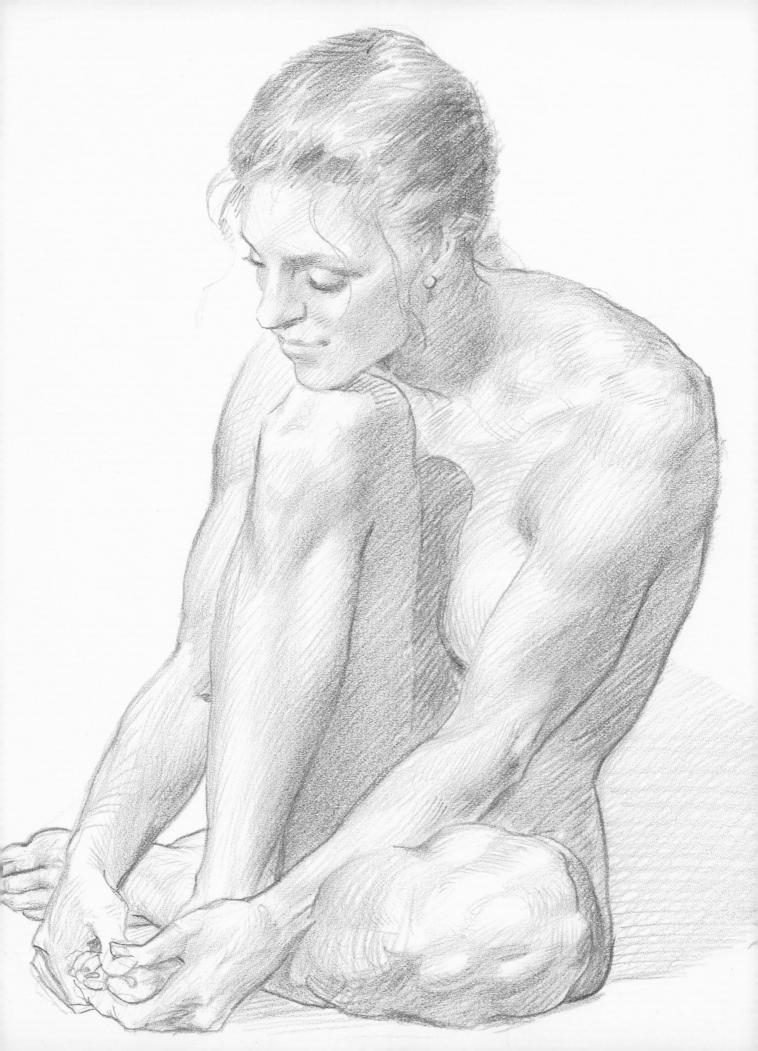

W hen I first began to draw from the nude, I found it an enormous chal-
lenge—like most art students. One very useful tool I cherished then (and
still do) was several photocopies of notes from my classmate Clem Robins,
summarizing and expanding on the teaching of our teacher Robert Beverly Hale. In
clear and skillful drawings and diagrams, Clem showed himself to be more than the
master of our lessons—he was already adding his own insights to what we had learned. I
studied Clem's notes so carefully not only because they were informative, but because
he drew much better than I.

Now, several decades later, Clem has put his ability to draw
well and explain well to splendid use in this new book. With an
almost uncanny sense of the issues that most perplex the aspiring
figure artist, Clem offers a volume's worth of insights and
examples. Here are a myriad of answers to that immemorial
beginner's question, "How do I start?" Here, as well, are guides
through some of the other rough spots on the road to mastery—shadow and edge, line
and weight, foreshortening and proportion. In every case, the explanations and
demonstrations are concise, lucid and to the point. I found myself impatient to get
to my drawing pad and try out some of Clem's ideas. And throughout, the author is
helpful and encouraging, just the thing for those times when the figure can seem so
frustrating and intractable.

Hale was fond of saying that any drawing book that offered even one good idea
was worth acquiring for your library. By that measure, this book earns its keep on
nearly every page. Long may it stay in print.

Foreword

BY GARY FAIGIN

*Gary Faigin is a painter, author, art critic and educator. His work has been
in many group and one-person shows, including a retrospective exhibition at
the Frye Museum in Seattle in 2001. Faigin also has a program on NPR in
the Pacific Northwest. His book,* THE ARTIST'S COMPLETE GUIDE
TO FACIAL EXPRESSION, *has been reprinted numerous times, and has
been translated into French, German and Italian. He is the co-founder and
Artistic Director of the Seattle Academy of Fine Art.*

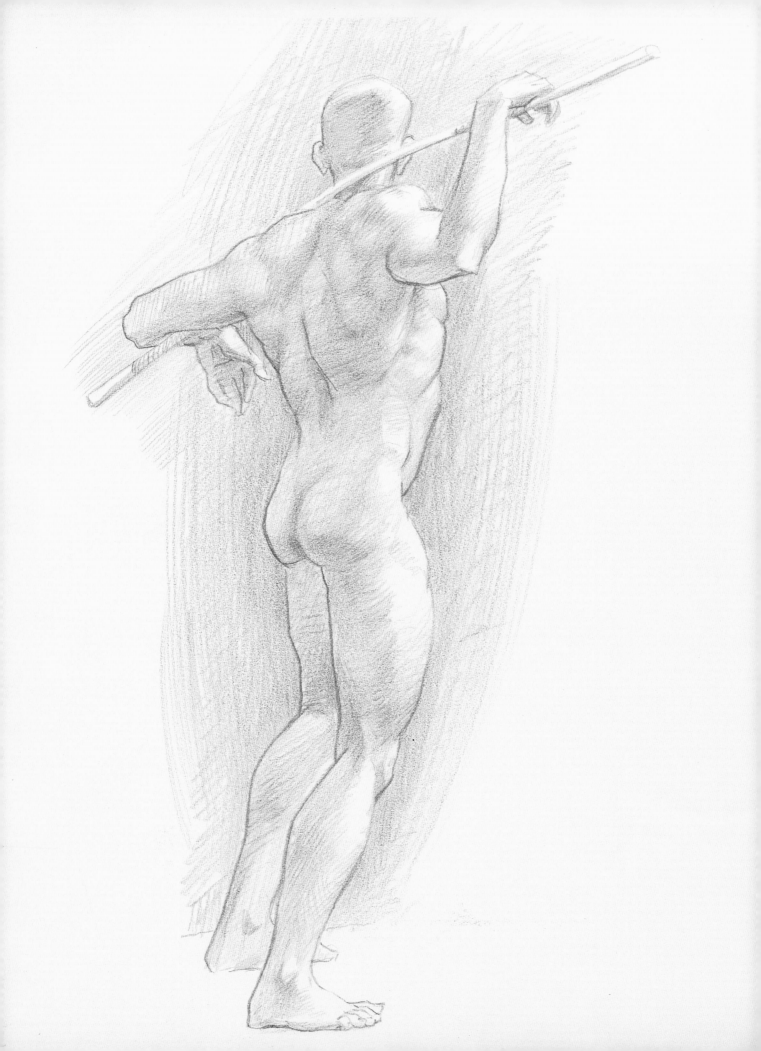

Introduction

The trained figure artist and the beginner stand before the same model, use the same materials and in the same amount of time emerge with entirely different results. If the distinction between their approaches were to be summed up, it would be this: Beginners try to copy what they see, while professionals fashion images designed for other people to see. The means by which the latter accomplish this are the subject of this book.

THE ART OF FIGURE DRAWING is divided into three parts. The first, "The Elements of Figure Drawing," discusses in some detail the means for reading and understanding a drawn image. These include such visual cues as lines, mass conceptions, the tonal palette, the principle of camouflage and the treatment of edges. It is through the use of such cues that a connection is made in the mind of the viewer between two totally dissimilar things: A flat piece of paper, marked up here and there with pigment, and a living model in three-dimensional space.

As important as such cues are, they are valueless unless the artist has the technical means to make pictures with them. Part two, "The Technique of Figure Drawing," demonstrates in a step-by-step fashion how to make life drawings, in a variety of drawing mediums. Technique is a rather personal thing, and the hints offered do not purport to be the only ways, or even the best ways, to solve the myriad of problems served up by the model. It is hoped, rather, that the examination of one way of working will help you find your own ways and avoid some common pitfalls. You may find it helpful to read part two first if you're just starting out. It will offer you some practical ideas that could save you some frustration.

The concluding section, "Problem Solving," addresses some of the unique challenges for the figure artist, including the head, hair, hands and feet. The Rule of Tipped Cylinders, presented in this section, shows how tone can express thrust and action.

Learning to draw the figure is not like skiing. A good ski instructor can show you enough in a morning so that you can at least have a good time and not hurt yourself too much that afternoon. The beginner coming at the nude must put in quite some time before expecting to produce even readable pictures. The payoff comes over time. Still, some approaches work better than others, and my hope is that the suggestions offered in these pages will save you some time and aggravation.

Greg Albert first suggested this project and aided in its fruition. A fine draughtsman and teacher in his own right, his understanding of the material and his skill at organizing it has in large part shaped this book. Thanks to Bethe Ferguson and Wendy Dunning. Bethe's editing skills, along with Wendy's elegant design scheme, accomplished the daunting task of allowing text and pictures to leapfrog each other throughout, making the material much easier to comprehend.

Models seldom get sufficient credit for what they contribute to figure drawing. If you look closely at the drawings in this book, you'll see a lot of the same faces again and again; some people just know how to pose beautifully. Discretion prevents me from thanking these very talented and hardworking people by name, but they know who they are, and they have my deepest respect and appreciation.

Thanks also to Vance Farrow, Janice Brown Checco, Jessica Bechtel, Zach McKee, Madeleine Robins, David Meuller, Jason Franz, Jeremy Johnson, Marlene Steele, Keith Kutch, Milt Odell and particularly to Rosalie Rivenbark. Without her vision, this book would not have been even remotely possible.

Lastly, I am grateful to my sons, Clint, Dylan and Michael, and especially to my very understanding wife, who inspired me, and bought me the time to complete this volume. It is said that art is a jealous mistress, but Lisa is a woman against whom no mistress could ever hope to compete.

The Elements of Figure Drawing

A picture of the nude, or of anything else, communicates via a language of cues. A line suggests certain things; a gray tone suggests certain things; a gray tone darkening or lightening as it moves toward an edge suggests certain things. These prompts all work together to produce a desired effect. Trained artists have learned this language and use it to their advantage. This section is a survey of some of these elements of drawing.

Lines

Drawing can be thought of as a kind of cat-and-mouse game played between the artist and viewer, in which the viewer's suspension of disbelief is pushed back as far as possible. For example, there really is no such thing to be found in nature as a line, yet all of us have learned to read pictures in which lines symbolize the edges of three-dimensional masses. Lines are a basic component of the language of drawing, evoking both the experience of seeing and the experience of touching.

This figure is described entirely by lines of different sorts. Sometimes a line's thickness varies; sometimes a line's darkness varies. By these two means—thickness and value—artists can give considerable variety to the contours they describe. These two factors are referred to as the line's WEIGHT.

A variety of line weight is so essential a tool in communicating a living form that artists call an unvarying line a DEAD LINE (or, sometimes, a WIRE LINE). Artists occasionally use dead lines in life drawing as a kind of figure of speech. Picasso and Matisse, among others, experimented with them, but both men had been thoroughly trained in the sort of classical image making you are studying and knew exactly what they were up to.

Line weight must be subject to the artist's whim at all times. Such concerns affect the choice of tools and techniques. For the drawings on the next three pages, I used a small sable brush dipped in sumi ink mixed with water. You can adjust both the thickness and the darkness of lines by varying the amount of water thinning the ink, by varying the quantity of liquid loaded in your brush and by your brushstroke. A pencil, if pointed by a mechanical sharpener, can give differing

In this sketch there is no shading at all and very little detail, yet it reads well despite the lack of a head, hands and so on.

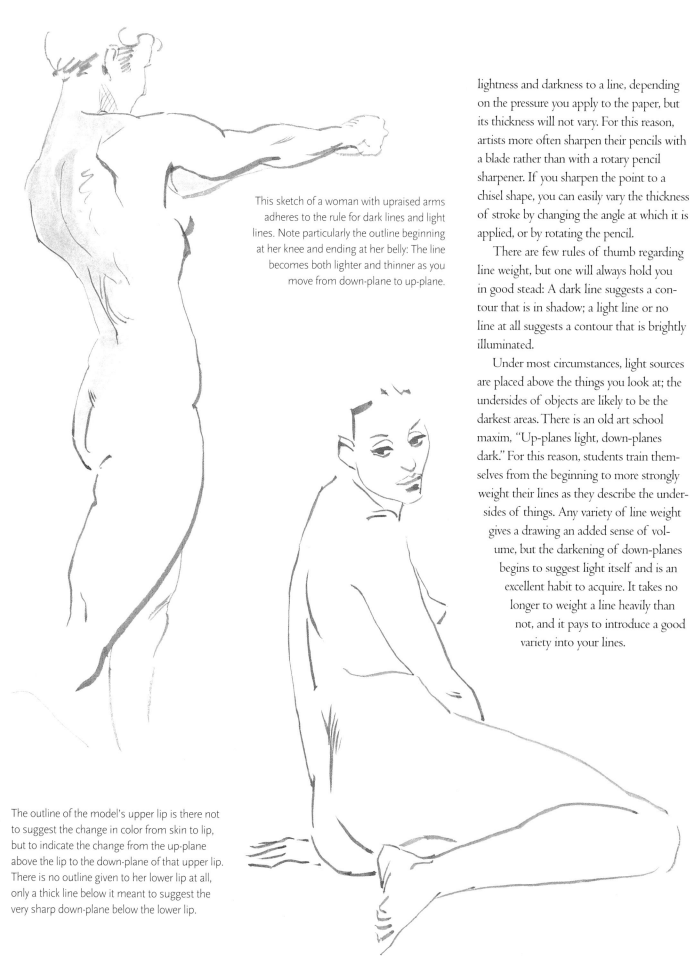

This sketch of a woman with upraised arms adheres to the rule for dark lines and light lines. Note particularly the outline beginning at her knee and ending at her belly: The line becomes both lighter and thinner as you move from down-plane to up-plane.

lightness and darkness to a line, depending on the pressure you apply to the paper, but its thickness will not vary. For this reason, artists more often sharpen their pencils with a blade rather than with a rotary pencil sharpener. If you sharpen the point to a chisel shape, you can easily vary the thickness of stroke by changing the angle at which it is applied, or by rotating the pencil.

There are few rules of thumb regarding line weight, but one will always hold you in good stead: A dark line suggests a contour that is in shadow; a light line or no line at all suggests a contour that is brightly illuminated.

Under most circumstances, light sources are placed above the things you look at; the undersides of objects are likely to be the darkest areas. There is an old art school maxim, "Up-planes light, down-planes dark." For this reason, students train themselves from the beginning to more strongly weight their lines as they describe the undersides of things. Any variety of line weight gives a drawing an added sense of volume, but the darkening of down-planes begins to suggest light itself and is an excellent habit to acquire. It takes no longer to weight a line heavily than not, and it pays to introduce a good variety into your lines.

The outline of the model's upper lip is there not to suggest the change in color from skin to lip, but to indicate the change from the up-plane above the lip to the down-plane of that upper lip. There is no outline given to her lower lip at all, only a thick line below it meant to suggest the very sharp down-plane below the lower lip.

Lines can stand for a number of different ideas. You can enclose the silhouette of the drawn figure with an outline. You can use a line to indicate where a mass changes direction inside of that silhouette, such as where the side of the model's rib cage meets the side of the flank. A line can also mark where colors change, although in figure drawing there is not a great deal of emphasis on color.

It is surprising how much you can leave out of a drawing. If the information you provide gives just enough cues, your viewer will happily fill in the blanks. Much of this has to do with the choice of medium. Used with confidence, a brush and ink produce very supple and brisk lines, which have a way of prodding the viewer into a mode of acceptance.

On the other hand, a pencil calls for a more artisanlike approach. Unlike a brush, which freely skims the surface of the paper, lubricated by the water and ink with which it is charged, a pencil point encounters considerable resistance. This invites a bit more deliberation as you draw.

The drawing on the right demands much less on the part of the viewer, and could be termed much more "realistic" than the preceding sketches. Still, while it more closely resembles the model, it could never be mistaken for her. Within the rules of the game, it plays fair.

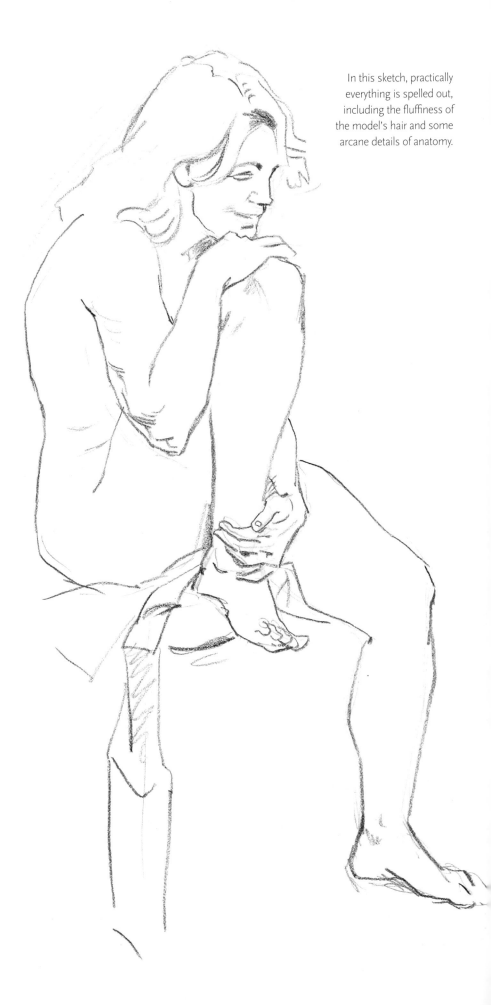

In this sketch, practically everything is spelled out, including the fluffiness of the model's hair and some arcane details of anatomy.

Mass Conceptions

Nature is complicated, and the human body is about the most complicated thing to be found in nature. In order to deal with the figure, the artist does a bit of translation, simplifying the masses of the figure into basic forms that are understandable and which can be manipulated. Such forms are called MASS CONCEPTIONS.

Masses come in three varieties, each with its own characteristics. There are HARD-EDGED ▼ (or, as they are sometimes called, BLOCKLIKE) masses, whose surfaces meet each other abruptly. These include cubes, irregular boxes, pyramids, tetrahedrons, prisms, keystones and so on. None of the masses of the human body are really blocklike, but some veer close to it and can at least be approximated as blocks.

There are SINGLE-CURVED ◄ masses, forms which curve in one direction but remain straight in the other. For example, a cigarette is round in cross section, but lengthwise it is straight. Single-curved masses include cylinders, cones and spools. There are also masses that straddle the fence between these two, such as a gravestone. No human form is really single curved either, but single-curved masses are a very close approximation of many parts of the body, and you can use them with only a little modification.

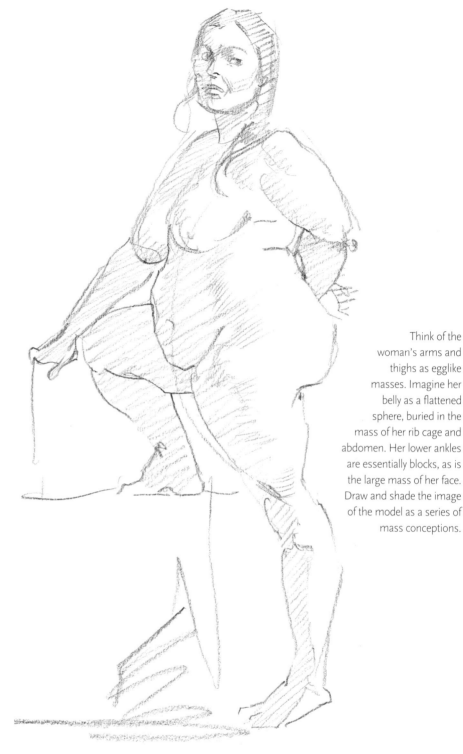

Think of the woman's arms and thighs as egglike masses. Imagine her belly as a flattened sphere, buried in the mass of her rib cage and abdomen. Her lower ankles are essentially blocks, as is the large mass of her face. Draw and shade the image of the model as a series of mass conceptions.

Hard edged

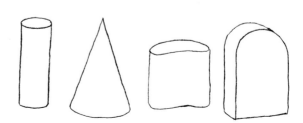

Single curved

Finally, there are also the DOUBLE-CURVED ▼ masses. These are forms that curve both vertically and horizontally. A sphere is the simplest example. Its curve remains the same no matter which direction on its surface you go. Other double-curved masses include eggs, teardrops, hourglasses, yo-yos, doughnuts and saddles. When you get down to it, every form on the human figure carries both a vertical and a horizontal curve. Most of these are convex both vertically and horizontally, such as a model's upper arms.

These mass conceptions function like visual similes. The artist studies the model and notices that the buttocks are like a yo-yo, or the rib cage is like an egg, or the back of the head is like a sphere. The artist then proceeds to draw that yo-yo, egg or sphere in the position occupied by the model's buttocks, torso or cranium, modifying it somewhat in the process.

Take note that these are not "shape" conceptions—that is, they are not flat rectangles, discs or cones, as primers on drawing sometimes imply. Rather they are mass conceptions—fully volumetric forms whose appearance changes depending on the angle from which they are seen. This is important because artists use these mass conceptions to suggest three-dimensional forms and to understand what light does as it illuminates them.

Mass conceptions, used properly, give the artist tremendous command over the nude. If the pose needs a bit of modification, which is often the case, or if the light illuminating the model is poor, which is almost always the case, the artist can manipulate the model and setting for a better effect.

If you remain unconvinced at this point, find a book of European paintings and compare the heads drawn by Michelangelo, Dürer, Cranach or Brueghel with those drawn by Gainsborough, Lawrence or Boucher. The first group clearly envisioned the human head as a modified block, while the second group seemed to have imagined it as a modified egg. Heads look about the same wherever you go. What are different are the mass conceptions each artist settles on.

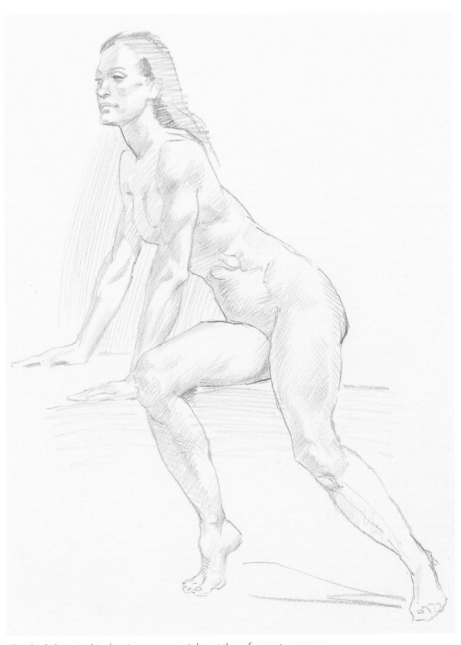

The shade lines in this drawing were certainly not there for me to copy on the model, nor did light and shadow divide on her body precisely as it does in the picture. However, having arrived at certain conclusions about the masses of her body, I was able to adjust these things for best effect.

Double curved

Contour Lines

Consider for a moment the outline of a sphere—say, of an orange placed on a table. Exactly what does this line mean? Does this line live on the table, showing you where the orange obscures your view? Does it lie on the orange itself? Or is it in some imagined area in between the orange and the table?

Generally, artists think of a line as something lying on the surface of the object they draw. If your model is standing in front of a wall, the person's outline is not the place where the wall stops, but the place where the contours of the body turn and become hidden from view. The contours of these forms may turn gradually, like the egglike form of the thigh, or quite sharply, like the knee or the nose. The softness or hardness of such contours affects the sort of line an artist uses to describe them.

Any line imagined as lying on the surface of a drawn object is called a CONTOUR LINE. Contour lines are not limited to the silhouette by any means. Any imagined line running over the surface of a drawn mass is a contour line.

Artists love contour lines, because as they travel over drawn masses, they reveal both the masses, shapes and their thrusts. Contour lines come in three varieties: surface, sectional and bisecting.

All of the lines in this figure are contour lines. The model's right breast is described by a series of curving lines, drawn as if they traveled over the hemispherical surface. Her right armpit is suggested by a similar series of lines.

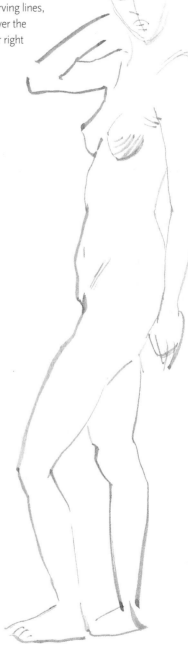

If you draw a world globe, the outlines of the continents are SURFACE CONTOUR LINES. ▶ Lines imagined as lying on the surface of any drawn mass—the stripes on a barber shop pole, lettering on a sign, the outline of a model's nipples or locks of hair cascading over the mass of the skull—are all surface contour lines.

You produce another kind of contour line, a SECTIONAL CONTOUR LINE, ▼ when you slice a section from a mass. If you draw a picture of a globe, the lines of latitude are sectional contour lines. If you slice a section out of any mass, the outline of the slice is also a sectional contour line. If you draw a model half-immersed in a bathtub, the waterline running around that person is a sectional contour line.

Sectional contour lines behave somewhat differently than surface contour lines. If you compare the cylinders in IN THE DIAGRAMS AT THE BOTTOM, ▼ the difference is quite clear: A surface contour line run diagonally on a cylinder takes on the **S** curve of a barber pole; a section cut diagonally out of a cylinder has no **S** curve.

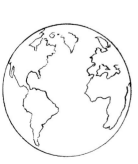
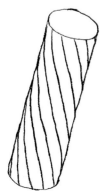

Surface contour lines

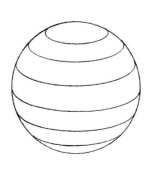

Sectional contour lines

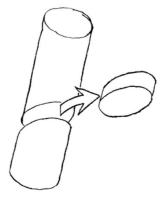

A third kind of contour line is imagined as the border of the entire visible surface of a mass. Think again of the orange on a table. When you look at it, you see only half of the orange; its back is hidden from sight. In fact, for all you know it may have no back portion at all. But if you pick up the orange and rotate it, the side comes into view.

Any contour line that traces the whole visible surface of a mass is a BISECTING CONTOUR LINE. ▼ On a globe, the lines of longitude are bisecting contour lines. Unlike latitude lines, every longitude line runs completely around the globe, from pole to pole, so that if you look at the globe from an appropriate angle, the longitude line forms the globe's outline. The silhouette of any drawn object is a bisecting contour line.

Bisecting contour lines play a role in understanding light and shade, as well. The light source that illuminates your model can "see" only half of the body. Therefore, the place where the body turns from light into shadow is a bisecting contour line.

A bisecting contour line that runs around a sphere and divides it into two hemispheres is called a HEMISPHERIC CONTOUR LINE. This term applies only to spheres. It will come in handy later, when you examine how shade travels over the surface of cylinders.

Another kind of contour line comes into play when you draw hands. This line is used to convey the fact that hands take on the shapes of the objects they interact with. If I reach out to hand you an egg, your hand instinctively assumes an egg-shaped concavity to cradle it. If you reach for a glass, your hand becomes bottle shaped.

To convey this shaping when drawing hands, artists usually connect the knuckles at the end of each joint with a construction line. If the hand is flat, this line is shaped like a **V**, with the point lying on the joint of the long finger. What is fascinating is that this **V**-shaped line is also a contour line, which lies on the surface of whatever the hand is holding. Such lines are IMPLIED CONTOUR LINES.

The model's left hand rests on his cylindrical thigh. The lines of the knuckles become implied contour lines over this cylindrical mass. You do not actually draw this line.

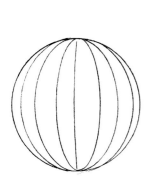
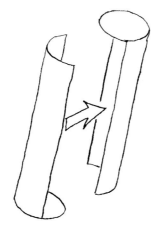

Bisecting contour lines

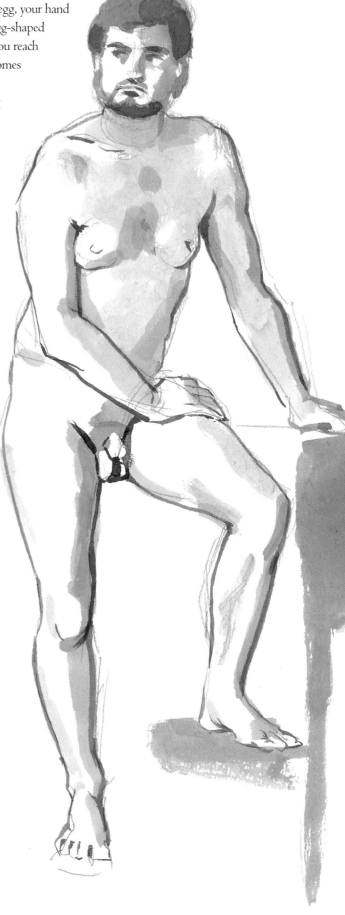

Conceived Light and Shade

Just as you simplify masses when you draw, you must also simplify the light that illuminates them. Unfortunately, the multiple light sources found in most interior settings—including most art studios—produce a chaotic effect unsuitable for illusionistic drawing.

Masses are best described under the light of just one source. If you familiarize yourself with how an one light source behaves on simple hard-edged, single-curved and double-curved masses, you will instinctively understand the light's effect on the more complex forms that compromise the human figure.

Imagine a single light source positioned behind and above your left shoulder. Its light reaches the upper left side of each mass but is hidden from the opposite lower side, AS INDICATED BELOW. ▼

The illuminated portion of a mass is referred to as its FRONT PLANE; the hidden area is called its SIDE PLANE. The border between the two areas is called the TERMINATOR.

The light source can "see" exactly half of each mass. Since any line that divides a mass in half is a bisecting contour line, you can conclude that the terminator of any mass is a bisecting contour line.

I have used only two tones so far, not counting the outline. The white of the paper stands for the front plane of each mass, and the gray tone suggests the side plane. This is the simplest formula for applying shade and is effective for quick sketches, such as gesture drawings (see pages 85).

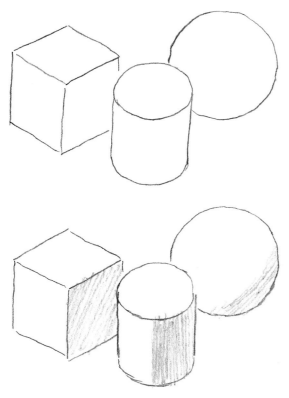

Single light source

IN THE SKETCH AT THE TOP RIGHT, ◄ the break between front and side planes is uniform throughout the picture. To improve on this effect, without adding to the two-value formula, vary the break between illuminated and hidden planes.

Generally, parts of the body that lie directly over bone are hard-edged while parts overlaid with muscle or fat are curved. These two qualities are referred to as SOFT EDGED AND HARD EDGED. ▼ Introducing variety to your edges enables you to describe the masses of the body in greater detail while keeping your shading quite simple.

You can introduce the same sort of variance with mass conceptions. The hard-edged box remains the same as before, but the single-curved cylinder and double-curved sphere move gradually from the dark

value of the side plane to the light of the front plane. This intermediate movement of tone is known as FEATHERING THE EDGE.

You can take it a step further and remove the outlines and add a halftone to the background. The viewer can still clearly read the silhouettes of the masses. (This is one reason artists sometimes draw using black and white crayons on toned paper. See demonstrations on pages 100-108.) Even without outlines, each mass is identifiable, with only the cues of front plane, side plane and hard or soft edge.

I spoke earlier of the benefit of introducing variety to

your line weights. This is so effective because a heavy line can stand for the meeting of hard-edged planes, while an indistinct line—or no line at all—can symbolize the edge of a curving mass.

The shading schemes discussed up to now are the simplest way of suggesting mass, but they are also quite powerful.

When the only cues provided as to a mass are one tone for the front plane and one for the side plane, the method

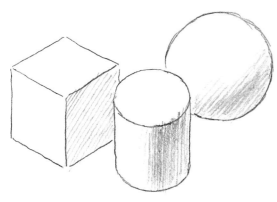

Hard and soft edges

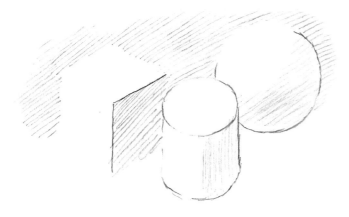

Hard-edged box, soft-edged cylinder and sphere without the outlines.

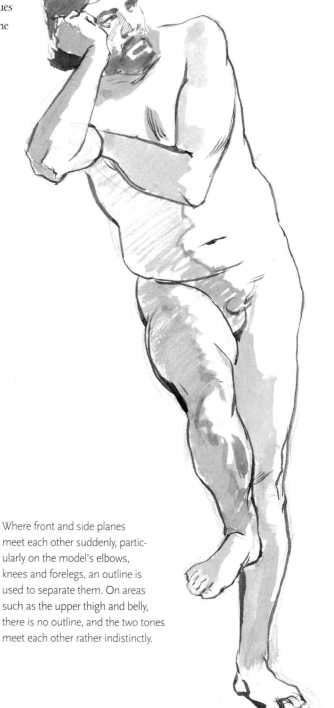

Where front and side planes meet each other suddenly, particularly on the model's elbows, knees and forelegs, an outline is used to separate them. On areas such as the upper thigh and belly, there is no outline, and the two tones meet each other rather indistinctly.

is referred to as DRAWING IN TWO PLANES. This method lies at the root of more comprehensively shaded drawings. You can easily identify front and side planes throughout the figures, as well as a wide variety of hard and soft edges.

To understand how light behaves within front and side planes, consider mass conceptions under the illumination of a single source. BEGIN WITH THE HARD-EDGED BOX. ▶

What if your light source was both behind and above you? The latter is the rule rather than the exception; things are seldom lit from below. Because of this, you can assign a lighter value to the facet of the box that faces upward. It remains close in value to the other front-plane facet but is visibly the brighter of the two. (The rule, "up-planes light, down-planes dark," pays homage to the fact that light usually comes from above.) You can introduce such a variation to your front plane so long as you make sure the front-plane tones aren't dark enough to be confused with side-plane tones.

The effect is a reasonably good one, but the light is flat and unvarying. In the real world, a surface does not run any considerable distance without its tones darkening or lightening at least a bit.

To best communicate the effect of a hard edge, butt the lightest values on the front plane up against the darkest values on the side plane.

Examine the side plane of the cube in the ILLUSTRATION ON THE FAR RIGHT. ▶ Although the side plane is darker than anything on the front plane, it lightens up just a bit as you move away from the terminator. Artists try to allow only one light source in their pictures, yet, something seems to be very weakly illuminating a portion of the side plane, where our light source by definition cannot reach. What then is lighting the side plane?

The answer is the floor, or the walls. Think of one light source that strongly illuminates the front planes of your masses, and then consider what happens when some of that light hits the floor or walls of your studio. Most of the light is absorbed, but a small amount reflects back and slightly lightens the back sides of the masses.

The main light source is called the DIRECT LIGHT, and the weaker, secondary

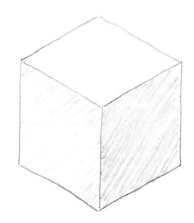

Light source is both behind and above.

WRONG: Here I introduced several gradations of values on each facet. The effect is rather jumbled, although it does give a curious sensation of reflective metal to the surface of the box. Hold this idea in reserve for the moment, and see if you can get a good effect through simpler means.

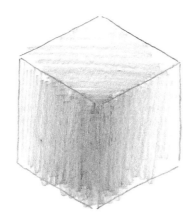

Here, I varied the gradations of values on each side, but this example still does not work well. This drawing contradicts the notion that the way to express a hard edge, such as on a box, is to allow values to contrast each other as much as possible where front and side planes meet.

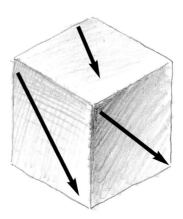

This drawing works quite well. There is a smooth gradation of values on each facet. The two facets in the front plane are close to each other in value; there is no mistaking front plane for side plane.

Ignoring the top surface of the box, there are just two shade movements: a dark to light as you move toward the terminator on the front plane, and a second dark to light movement as you go from the terminator on the side plane.

source is called REFLECTED LIGHT. It is this reflected light that altered the values on the side plane of the box and allowed me to ram the lightest values of the front plane up against the darkest values of the side plane. In so doing, I obtained a much better illusion of a box.

The most important thing in shading a box, or any hard-edged mass, is this juxtaposition of lightest lights and darkest darks at the terminator. There is just one movement of shade per facet, and it is aimed so as to get as much of a contrast at the terminator as possible.

To adjust the recipe for shading single-curved masses, such as cylinders, first recall the things you already know about such forms: A direct light source divides a cylinder into front and side planes, as it does with a hard-edged box, and the terminator that borders front and side planes is a bisecting contour line.

It is important to remember that the terminator on a cylinder is always parallel to that cylinder's central axis. If the terminator skews in some other direction, your spectator will not read the picture as a cylinder. Later, when you study how shade behaves on tipped and tilted cylinders (pages 136–138), this information will prove quite crucial.

You have also seen that the terminator does not abruptly appear on single-curved masses. Artists feather the edge, that is, introduce a gradation of tone between the light values of the front plane and the darker values of the side plane.

With these ideas in mind, take a closer look at the modeling of the cylinder, and all single-curved masses, as you move around its surface.

You are still dealing with one light source, from behind your left shoulder IN

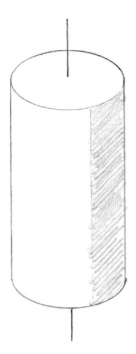

I sketched in the central axis of the cylinder, together with its terminator, to demonstrate that the terminator is always parallel to the cylinder's central axis.

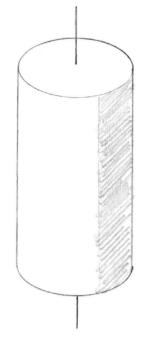

WRONG: Here the terminator is not parallel to the cylinder's central axis. This makes is impossible to read the mass as a cylinder.

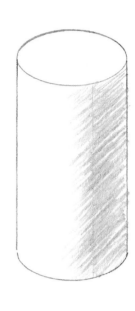

Feather the edge to introduce gradation of values.

THE SKETCH ON PAGE 23.▶ The outline facing the light source is called the NEAR EDGE (A). Where light strikes the surface of the cylinder in such a manner that it is reflected directly to your eyes, like a bank shot on a pool table, you have the brightest values, the HIGHLIGHT (B). The placement of highlights depends on the position of the mass, the light source and the position of the spectator. As you move around the object, the highlight's location moves with you. The TERMINATOR (C), however, stays put. It lies where the direct light can no longer illuminate the cylinder.

So you know the brightest values will be on the highlight and the darkest ones will be on the terminator. But what happens on the rest of the cylinder's surface?

Look at the example on THE BOTTOM RIGHT. ▶ Moving from the near edge (A) to the highlight (B), you have the first shade movement from dark to light (1). Then as you proceed from the highlight (B) to the terminator (C), you have a second movement from light to dark (2). Now you are in the side plane, and although the values will still change, they must not rival those on the front plane or you will lose the illusion of mass. Go from the terminator into reflected light. The reflected light produces a weak, but discernable, highlight (D). This is the third shade movement from dark to light

(3). Finally, from the side-plane highlight to the far edge (E) is a fourth shade movement from light to dark (4).

This is the classic recipe for cylinders and all other single-curved masses: four shade movements—unlike the hard-edged mass, which has only two. There is considerable variation allowed. You can move the highlight closer to the terminator, and you can make the highlight more or less distinct. Pretty much the only ironclad rule is that values on the side plane must be darker than those on the front plane.

Incidentally, with the lid off the cylinder, it is clear that the same four movements, in reverse, describe the concave inner surface.

There are no pure hard-edged or single-curved masses on the human body. Although conceptions of boxes and cylinders make good approximations, sooner or later you must reckon with the real thing. Every form you draw on the figure will have a vertical curve and a horizontal curve.

This introduces some problems. Shade runs in just one direction on hard-edged and single-curved masses, but on the double-curved masses—spheres, ovoids and the like—it runs in two directions at once. It takes a little practice to get the hang of applying shade to such forms.

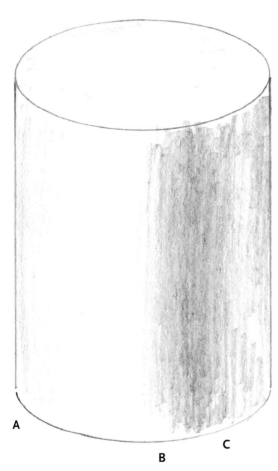

Gradation of values on a cylinder lit by a single-light source.

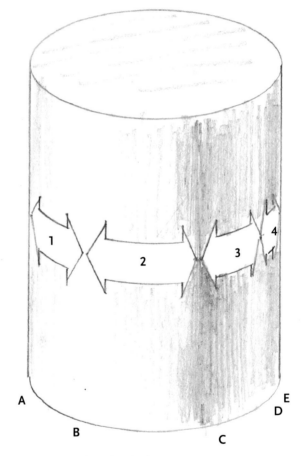

Shade movements along the cylinder.

START BY LOOKING AT A SHADED SPHERE ▶ and taking inventory of how much you already know that applies to it. Like its hard-edged and single-curved cousins, the sphere has both a highlight (A) and a terminator (B). As with the cylinder, the terminator is not a sudden break but a gradual one; to get it to look right, you must feather its edge. And as with all masses, the sphere's terminator is a bisecting contour line, and, as noted before, the line is more descriptively termed a hemispheric contour line.

The similarities end there, however. Instead of one movement of shade, there is a light to dark movement from the highlight toward every single point on the terminator, including those you cannot see. The arrows ON THE DIAGRAM TO THE RIGHT ▶ represent this, although to really tell the story requires an infinite number of arrows. (Notice that these arrows move over the surface of the sphere. These also are hemispheric contour lines.)

Add reflected light to the mix, and another quirk becomes evident: If the reflected light is imagined as coming from opposite the direct light, both direct and reflected light share the same terminator. But this rarely happens. Usually the two light sources actually overlap each other a bit.

This has a big effect on the shading of a double-curved mass. In area 1, the direct light is strongest at the highlight and goes from light to dark as you move toward the terminator. In area 2, direct and reflected light overlap, but reflected light is so weak it has no discernible effect on shade; its effect is overpowered by the direct light, much as a car headlight has no effect at high noon.

Where the overlap makes its presence felt is in area 3, where reflected light overlaps the terminator. What would otherwise be a dark, even band running around the edge of the sphere is fuzzed out or, depending on

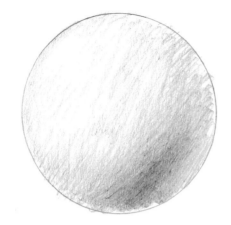

Completed sphere with shading applied.

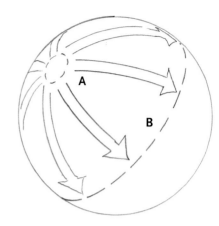

Sphere with hemispheric contour lines applied.

Shaded sphere without any reflected light.

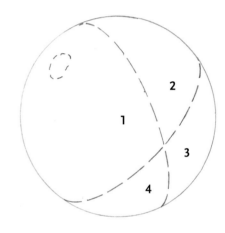

This diagram shows the hemispheric contour lines produced by both direct and reflected light. The two lines divide the visible surface of the sphere into four areas.

the reflected light's strength, eliminated. Area 3 is entirely hidden from the direct light but lit by the reflected light. It would contain a feeble highlight, from which tones would move from light to dark in every direction.

Neither direct nor reflected light reaches area 4. It contains the darkest darks. Its shape is triangular; it is a contour line. This curving pie-wedge shape is less distinct in an actual drawing than it is shown here, but it is the essence of what makes a drawn sphere look spherical. It is quite tricky to draw at first, but it will yield to a little practice.

More than anything else, it is this indistinct and ever-changing form of the terminator that characterizes double-curved masses.

Now it is time to apply the concepts you have learned to render the human form.

LOOK AT AREAS A AND B OF THE SEATED MAN. ▶ You see several passages where the lightest tone of one plane is rammed up against the darkest tone of the adjoining plane. The effect is that of a boxlike edge. Wherever I wanted the masses of his body to appear to take a sharp turn, I rammed the terminator up against the lightest values I

could get away with on the front plane and then lit up the side plane as brightly as I could. This is the artist's recipe for suggesting hard edges.

The model's left thigh (area C) is a good example of the single-curved shading recipe. The top surface is its near edge; the highlight follows this, then the terminator, then the side-plane highlight and finally the far edge.

Study the drawing and you will notice that the double-curved masses and their characteristic pie-wedge-shaped terminators are found everywhere. The shade on his left deltoid muscle (area D) contains a variation on this shape where the values are darkest. The same effect is on his right breast (area E). You could find more examples on this drawing or on practically every other drawing in this book.

The use of the word CONCEIVED regarding light and shade is quite deliberate. No matter how interestingly light falls on your model, you will never apply shade convincingly by simply copying what you see. Why it looks as it does must be understood if you are to have any hope of making a readable picture. Certainly you should study the shade on the model, but the fleeting effects you see in the studio are not the significant thing. It is the shade on your picture that matters. Your loyalty, as always, belongs to the viewer.

The tones in this drawing are more detailed than the simple two-plane scheme. Instead of a single value each, both front and side planes contain a variety of tones—although, for the record, far less variety than was on the model. The light and shade in this drawing was as much a conception as that of the previous pictures.

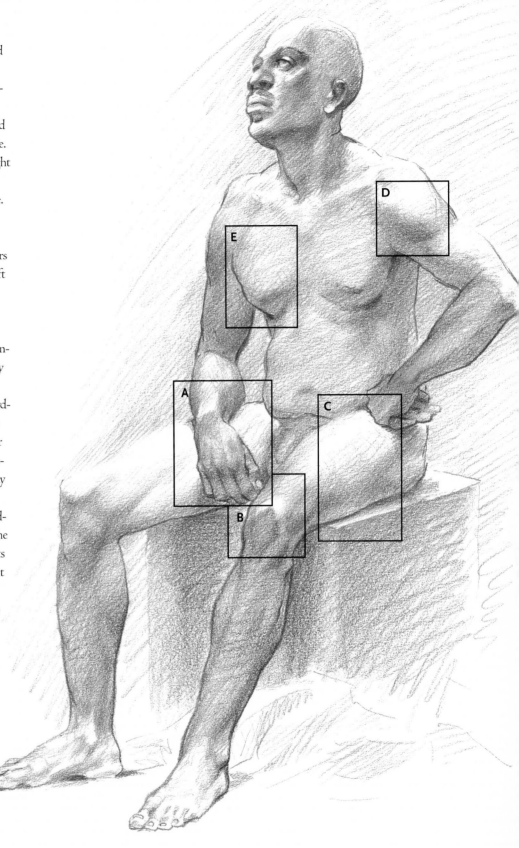

Massing

The perennial criticism of student drawings is that they're "spotty"—that is, small details on large masses resemble dark spots. Trained artists emphasize large forms and do whatever they can to subordinate small details. The body is certainly replete with small forms, and you should draw these, but this must be accomplished in such a way that they don't detract from the effect of large, volumetric forms. It is quite challenging to get students to accept this. The trick is to always make small masses obey the larger shading scheme of the big masses upon which they lie.

Compare a mass conception, such as an elongated egg, to some body part that resembles it, such as a thigh. To the trained eye, the thigh resembles the egg in all but the most trivial of details.

Untrained artists use the nude as an opportunity to show off the little details they know to be there— nipples, navels, pubic hair, and so on. But trained artists are just the opposite: The details they choose to include are provided solely for the purpose of reinforcing the sensation of huge, volumetric masses. Remember this: If a nipple helps communicate the mass of the torso, then draw it. If it hinders that effect, subordinate it or leave it out entirely.

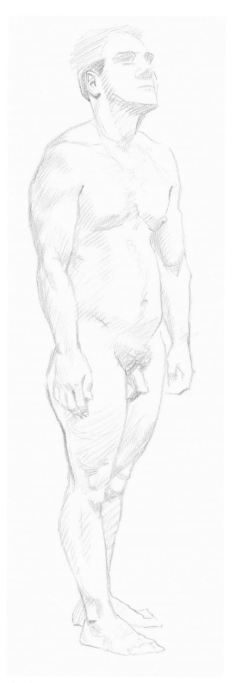

Look at the little bumps that run up the middle of the model's back. They are the dorsal spines of her vertebral column—about as small a detail as one would expect to find on a drawing. Students have a habit of accentuating them so much that they resemble bullet holes. However, if you think of these as very small mounds set in the large controlling mass of the back, it's not too much trouble to subordinate them.

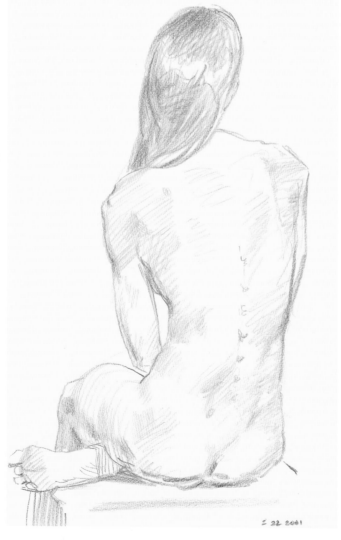

This figure is modeled in some detail, and you can get a look at the massing principle in action. The model's breast muscles are buried in the large mass of his rib cage. They are clearly rendered, but the values given them remain within the range assigned to the front plane. The closest I come to violating this is on the model's navel. Its down-plane is suggested with a line that is quite dark, but the line's weight is restrained enough that it does not appear to poke a hole in the figure.

If you remember how shade runs on hard-edged, single-curved and double-curved masses, the treatment of the smaller masses on this figure are not difficult to understand.

Texture

In all but the most highly finished drawings, the masses of the figure are shaded essentially as if they were made of white plaster. Students used to spend the first months of their training copying plaster casts of heads, hands and feet, and it is still a good idea today, although the practice has fallen out of favor over the past few decades. Plaster's matte surface has a way of subduing detail in favor of mass, and since this is the primary mission in figure drawing, plaster and the artist have always had a close kinship. In academic drawing, variety of texture is not the overriding concern.

Where texture plays an important part is in the drawing of hair. Individual shafts of hair are smooth and shiny, whereas skin is generally rough, like plaster. When hair is combed or curled, the strands of shiny hair are massed into large, ribbonlike forms, also very smooth and shiny. To draw hair convincingly, the artist must have an idea of how to suggest the difference between rough skin and smooth, shiny hair.

One difference is that of value range. If both are the same color, the lightest lights of a matte surface are somewhat darker than the lightest lights of a smooth surface. Matte surface's darkest darks are lighter than the shiny surface's. In other words, the value range of the shiny surface is wider than that of the matte surface.

Another difference is contrast. Contrast on a matte surface is quite muted; shade movement is more gradual. On a shiny surface, there is little halftone. You can describe a shiny surface with a highlight tone and a dark tone.

The model's hair is composed of two zones of value, one a dark halftone, the other a bright white. There is little gradation between the two zones; you move abruptly from highlight into dark halftone. Compare this with the tones on her flesh, which follow the shading recipes described earlier.

You can see contrast even more clearly in this brush-and-ink study. The brightest values are where the model's hair reflects direct light sharply toward you. This turns into the darkest darks with very little transition.

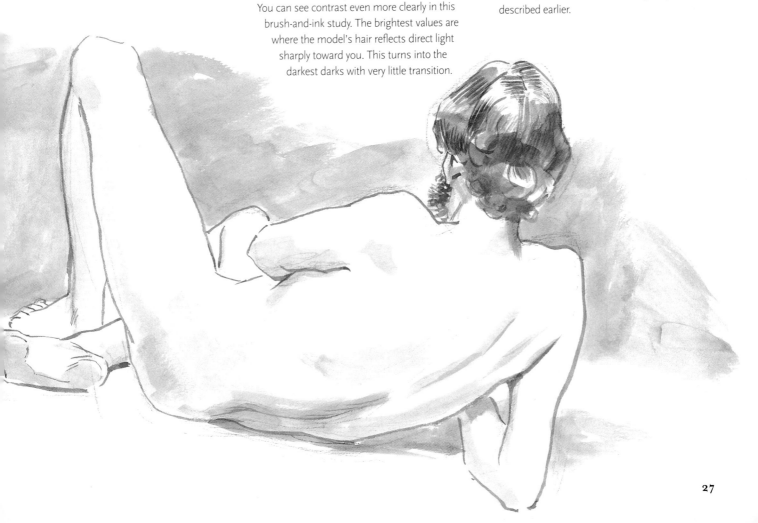

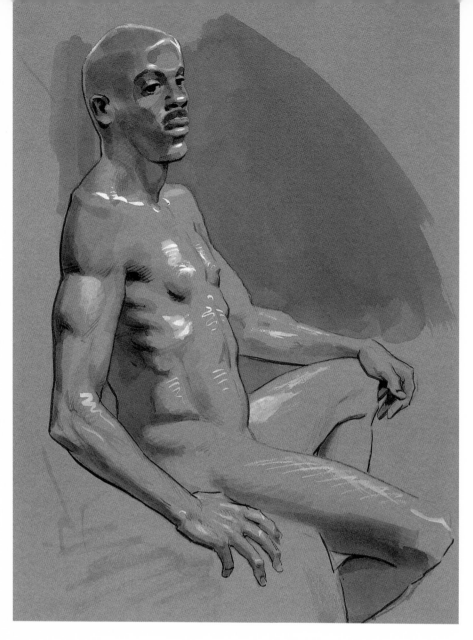

This model's skin is darker and smoother than the model in the image below. The very sharp, transitionless highlights seen here, together with the very dark halftones, suggest this.

Cast Shadows

A large part of fashioning a readable image is deciding what to leave out. Because it is impossible to draw all that you see, you must provide a small handful of cues and omit everything else. Your focus is the large masses, simplified as much as possible, illuminated by just one light source.

What must be left out? The answer to that, in large part, forms the essence of your style. Still, a few likely candidates for the ax could be cited: severe perspective effects (such as a reclining model with huge feet and a tiny, faraway head), any concave outlines you think you see on the figure, any severely dark patches you think you see on the front plane and certain details, such as eyelashes, that invariably look ridiculous unless they're massed into a larger group.

And then there's the beginner's favorite: cast shadows. Cast shadows are guilty until proven innocent. It's not always a bad choice to use them, but unless they are very artfully handled, cast shadows have a nasty habit of destroying your illusion of mass. Getting a strong sensation of front and side planes is tricky enough without throwing useless dark blobs over what should be the lightest part of the figure. Usually you can just leave the darn things out and nobody will notice.

Bear in mind the distinction between side planes and cast shadows. A side plane is an area of a mass that has turned away from the light source. As such, it is as much a characteristic of that mass as its outline. A cast shadow, on the other hand, is produced by some foreign object standing between the mass you want to draw and the light source. It has nothing in particular to do with the mass upon which it falls, and it tells you very

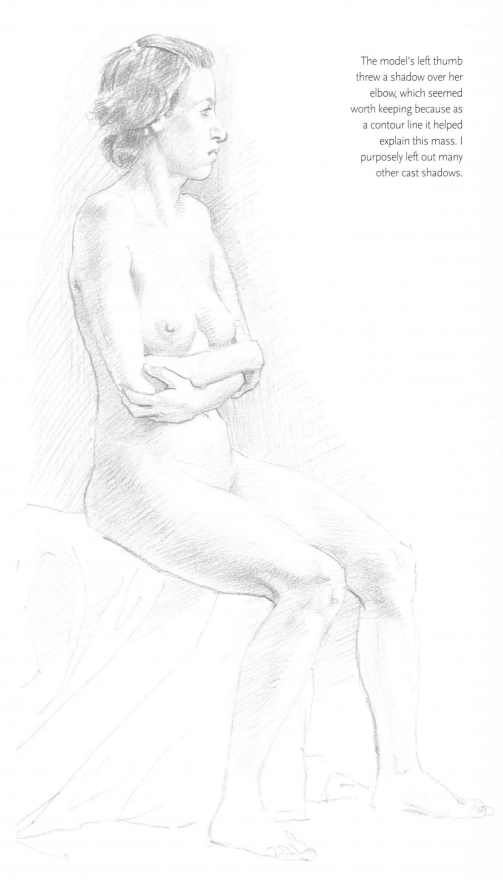

The model's left thumb threw a shadow over her elbow, which seemed worth keeping because as a contour line it helped explain this mass. I purposely left out many other cast shadows.

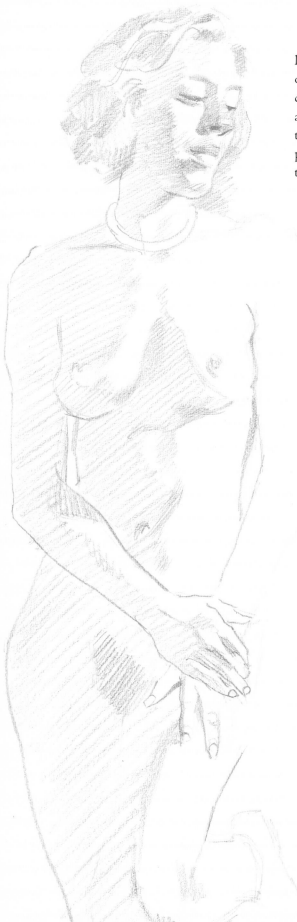

little about that mass. About the only kind thing you can say about cast shadows is that they are always contour lines, and as such they can help explain the topography of the surfaces upon which they fall, if handled properly.

There are also situations in which if you omit the cast shadow, you will lose the sensation of one mass lying in front of another. But cast shadows are useless more often than not, and when they are indeed necessary, they can and should be adjusted so that they become much more subtle than what you see.

The shadow thrown across the model's throat and neck is quite useful, explaining the surfaces of these forms and allowing a nice variety of edge. The shadow thrown over the top of the woman's left forearm, on the other hand, is quite useless and should have been omitted. It is the shadow of the tip of the woman's right breast, but it tells us nothing about the breast and severely damages the illusion of her forearm's joining to her upper arm.

So do you use it or lose it? Consider retaining a cast shadow if it helps explain the mass upon which it falls. You might include it if it explains something about the mass that cast the shadow, such as an arm or a leg. Most importantly, you might opt for the cast shadow if its presence improves the picture's design.

If you do use cast shadows, make sure you understand their anatomy. Every shadow is composed of a dark, sharply defined area called the UMBRA and a diffused outer area called the PENUMBRA. And handle them delicately, always remembering that this shadow is a contour line and must be shown to travel over the surface upon which it falls.

Finally, be aware that the farther a cast shadow is from the object which produced it, the fuzzier the edge will be. For example, if a flagpole throws a shadow on the ground, that shadow's edge will begin sharp, but grows less and less distinct as it moves away from the pole. Few things will sabotage the illusion of form more disastrously than a cast shadow with a wiry, unvarying edge.

Incidentally, the shadows the model throws on the model stand generally should be retained, as they help define the model's position in space. They may damage the illusion of the model stand's mass, but who cares about model stands?

When the model is side-lit, it is difficult to avoid using cast shadows; their presence is so characteristic of sidelighting that leaving them out might actually undercut your illusion of mass. Still, some cast shadows are better than others. View them all with suspicion, and only allow them into your drawing if they will earn their keep.

Tonal Detail

If you shade your figure drawing in some detail, be careful not to go overboard with it. The simpler the better.

THE SEATED MODEL ▶ is rendered quite carefully, but if you examine the picture, it is apparent that the degree of tonal detail is unequally distributed. On the front plane of the figure, there is a wide spread of lights and halftones, and these are used to describe a large number of bumps and hollows on her body. However, on the side plane, the shade treatment is much simpler, and the range of values is also less. No small forms are modeled out; there is simply a dark to light movement as you move out from the terminator into reflected light.

This works because when you look at something, your eyes adjust to either its dark areas or its light areas; you cannot see both clearly at once. So either an object's front plane will be detailed with tone or its side plane. One side gets the royal treatment, while the other is broadly summarized, or even has to make do with a single flat tone.

Generally, the artist favors the front plane, allowing the side plane very little tonal detail. The viewer's eyes are thought of as having adjusted to the light areas and perceiving little in the shadows.

There are exceptions to this practice, however, especially if you are drawing out-

Here you can see that despite the model being rendered carefully, the degree of tonal detail is not equally distributed throughout.

doors. The bright noonday sun can be so overwhelmingly powerful that its reflections light up the side planes of objects. If a mid-day picture is backlit by the sun, you will be looking at mostly side planes. These can be enormously detailed in tone, while the direct light of the sun is so powerful it simply washes out into a flat, hard-edged tone.

This is the recipe Monet and his colleagues came up with for their midday outdoor pictures. Today the practice is called Impressionism.

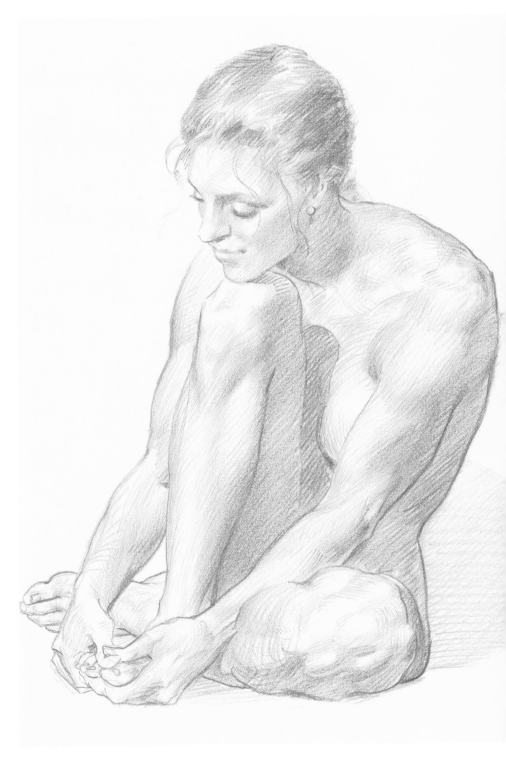

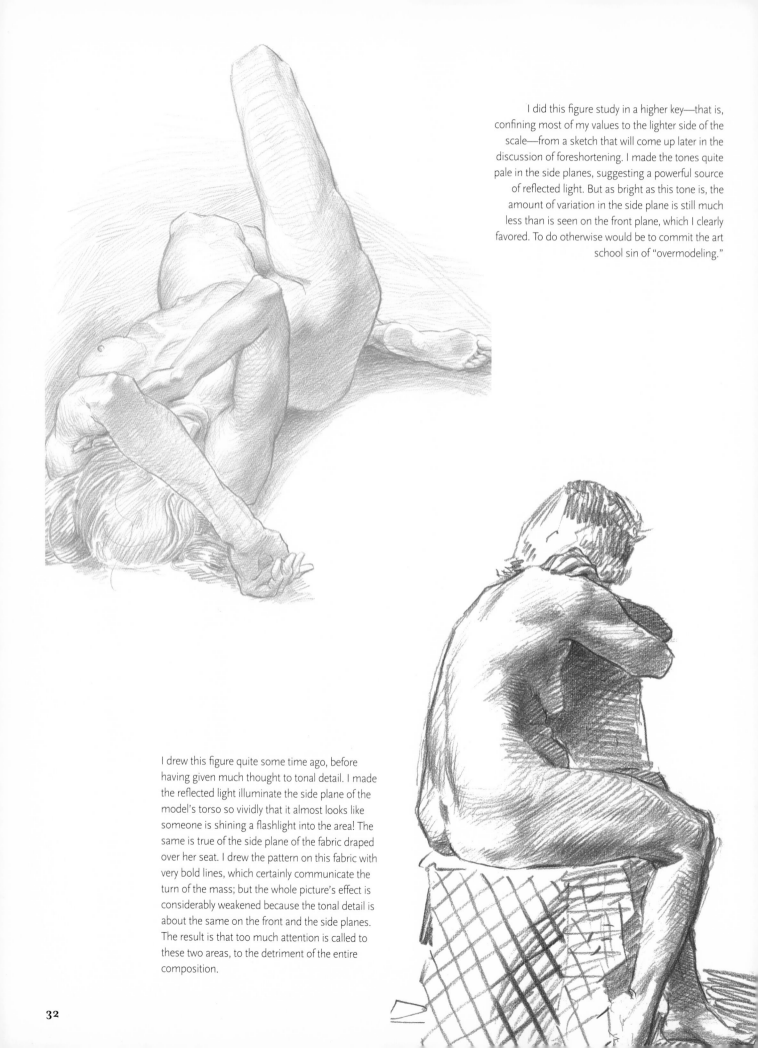

I did this figure study in a higher key—that is, confining most of my values to the lighter side of the scale—from a sketch that will come up later in the discussion of foreshortening. I made the tones quite pale in the side planes, suggesting a powerful source of reflected light. But as bright as this tone is, the amount of variation in the side plane is still much less than is seen on the front plane, which I clearly favored. To do otherwise would be to commit the art school sin of "overmodeling."

I drew this figure quite some time ago, before having given much thought to tonal detail. I made the reflected light illuminate the side plane of the model's torso so vividly that it almost looks like someone is shining a flashlight into the area! The same is true of the side plane of the fabric draped over her seat. I drew the pattern on this fabric with very bold lines, which certainly communicate the turn of the mass; but the whole picture's effect is considerably weakened because the tonal detail is about the same on the front and the side planes. The result is that too much attention is called to these two areas, to the detriment of the entire composition.

Tonal Palette

Artists must apply values according to specific rules. Ration out detail in tone, with the larger share going to either the front plane or the side plane; never equally divide tonal detail between the two. To show texture, you must narrow or widen the range of tone on a drawn mass.

You must deliberately limit the use of certain tones to specific passages to produce the desired effect. Good drawing tends to be tonally quite simple. Select a small number of values and use these throughout the picture. Just as painters lay out the colors best suited to their intent, so you must designate the required tones and limit yourself to these. Think of this as a TONAL PALETTE.

Set up a scale of tones numbered from zero to ten. The lowest note on the scale, the zero, corresponds to pure white, while the ten is pure black. There are far finer value distinctions than this, but it is useful to have some kind of broad categorization. If you want to learn to accurately grade your values, devote a couple of hours learning how to produce each of these values with your chosen drawing medium. Then you can think about the apportionment of values to various parts of a drawing.

There are really just three values that matter in a drawing: a light, corresponding to the lightest values on the front plane; a halftone, the darkest front-plane value; and a dark, the darkest value on the figure. (The highlight, previously defined on page 22, occupies so small an area on a given mass that it can be considered incidental to this discussion.)

Keying in these three values produces the final effect of your drawing. For example, if the lights are considerably brighter than the halftone but the halftone is only slightly brighter than the dark, this leaves you a lot of leeway to model fine detail in the front plane. Conversely, if the lights and halftones are quite close to each other in value but the darks are far darker than the halftones, you are more or less compelled to concentrate your detailed shading in the side plane. This is what happens in backlit situations.

Tonal values and their placement cannot always be determined in advance. The more fragile mediums—charcoal, for example— make predeterminations almost impossible, and not particularly desirable; the mediums' fluid nature enables you to explore value as the picture is fashioned. However, as you complete a picture, be on the lookout for ways to simplify values. If you're drawing with charcoal or soft Conté, you can simplify values by rubbing a tissue lightly over the area you want to unify. The darks lighten and the lights darken somewhat, and the edges soften, as well.

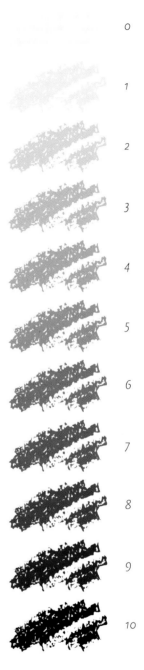

0

1

2

3

4

5

6

7

8

9

10

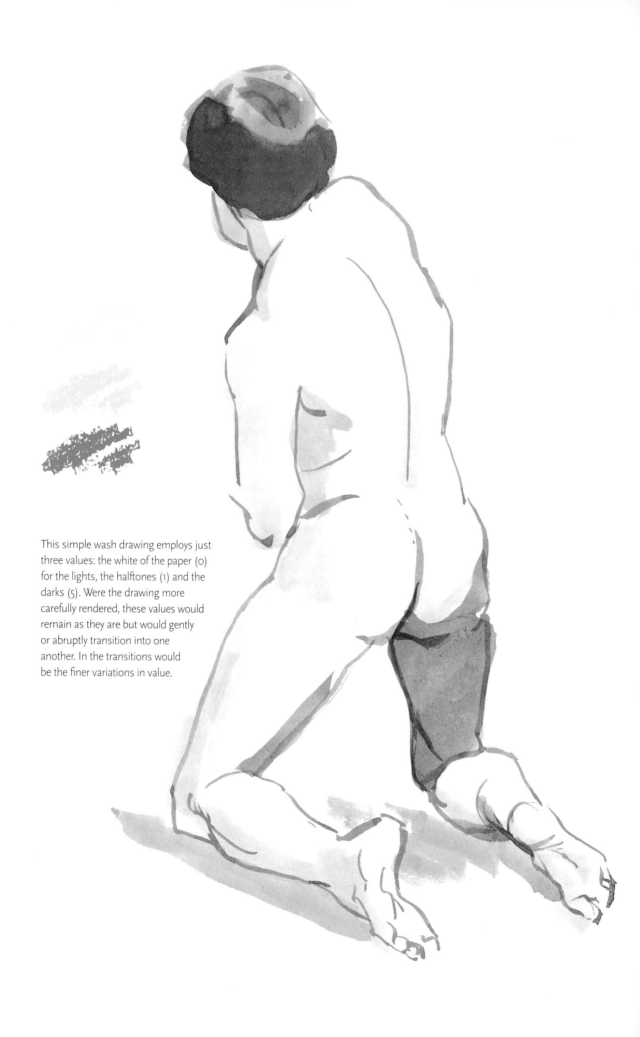

This simple wash drawing employs just three values: the white of the paper (0) for the lights, the halftones (1) and the darks (5). Were the drawing more carefully rendered, these values would remain as they are but would gently or abruptly transition into one another. In the transitions would be the finer variations in value.

There are essentially just three values here, all clustered in the middle of the scale, with the transitions in between them. There are highlights scattered here and there, as well. The palette corresponds to values 1, 2 and 4.

This backlit pose concentrates its tonal detail on the side plane. The front plane, an almost uniform strip of white, does not compete with the fuller modeling to be found on the side plane. The side plane gets a halftone, value 4, and a dark, value 6, while the front plane is a featureless band of 0.

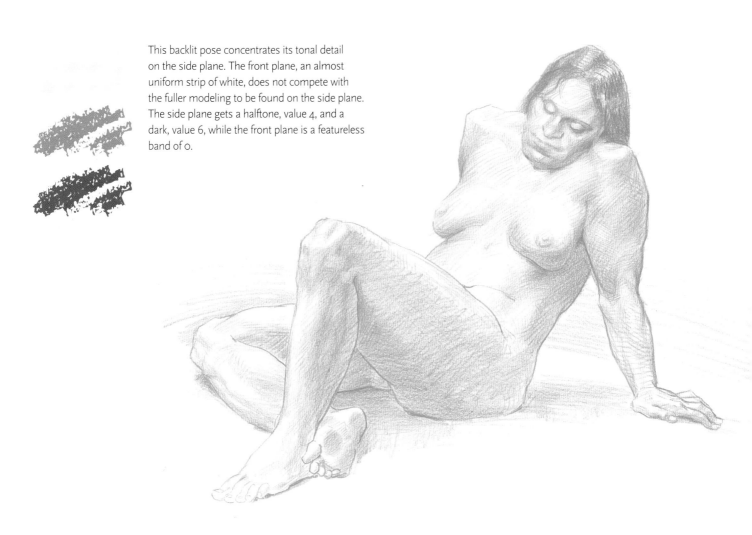

Foreshortening

The masses of the body are easily recognized when their longest dimensions are perpendicular to you. That is, an arm looks most like an arm if you can see its full length. Unfortunately, the masses of the human body point in a variety of directions, and it's unlikely all of them will present their full lengths to your eye. Something is bound to be pointed toward or away from you. Viewed in this way, masses take on different configurations than what you are used to. Lengths are truncated; the outline resembles the mass's cross section. A thigh, viewed straight

You can easily see the concept of foreshortening in this reclining pose.

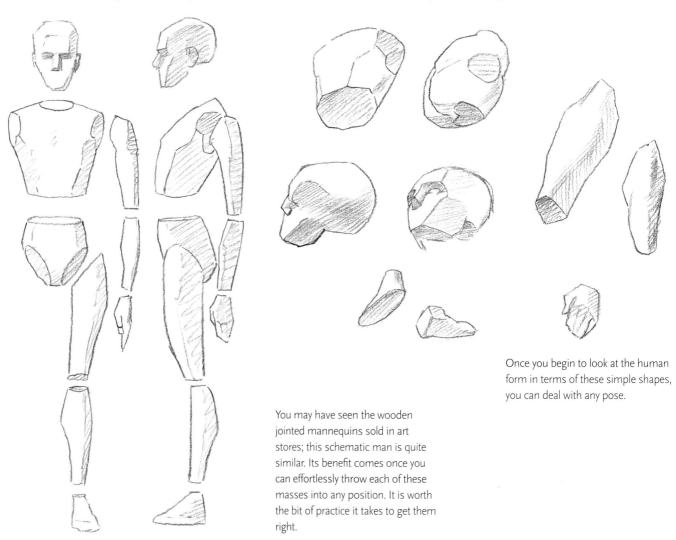

You may have seen the wooden jointed mannequins sold in art stores; this schematic man is quite similar. Its benefit comes once you can effortlessly throw each of these masses into any position. It is worth the bit of practice it takes to get them right.

Once you begin to look at the human form in terms of these simple shapes, you can deal with any pose.

up its axis, resembles the outline of a pear. A form distorted in this fashion is said to be FORESHORTENED. Foreshortening is most apparent in reclining poses, but its influence is found in all poses.

Foreshortening goes beyond studying the appearance of body masses as they swing this way and that; it includes the assembling of these masses into a believable figure. This assembly is somewhat problematic. The places where the legs fit into the abdomen and the neck protrudes from the torso become as distorted as the masses themselves, and it is in these joinings that the real challenge lies. Often in a foreshortened view, the slightest tipping or rotating of one mass on its neighbor has enormous effect on the forms you see. You have to observe sharply and draw very descriptively to make such views credible.

There is a kind of simplified anatomy you can use to construct foreshortened poses. These mannequin-like forms (at left) are fairly easy to memorize and visualize in any position. Strong cross-sectional information is built into them.

You can use these simple forms to construct figures out of your imagination, and view them from various vantage points. This is also how many storyboard and comic book artists design their figures.

However, the schematic figure, once learned by heart, is invaluable in drawing from life. THE SIMPLE PLANE BREAKS OF THIS SCHEMATIC MAN ◄ correspond closely enough to the real thing to enable you to conceive shade, decide on thrust (see next section) and, most importantly, handle foreshortening.

You will practice these foreshortening techniques in an ink wash demonstration in part two page 112.

Take another look at the reclining man on page 36. He really isn't that far a cry from the schematic figure.

This reclining figure is unusual in that every mass except for the half-seen left foot is strongly foreshortened. Normally it is easier and more descriptive to have some masses foreshortened and others not. In this drawing, one thigh, one arm and one forearm are virtually at right angles to the viewer, while the other thigh, arm and forearm are strongly foreshortened. This gives the viewer a frame of reference with which to unscramble the distortions inherent in foreshortening.

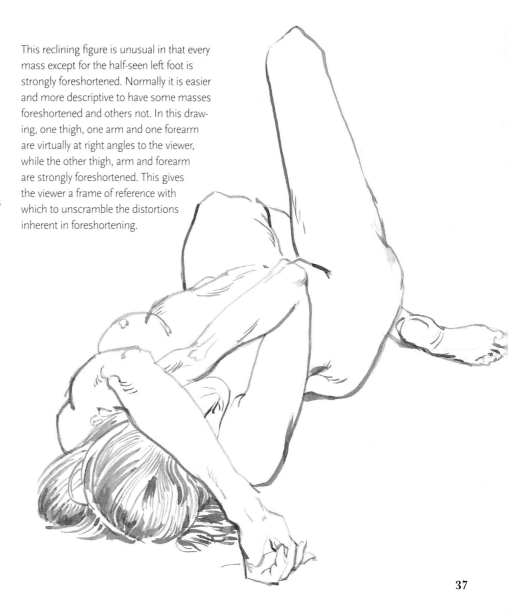

Thrust Must Be Obvious

The human body is comprised of sixteen masses: the head, neck, torso, abdomen, arms, forearms, hands, thighs, forelegs and feet.

These all move with respect to each other, and making clear the direction of each of them points is quite important in producing a convincing figure. Artists call the direction a mass is pointing its THRUST. The thrust of every mass on your figure must be obvious to your viewer. Although artists take a warped satisfaction in keeping certain things vague in their pictures, they rarely allow thrust to be unclear.

This is because foreshortening, which is caused by changes in thrust, distorts shape so wildly. Thus, it is imperative that the spectator understands why familiar shapes have suddenly become unfamiliar. The answer to this question is thrust—thrust made as obvious and unmistakable as possible.

When you move from mass to mass, thrust always changes; this is true even when the figure is standing rigidly at attention. In fact, it is impossible to avoid a change in thrust. Try pointing your finger in a straight line. No matter how hard you try, you can't avoid a zigzag as you move from joint to joint. The change may be subtle, but without it a straight finger resembles a tree-trunk. The same goes for every mass on the human body. The Greeks discovered the importance of this in the fifth century B.C., and within a single generation, their sculptures came alive,

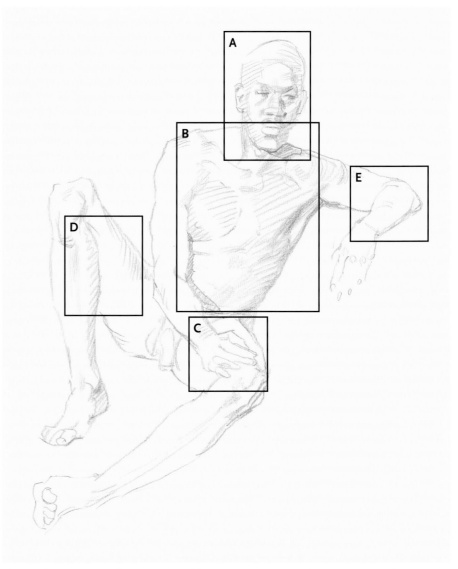

The pose here is a series of zigzags; none of the masses even comes close to pointing in the same direction. The thrust of each mass is made as clear as possible. A few simple devices help to accomplish this.

Indicating the thrust of the head is easy (A). The features are clearly viewed off center, so it is obvious that the head is pointed slightly to the model's left. The nose and eyebrows are level with the bottom and top of the ear, and so it is with this head. This tells you that the head itself is level. The torso is clearly slanted to the left (B). It is also tilted slightly toward the viewer. This is made clear by the full view of the top of the shoulders. The shade lines along the model's left side reinforce this; they are surface contour lines, revealing the thrust of the mass as it turns away from the spectator. Here they form an implied contour line over the cylindrical shape of the left thigh, thus revealing its thrust. As with the torso, the scribbly shade lines on the right thigh and foreleg act as sectional contour lines, making clear the direction in which each of these masses point (D). The forearm, strongly foreshortened, is clearly pointed toward the viewer. Fingers, grouped together, take on the shape of the masses upon which they lie (E). This is reinforced by seizing every opportunity to draw a contour line over the forearm's cylindrical surface, thus explaining its thrust.

with masses bending and twisting one on the other. Yet, although this problem was solved a millennia ago, all artists must slay this particular dragon anew if they wish to draw credible figures.

Mass conceptions are helpful in making thrust obvious. The thigh is like a cylinder, and a cylinder's thrust is very obvious, due to the contour line formed by its rim. If you very lightly draw a cylinder where the thigh should be, you can draw the real thigh right on top of this sketch. Prompted by the highly schematic cylinder, you will find yourself hunting for surface contour lines on the thigh that will reinforce its simply cylindrical quality.

The model's left forearm is thrust sharply away from the viewer, but the contour lines running around its shaft explain the mass's thrust clearly enough to make the picture easy to read.

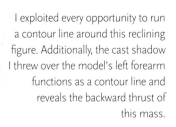

I exploited every opportunity to run a contour line around this reclining figure. Additionally, the cast shadow I threw over the model's left forearm functions as a contour line and reveals the backward thrust of this mass.

Action

The masses of the body, each pointing in its own unmistakable direction, constitute the pose. It is the relationship of all of these separately thrusting forms that gives the figure a sense of animation, of life. For example, the arm and forearm may extend outward in roughly a straight line, or they may bend one on the other at right angles. The back may arch forward on the abdomen or stand up rigidly. As seen previously, whenever you move from one form to its neighbor, thrust always changes.

The orchestrating of these differently thrusting masses, one on the other, is referred to as the figure's ACTION. This term has nothing to do with whether your figure is at rest or is caught in the middle of some activity.

Inevitably, one side of the figure bends more than the other. The side with the stronger sense of action is called the figure's

This drawing is of a very energetic pose, with the model's torso rotated sharply away from her abdomen and both knees bent. The abrupt changes in direction of each mass is an example of action.

The model shown here was actually asleep, but the forms of her body, with their angles one on another, display as much action as the more energetic pose.

ACTION SIDE; the one with less is called, appropriately enough, its INACTION SIDE. Not only the whole figure, but also every individual mass—every forearm, every thigh, every single mass—has an action and inaction side.

There is a tendency on the figure for the action side to leapfrog, moving from the right to the left and back again, as you move down the figure. This is a charming characteristic of the nude and should be sought after.

The figure taken as a whole has its own thrust. It is more or less the sum total of all the thrusts of the sixteen masses. In this sense, you might liken the body to an automobile, with a gas pedal and a brake pedal. Some component of the model's body is

This standing figure's left side is essentially one long, simple curve. His right side, however, is described by one long curve ending at the back of his bent knee and then a second curve running down his foreleg to his foot.

The model's left arm and forearm are outlined on the right with a more sharply curving line than on their right. The right side here is the action side; the left, the inaction side.

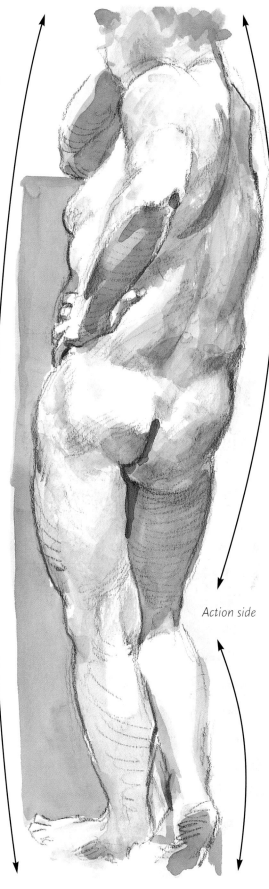

Inaction side

Action side

This kneeling figure is quite clearly thrusting forward and to the viewer's right, even though some of the individual components of his body are positioned in different directions.

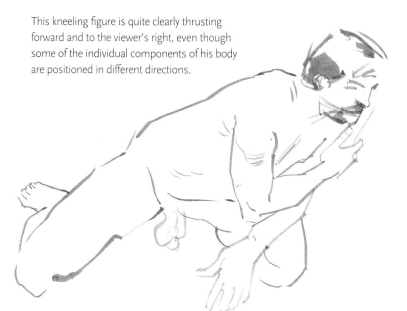

acting to stabilize it, partially countering its forward lunge.

Some models are easy to draw; they instinctively take poses that display a very clear and logical action; for others, it may be difficult to sort out the action of their pose. If you are in a position to suggest poses to your group's model, probably the most useful advice you could give is to twist the masses of the body one on the other.

If the model's abdomen is pointing to the right, suggest twisting so that the rib cage points to the left. In doing this, you will have to suggest compensating adjustments to the other masses of the body. Poses like this are difficult to hold, and very difficult to regain after a break, so learn to get down the sense of action on paper within a few minutes.

In section three, "Problem Solving" I will discuss The Rule of Tipped Cylinders. This

is a simple trick that can be of some use in bringing emphasis to changing thrusts through the use of tone.

There is little else I can teach about handling action, other than to repeat that thrust must always change when you move from one mass to the next, and to repeat that the action of all sixteen masses of the body, well orchestrated, gives a wonderful sense of animation to the figure.

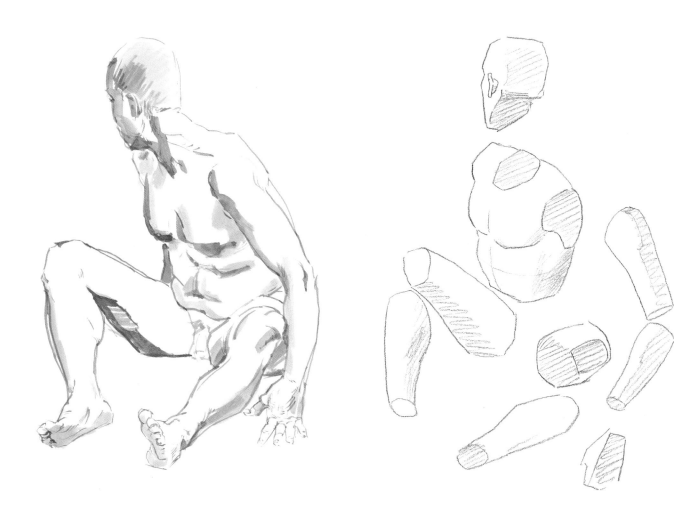

The action in this seated pose is explained by breaking its forms into simple masses (right). When you draw the figure, seize on lines that help you reinforce the action you see in the pose.

Equilibrium

Equilibrium is the result of the struggle to remain upright against the force of gravity. Whenever you try to accomplish a task—crawling, walking, climbing, digging a ditch—you are constantly adjusting your body to maintain equilibrium against the ever present pull of gravity. The story you tell in your drawings is the story of the human body at war with that force.

The physics of this, for your artistic purposes, is just a matter of common sense. You must average out the weight of an object over its volume. The point where the mass of an object is centered is referred to as its center of gravity. If this point extends beyond the supports, the object will fall over.

A builder or sculptor can construct a building or statue so that its center of gravity falls between its supports. However, a living being is always moving and must learn to adjust its movement so that balance, if lost, can be restored before catastrophe takes place. The figure strives to regain this state, which we call EQUILIBRIUM.

A person may shift body weight from one limb to the other. The rib cage may pitch forward to compensate for a backward movement of the pelvis. The head may tilt to one side and the arms may flail to find balance. The most sought-after moment in time for the figure artist is the instant just before full stability is regained. The body's response to gravity is best illustrated at this instant as it marshals the lever action of its bones and muscles so as to place its center of gravity safely between the points of support. The great nineteenth-century drawing teacher and anatomist William Rimmer believed that the ultimate test of the figure artist was to capture the body in a state of free fall. In such a state there can be no real equilibrium to make credible the action of the body's sixteen masses. The falling figure is frozen at that moment in time when equilibrium is sought for but not achieved; it lives in a

Prevent the appearance of instability in your drawings by establishing a clear center of gravity.

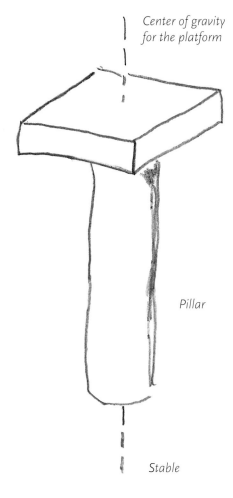

Center of gravity for the platform

Pillar

Stable

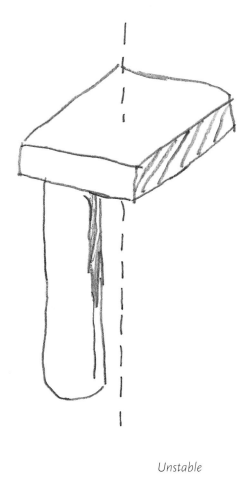

Unstable

perpetual state of transition—until it hits the ground.

One means of balanced movement is walking on all fours. The four points of contact become three when a leg or hand is lifted and thrust forward, but the remaining tripod arrangement is stable enough.

If a person stands upright, body weight is now shared by only two supports, the feet. This is a far less stable situation, and babies take quite some time to master the trick. The obvious solution is to take a position where the center of gravity falls between the two feet. This prevents swaying from one side to the other, but the body remains vulnerable to falling forward or backward. Because of this, various compensatory devices are adopted. If one mass leans one way, the adjoining one is thrust in the opposite direction. The great masses of the standing figure invariably take on a zigzag configuration of this sort.

When artists study the muscles that animate the body, they take note of the systems that oppose each other: One muscle tugs the body on the right, the other on the left, and the result is stability. Such muscles are said to be in opposition to each other. For example, the rectus abdominis muscle in the front opposes the erectors of the spine in the back.

The figure achieves balance by placing a hand on the floor.

Whether a person is walking on all fours or maintains only three points of contact with the ground, the body's center of gravity always must lie at its midpoint.

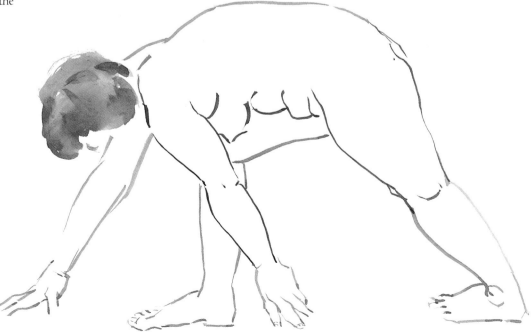

44

Somewhat stabler than standing up straight is the contrapposto stance, in which one leg takes the weight of the upper body while the other rests. In the classic formula for this posture—that is utilized in countless Roman statues—a gravity line dropped from the center of the back of the head passes through the ankle of the leg of support. The model seldom adheres to this formula, but it is not difficult to tweak the position of the masses to make it so if you wish.

On standing poses, the hips are higher on the side taking the weight. The rib cage and shoulders, generally, do just the opposite. Usually, the side taking the weight is the inaction side, but not always. The pose is one such exception; the side of support is clearly the action side.

When you draw gestures (quick sketches, see page 85), go after the equilibrium of the pose. Three minutes is a good length of time to do this. It is short enough for the model

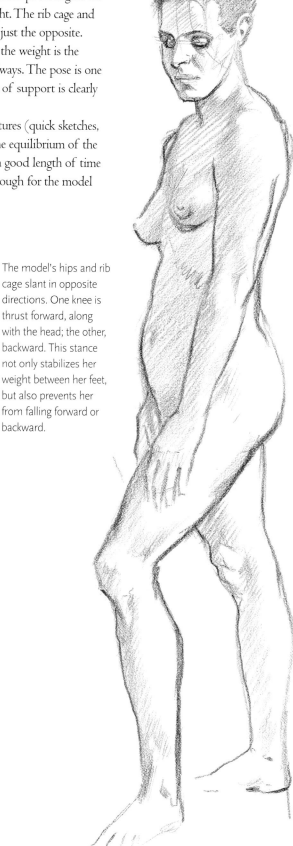

The model's hips and rib cage slant in opposite directions. One knee is thrust forward, along with the head; the other, backward. This stance not only stabilizes her weight between her feet, but also prevents her from falling forward or backward.

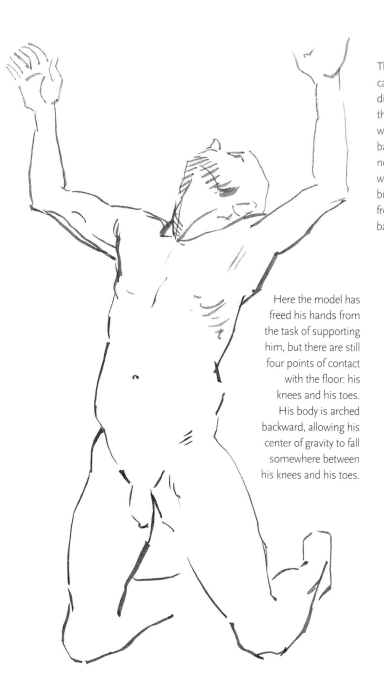

Here the model has freed his hands from the task of supporting him, but there are still four points of contact with the floor: his knees and his toes. His body is arched backward, allowing his center of gravity to fall somewhere between his knees and his toes.

to adopt very energetic poses, but long enough for you to make a clear statement of action and equilibrium. The directions of the feet are often an important clue as to how the pose is stabilized against gravity.

From the standpoint of equilibrium, the arms play a secondary role, unless the subject is unable to make lateral adjustments with his feet. Try walking a tightrope, or a set of railroad tracks, and your flailing arms will suddenly take on a crucial role in maintaining equilibrium.

You can use very casual lines to describe a gesture, but though casual, they search after the thrust, action and equilibrium of the pose. These lines clearly note the direction of every important mass, and for all the informality of the rendering, the pose itself is clearly quite stable. A drawing of this sort is more a study of equilibrium than an attempt to copy the model. Substitute mass conceptions for the figure before you, and tilt or tip these masses one way or another to produce a stable arrangement.

Even a sitting pose must illustrate the struggle to remain upright, particularly if there is no chair back or wall for the model to lean against.

The longer models hold a pose, the more lethargic they are likely to become. It is a good idea to capture the essentials and remember them as the pose wears on. After a while, the center of gravity shifts and models are likely to take a less physically demanding pose. Try to get the initial story recorded quickly, and then stick to it.

A useful construction line is the ACTION LINE, a single stroke, usually curved, illustrating the thrust of the body as a whole. This line more or less bisects the masses of the

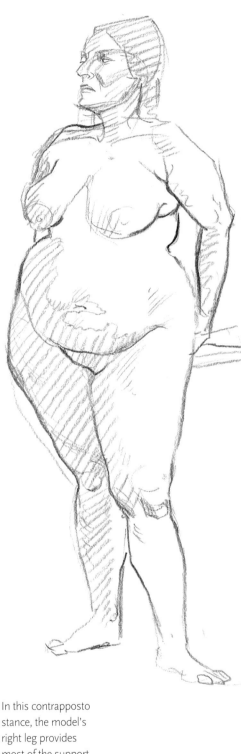

In this contrapposto stance, the model's right leg provides most of the support.

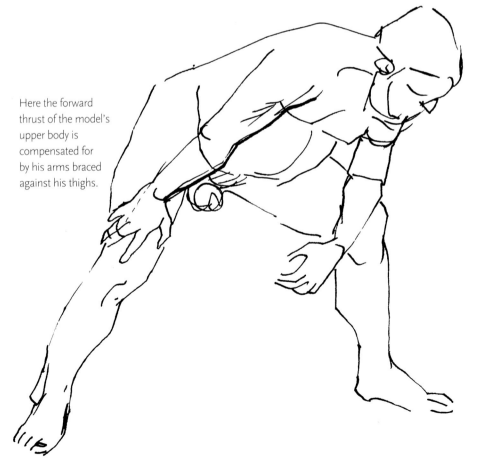

Here the forward thrust of the model's upper body is compensated for by his arms braced against his thighs.

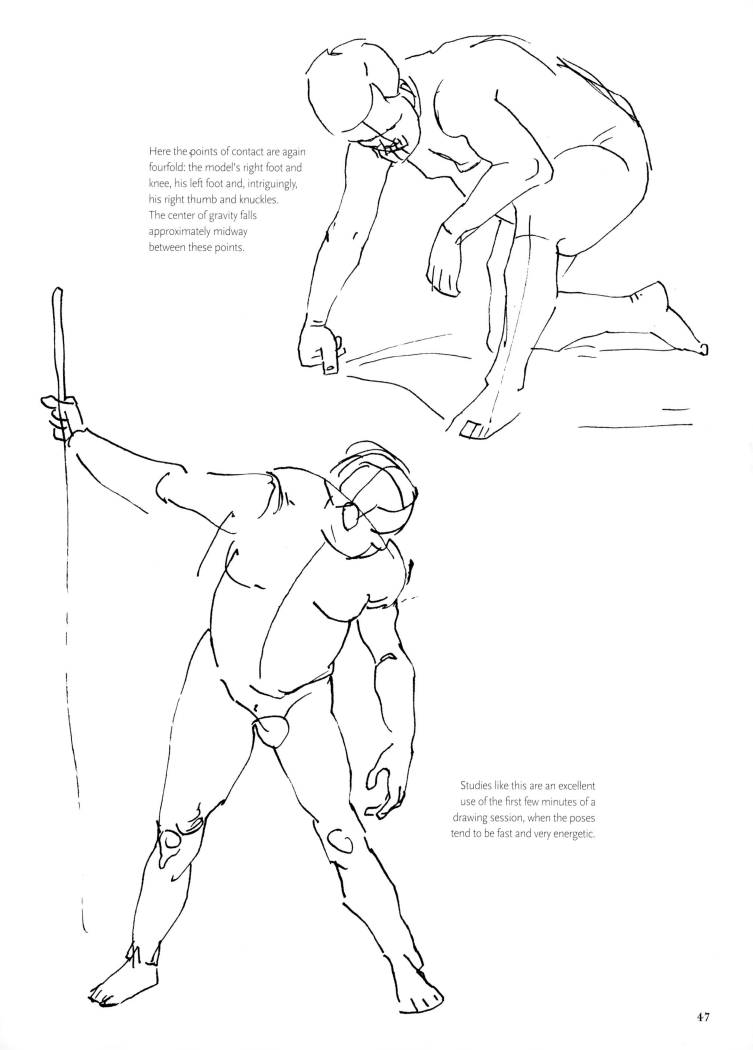

Here the points of contact are again
fourfold: the model's right foot and
knee, his left foot and, intriguingly,
his right thumb and knuckles.
The center of gravity falls
approximately midway
between these points.

Studies like this are an excellent
use of the first few minutes of a
drawing session, when the poses
tend to be fast and very energetic.

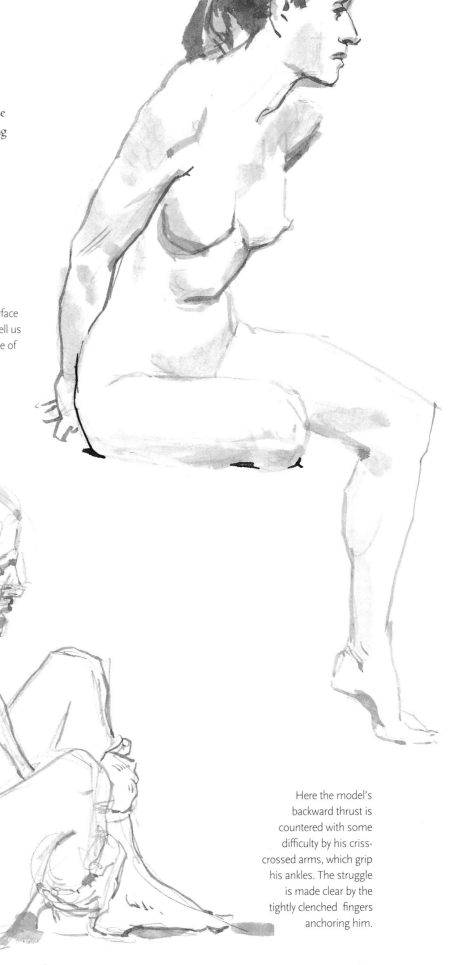

body that are concerned with its motion—forward, backward or to one side. If the figure is to be stable, however, you must oppose this action line by some means of countering force. If the model is arching forward, the person will poise one limb for support in case of a fall. If the model is leaning to one side, some opposing force must be there to prevent a fall.

This seated model's forward thrust is stabilized by her hands, clenched together at her buttocks. Incidentally, her left leg and foreleg lie on the surface of the mass upon which she sits. Their thrusts tell us it must be a boxlike form. This is a good example of implied contour lines—separate masses whose thrusts tell something about the surfaces upon which they lie.

Here the model's backward thrust is countered with some difficulty by his criss-crossed arms, which grip his ankles. The struggle is made clear by the tightly clenched fingers anchoring him.

48

Asymmetry

Standing rigidly at attention, the human figure is bilaterally symmetrical—that is to say, its left side is a mirror image of its right. However, unless you intend to draw nothing but drilling soldiers, and these viewed only from dead on in front, you'll never encounter symmetry on the nude. The moment any mass tilts or tips, even a little bit, symmetry breaks down completely.

This point is so important that as an aspiring figure artist you must train hard to eliminate symmetry from your hand; you must acquire an innate prejudice against the slightest hint of symmetry on the figure. Asymmetry goes far beyond the action and inaction sides discussed earlier.

The concept of asymmetry is really just a logical extension of what you have already

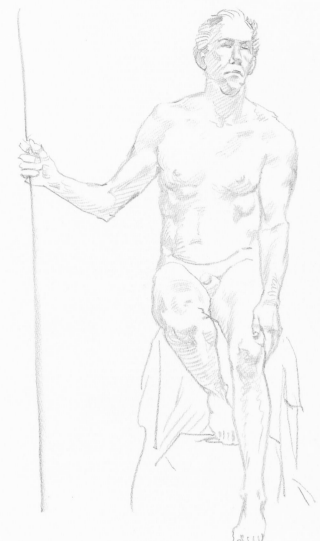

In this figure, the outline on the left is never a reflection of that on the right, not even in the smallest detail. Nor do lines on two sides of a mass ever break on the same level. People seem to favor symmetry when they draw, until they intentionally break the habit. It takes a little while; artists' hands seem to gravitate toward mirror images.

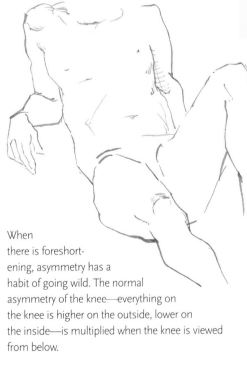

When there is foreshortening, asymmetry has a habit of going wild. The normal asymmetry of the knee—everything on the knee is higher on the outside, lower on the inside—is multiplied when the knee is viewed from below.

The model's hair and toes are much more sharply observed than the rest of her. This is asymmetry of detail.

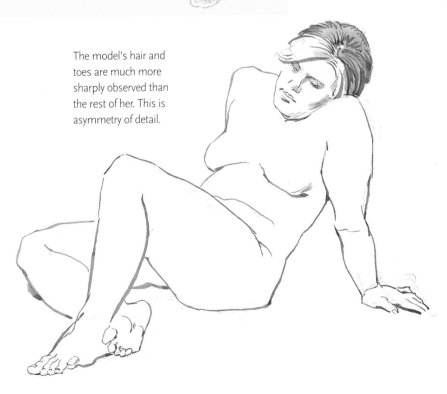

examined about thrust, action, equilibrium and foreshortening. There is little more that needs to be said about asymmetry, except that you must eliminate symmetry from your drawings—including when you think you've seen some symmetrical passage on the model. Either your eyes have deceived you or it is a chance occurrence. Either way, symmetries look awful in a drawing of a human being.

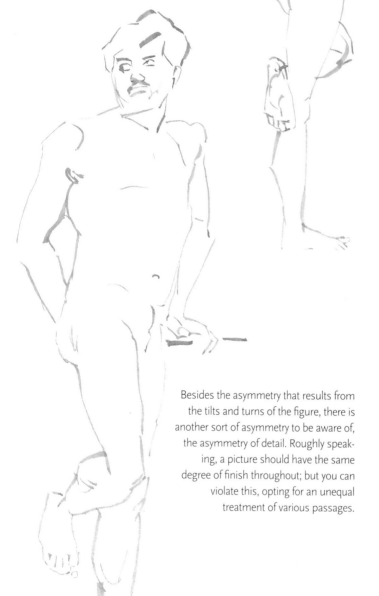

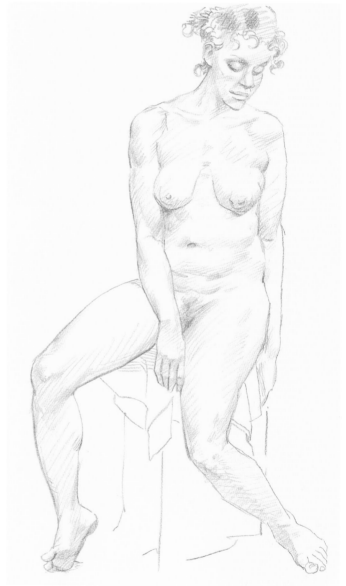

This subject's rather ambitious one-legged stance required him to balance himself through the alternate pulling and relaxing of muscle groups on either side of his body. The asymmetry built into every brushstroke helps to make this unlikely pose believable.

Besides the asymmetry that results from the tilts and turns of the figure, there is another sort of asymmetry to be aware of, the asymmetry of detail. Roughly speaking, a picture should have the same degree of finish throughout; but you can violate this, opting for an unequal treatment of various passages.

The outside contours of this woman's left and right arms are not exactly mirror images of each other, but they are closer to symmetry than I usually like to depict. The same goes for her shoulders and the bottom-most borders of her feet, both of which lie on more or less the same level as each other. The effect is less realistic, more flat than I generally like, even though it is very close to what the pose actually looked like.

Y-Lines

You will frequently encounter places on the nude where one mass overlaps another on the outline. Line drawing offers you an opportunity to describe this quite simply, by the use of what are referred to as Y-LINES. These are so called because they resemble the letter **Y**: Think of the long diagonal of the **Y** as the outline of the overlapping mass; the short diagonal, the outline of the mass that has been overlapped. On the face of it, Y-lines are an obvious idea, but students never seem to draw them until they're exhorted to look for them. Y-lines appear on pretty much all figure drawings; THIS EXAMPLE IS REPLETE WITH THEM. ▶

It's hard to talk about Y-lines without talking about anatomy, but you can certainly draw them without knowing anatomy. They're on the model; study the contours carefully. Still, Y-lines offer one of the strongest arguments in favor of anatomical study, for such lines on the model are often very subtle, and if they lie in shadow, they might be altogether invisible. Anatomy tells you in advance what forms overlap other forms from any given point of view. If you know your bones and muscles, you can draw your Y-lines quite fearlessly, knowing where and in which direction they fork.

A word of caution: If your model is a muscular woman, go easy on Y-lines or she will look freakish. You may want to outline her silhouette without them and then very gingerly put them in where you see them. Like habanero peppers or four-letter words, Y-lines pack a wallop. Be sparing with them.

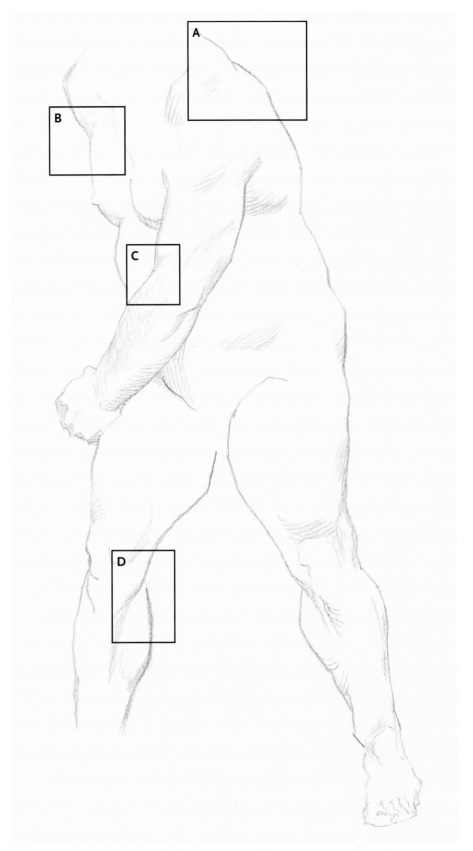

Four of the many Y-lines are identified here: The outline of the model's upper left shoulder overlaps the outline of his upper back (A). His left breast overlaps what little we see of his left upper arm (B). The forearm overlaps the bottom of the upper arm in this view because the biceps muscle of the arm disappears behind the supinator group of the forearm (C). The hamstring muscles of the back of the thigh overlap the top of the calf muscles of the foreleg (D).

Edges

As a figure artist you are called on to define where one thing ends and another begins—be it the silhouette of a mass, the border of a detail lying on that mass, a change in direction, a place where illumination can reach no further, a change in color or a change in texture. The border where one thing turns into another thing is referred to as an EDGE.

CONSIDER THE EDGES OF A CYLINDER, ▼ identified previously as the near edge, highlight, terminator, side-plane highlight and far edge. A cylinder is unchanging as you move down its shaft, but if you are dealing with a more complicated mass, such as a thigh or foreleg, the edges take on a more complex character.

When you draw the figure, don't slavishly copy the pattern of light and shade you see; try instead to understand it. As complicated

as human bodies are, they all essentially have the same bumps and hollows. If you have really studied the forearm or thigh, you will notice they all have logic to them.

Though the language of anatomy may be arcane—deltoids, tendons, triceps and the like—the forms are actually old friends to anyone who has drawn the figure for a few months. Each, in turn, has its own quality of edge. The quality of edges, over time,

becomes second nature to the artist, much as the fingering of a G7 chord becomes to the guitarist. It just takes persistence.

STUDY THE EDGES AT WORK IN THE DRAWING ON THE RIGHT ▶ Note that while her left upper arm gets an outline, the protruding breast does not—at least not where its silhouette intersects with the arm. Do not let the outlines of a foreground mass (such as the arm) intersect with those of a back-

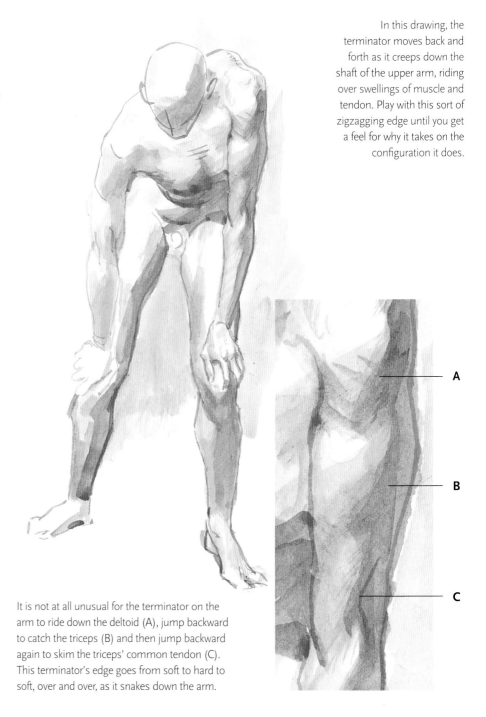

In this drawing, the terminator moves back and forth as it creeps down the shaft of the upper arm, riding over swellings of muscle and tendon. Play with this sort of zigzagging edge until you get a feel for why it takes on the configuration it does.

A Near Edge
B Highlight
C Terminator
D Side Plane Highlight
E Far Edge

A simple single-curved mass has a total of eight edges: The highlight, terminator and side-plane highlight have two edges each, one on either side, plus there are the near and far edges. Each of these eight edges have its own degree of hardness or softness.

It is not at all unusual for the terminator on the arm to ride down the deltoid (A), jump backward to catch the triceps (B) and then jump backward again to skim the triceps' common tendon (C). This terminator's edge goes from soft to hard to soft, over and over, as it snakes down the arm.

ground mass (such as the breast) or you will lose the sense of intervening space between the two masses. This is why the up-plane of the breast does not get an outline.

That same arm throws a cast shadow over the torso and abdomen. In addition to running as a surface contour line, that shadow's edge is slightly fuzzed out as you move downward. Here you find a salient truth about cast shadows: The farther they stray from the mass that produced them, the less distinct they become.

The same effect occurs when the model's nose and jaw throw cast shadows over (respectively) the mouth and neck. The farther you move from the nose or the jaw, the less distinct the edges become.

If you follow the orbital cavity of the eye, you'll find that its edge is constantly changing, softening noticeably as you move outward from the center of the head, and then suddenly reasserting itself as you move past the eye.

The values on the whole figure are not particularly profound. There is a range of values for the front plane and one for the side plane. Other than making sure that the one is clearly distinct from the other, the values could easily have been different. The edges between front and side planes, however, are indeed profound, as are the edges around the smaller front-plane forms of the arm, torso, abdomen and legs.

But edges are more involved than this. With manipulation they can produce an effect of light. For example, if direct light is very strong, it tends to fuzz out the edges of a mass. The rough brushwork of the French Impressionists, in fact, was an attempt to suggest light's propensity for dissolving edges. Examine again the woman's breast: The outlines of strong up-planes are quite indistinct. This is a means of communicating an intense source of direct light. The

scribbled background tone is there in order to lose the near edges of the figure against a darker value.

The mass-drawing mediums—charcoal and oil paint, particularly—are well suited to the study of edges. (Look at an apparently flat object, such as a door in a Vermeer painting, and see how the edge of this object is never static but is lost and found as you move along its contour.) But you can and should develop a sensitivity to describing different sorts of edges, whatever tool you use. It is a subtle business, but the melody of your different edges will produce both the illusion and the charm of the image you fashion.

If you want to understand edges, simplify your values. You need only three or four really: a halftone, a light, a dark and perhaps a side-plane halftone. Key these in and you have only to produce values that transition from one edge to the next.

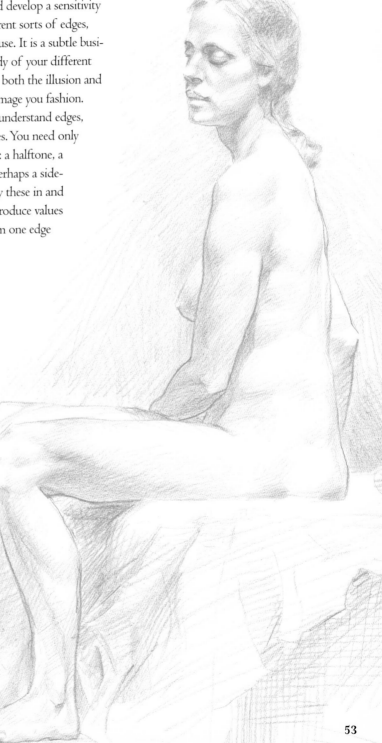

This study of a seated woman gets its effect almost entirely by virtue of its edges. (This is no great distinction; you can say the same of pretty much every readable drawing.)

Camouflage

Some things are easy to see. A brightly lit area of a mass stands out against a shadow behind it; a dark side plane of a mass stands out against a light background.

Other things are difficult to see. The side planes of the body tend to merge into a single patch of dark, even if that side plane consists of parts of an arm, a thigh, whatever. These masses lose their separate identities. Similarly, two brightly lit masses adjacent to one another merge into essentially one mass. This is the PRINCIPLE OF CAMOUFLAGE.

The knee-jerk reaction is to ignore this effect and run a stark outline around each form so that it is clearly seen. If you can't see something clearly from where you stand, ask yourself if your spectator needs to see it clearly. If naturalism is your aim, the answer is no, and you should not seek to make clear what the human eye leaves vague.

Recognizing the principle of camouflage greatly helps in suggesting the effect of light—particularly intense light, which has a way of washing out front-plane values to a degree that the camouflage effect must be reckoned with if any illusion at all is to be provided your spectator.

If camouflage is helpful on the front plane, it is absolutely required on the side plane, where detail must be lost in the meager illumination of reflected light. As noted earlier, tonal detail must favor the front or side plane, and it usually favors the front plane. Side-plane details are lost in the camouflaging murk; were they not, your spectator would wonder why things are as clear where there is no direct light as they are where there is—a condition never found in nature except in bright sunlight, where the opposite occurs and front-plane detail is fuzzed out.

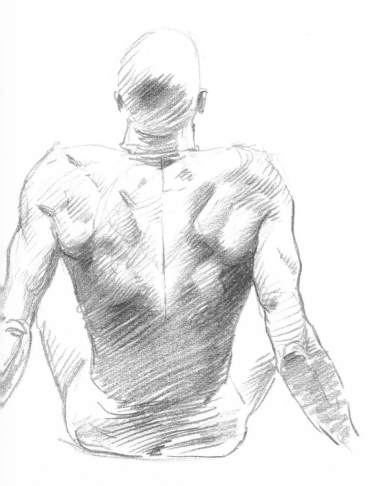

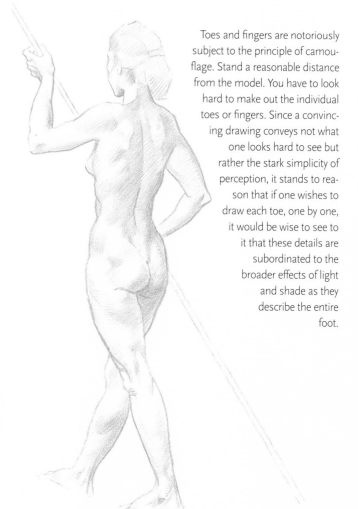

Toes and fingers are notoriously subject to the principle of camouflage. Stand a reasonable distance from the model. You have to look hard to make out the individual toes or fingers. Since a convincing drawing conveys not what one looks hard to see but rather the stark simplicity of perception, it stands to reason that if one wishes to draw each toe, one by one, it would be wise to see to it that these details are subordinated to the broader effects of light and shade as they describe the entire foot.

In this back study, the front plane is replete with detail, but in the side plane—the lower half of the man's back—all details are concealed in the simple gradated tone. (Incidentally, the straight line on the back's center is often noticeable when a muscular subject throws his arms backward. It represents where the muscles of the two sides of the back slam up against each other. Take some care to ensure this line is constantly varying in weight, or it will look quite unconvincing.)

The Etcetera Principle

Students do their best to put down every detail they see, but the harder they try, the more a readable image seems to elude them. This problem isn't a lack of initiative but a misunderstanding of how the language of drawing works. Images are built of cues, not copied minutia. The idea is to provide just enough such cues that an image is made, not on paper but in the mind of the viewer. A well constructed picture, then, is not so much one that spells everything out, but one that provides no false cues. Drawing, it has been rightly said, is the art of omission.

This sort of paring down is sometimes called THE ETCETERA PRINCIPLE. One way of stating it would be that if what you have spelled out in your drawing is convincing enough, your viewer will mentally supply what you leave out.

This sort of simplification is helpful for drapery, and it is absolutely required when it comes to hair. The average head contains thirty to eighty thousand individual hair shafts; obviously you can't draw them all. (You will learn more about hair in part three, pages 133-135.)

When you get crazy ideas for simplifying the details of the figure, go ahead and try them. Experimentation can lead you to amazing discoveries.

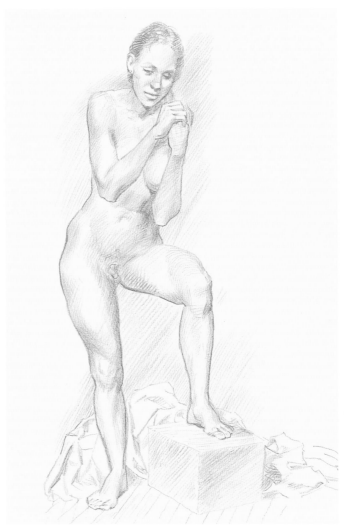

Here, the hundreds of pleats and folds on the woman's robe are vastly simplified. Drawing every detail of this still life would have obligated me to give the model the same treatment, and neither the pose nor the time allotted for it merited that. Still, it brings to mind an inescapable truth regarding the simplification of the complex: You can do it well only if you're quite familiar with the real thing, in all of its prolixity. If you want to simplify drapery, or anything else, you need to put in some time studying how it works.

I chose not to draw any individual hair shafts; instead I suggested whole masses of hair locks with a few scribbly brushstrokes.

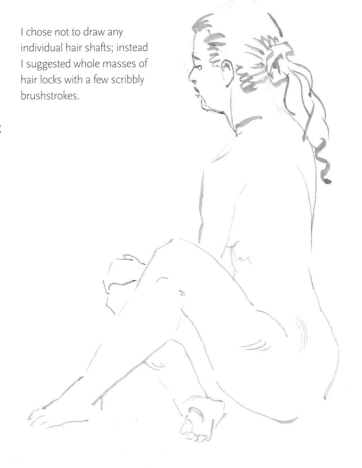

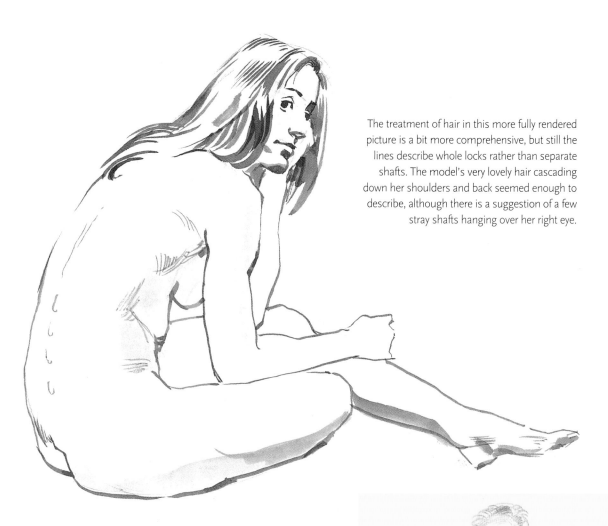

The treatment of hair in this more fully rendered picture is a bit more comprehensive, but still the lines describe whole locks rather than separate shafts. The model's very lovely hair cascading down her shoulders and back seemed enough to describe, although there is a suggestion of a few stray shafts hanging over her right eye.

This seated male model's thinning hair is described in even simpler terms. Where there is enough to produce a side plane, I threw in patches of dark. That's about as far as I went with it, except to scribble in a few lines to suggest the presence of the rest of his hair. When the effect seemed complete to me, I stopped. I don't believe it could have been helped by putting in more detail (or by drawing each of the toes on his feet, for that matter).

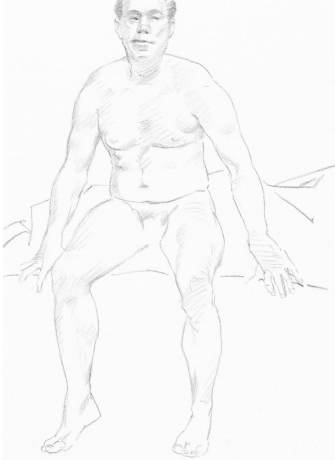

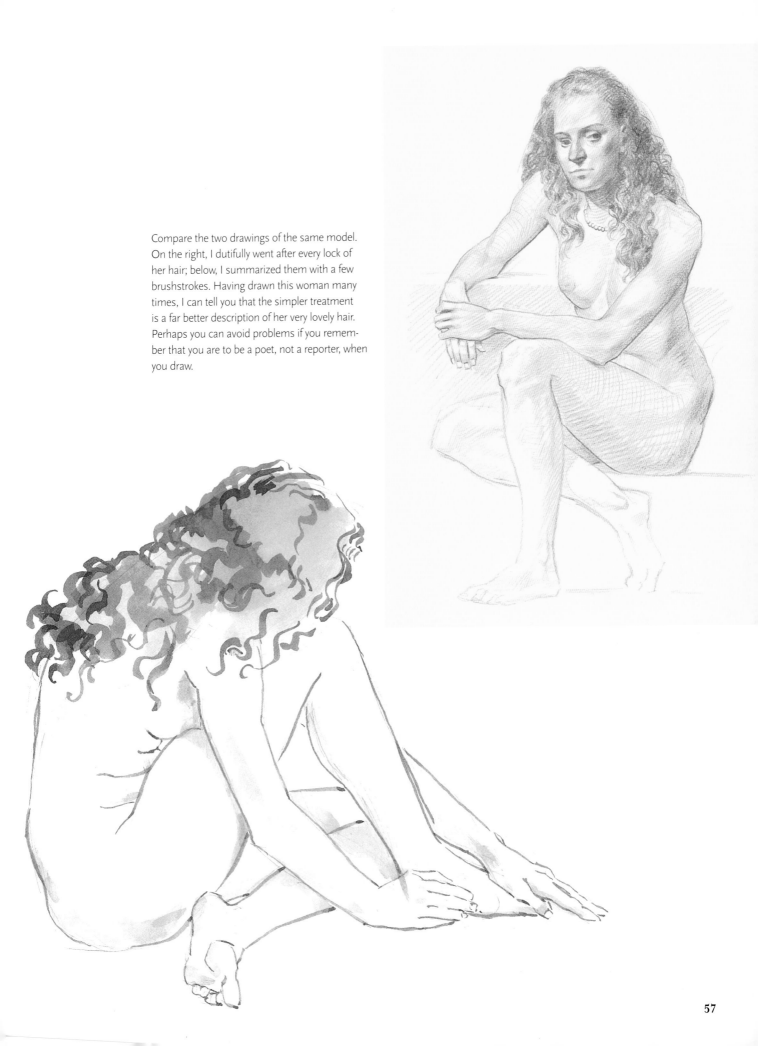

Compare the two drawings of the same model.
On the right, I dutifully went after every lock of
her hair; below, I summarized them with a few
brushstrokes. Having drawn this woman many
times, I can tell you that the simpler treatment
is a far better description of her very lovely hair.
Perhaps you can avoid problems if you remem-
ber that you are to be a poet, not a reporter, when
you draw.

Lines Redefined

When you think of a line, you likely think of a mark you make with a point, a mark that has length but no width. Perhaps this is a good time to rethink that definition.

The more descriptive you get with tones, the more judicious you get in your use of lines. They become less necessary, and in fact their presence can undercut or destroy the sense of mass you seek.

However, you can expand your definition of what constitutes a line. Where one plane of a mass meets another plane, values change. If you describe this change with your pencil, butting one value against another value, the border between these two areas is as unmistakable as if you had outlined the two areas. You can think of this border as a kind of line.

A CLEAR EXAMPLE OF SUCH A REDEFINED LINE IS THE TERMINATOR SEEN RUNNING DOWN THE MODEL'S FOREHEAD. ▶ There is no literal line here in the laymen's sense of the term, but values and the direction in which they run change quite radically at this juncture. To the artist, such a border is a line. The four-sided patch of gray describing the underside of the woman's jaw can be thought of as a plane, bordered by four lines. So can the tone running from her cheekbone backward toward her ear. Pretty much every mass in this drawing is described in this fashion.

This sort of quasi-line treatment takes longer to carry out than a simple outline, but it can describe many things that an outline cannot.

If you examine this study of a head, you'll find hardly any outlines at all, and even less pure line work inside the masses described. (I made tones with pale, diagonal lines, but this is not the same thing.)

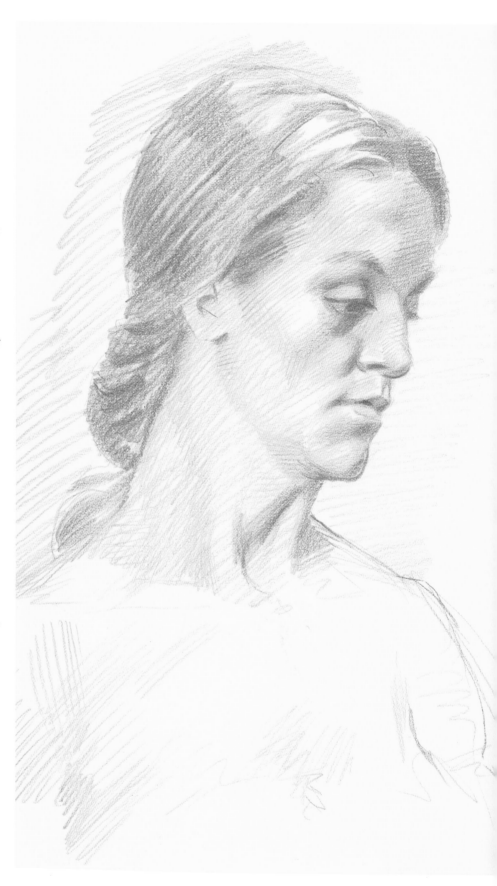

Configuration of Shade Lines

You can apply shade to your drawing many different ways. If you're using ink wash, you can simply throw an even tone over the side plane of your figure. Rub charcoal or soft Conté with a tissue, a stump or your finger. Use a pencil with a blunt point to lightly scribble shade until the desired value is produced, or use the pencil on its side to get a similar effect.

However, shade lines can also be produced by a series of somewhat mechanically drawn lines. Exactly what sort of lines you will use for this depends on the kind of image you wish to fashion.

Shade must appear transparent. The tone on your side planes must not resemble a coat of gray paint thrown over part of the model's body. This calls for some delicacy on your part. Whatever configuration of lines you use, learn how to make them so that the viewer's eye blends them into a clean overall effect of gray. This requires both a light touch and some expediency, since time before the model is precious and you don't want to spend too much on the mechanical task of applying a flat tone.

Don't hesitate to rotate your pad so that you can get the stroke direction you want comfortably. Anything that gets you a clean, anonymous gray tone will be worth it, if it doesn't take up too much time. If you're short on time, try using a lead pencil to note where front and side planes meet with a series of pale dotted lines. You can add your shade lines at your leisure, and erase the original pencil lines.

I don't recommend you simply run your pencil back and forth; at the end of each

A simple shading technique is to run diagonal, parallel lines across the side planes of the model, in whatever direction is comfortable for you. (If you are right-handed, the direction will likely be from the lower left to the upper right.) If you do this neatly and choose your values well, it produces a wonderful sense of luminosity. The eye "etceteras" these parallel lines into an anonymous gray. Such lines are also easy to adjust; you can lay a second line on top of the first to darken tones where planes break.

Quicker studies can be executed in the same fashion, with broader and looser lines if time is at a premium. Some of the shade lines in this example "hook," reversing direction at the terminator and running backward a bit. This hints at the shade movement from dark to light as you move from the terminator into reflected light.

terminator

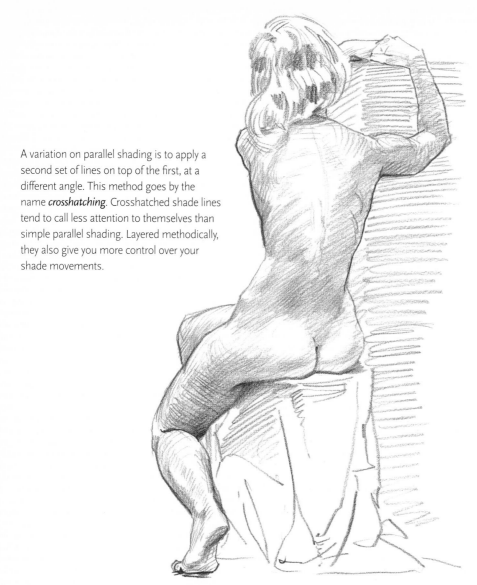

A variation on parallel shading is to apply a second set of lines on top of the first, at a different angle. This method goes by the name *crosshatching*. Crosshatched shade lines tend to call less attention to themselves than simple parallel shading. Layered methodically, they also give you more control over your shade movements.

pass, where the pencil reverses course, you'll inevitably get an unwanted darkening of the whole effect, which will interfere with both the transparency of your shadows and the shade movements that should produce the effect of mass.

When you use pencil, keep several of them nearby, in various states of sharpness. If your point has been blunted in the course of drawing, it may be ideal for rendering less distinct passages.

You can use parallel shade lines on the front plane, but tread lightly; a little goes a long way. These lines are not always parallel to each other, but they are mostly parallel to each other on individual masses. Diagonal lines seem to work best for parallel shading, although you may want to play around with vertical and horizontal lines just to see what happens. I think the old cliché about verticals and horizontals in composition—the former suggesting strength, the latter suggesting repose—is valid for determining the direction of shade lines.

There are other ways to use lines to apply shade. If the pose involves a lot of complex

The sectional contour lines used here help explain the direction of the masses in this pose.

The surface upon which the model lies was mostly invented, to make credible the action of her feet. I ran surface contour lines along this surface, to explain how she could be lying higher than her feet. I used the pencil on its side for the cast shadows beneath the model. The broader, fuzzier lines thus produced do not compete with those on the model herself.

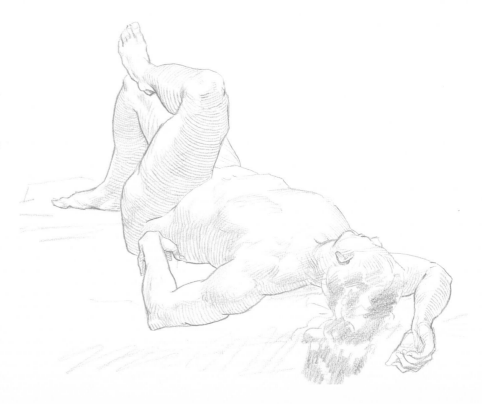

foreshortening, you'll want to explain the direction of masses as clearly as you can. Indicate thrust of the shaded area with sectional contour lines. Albrecht Dürer, one of the most passionate students of human cross sections in all of art, used this method frequently. It's a lot of fun to run shade this way once you get the hang of it, so much so that you may be tempted to use it all the time. Its chief drawback is how much attention it calls to itself. Also, the lines themselves must be made quite delicately, lest in describing the forms of the body, the lines overpower those forms.

Another option is to mix parallel and contour shading with scribbled shading. Generally, the more you mix your techniques for applying shade, the less attention you draw to your way of working and the more to the image itself.

You may use a hybrid of the parallel and cross-hatched shading to good effect. The shade lines describing the side planes of the model were essentially parallel but altered direction slightly as you move from her sloping back to her almost vertical behind. The shade lines on her right calf describe the curve of this mass. The lines describing her hair move more freely, suggesting the myriad forms on which it lies.

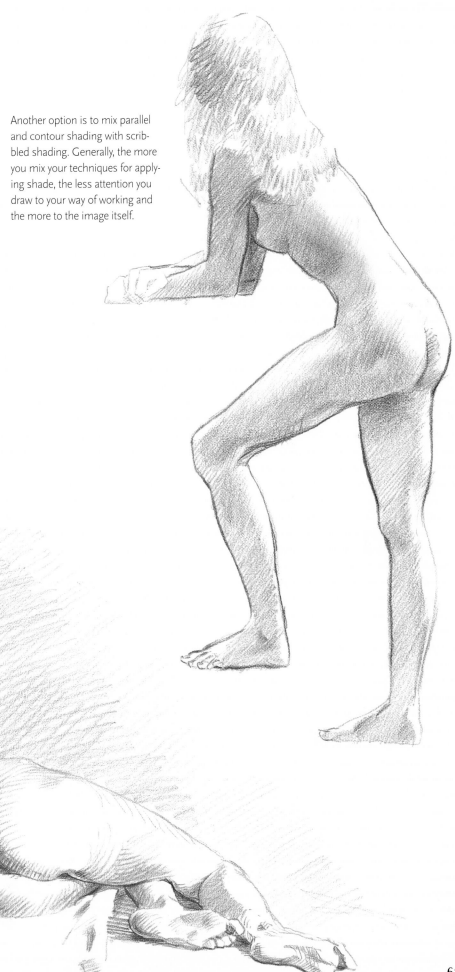

61

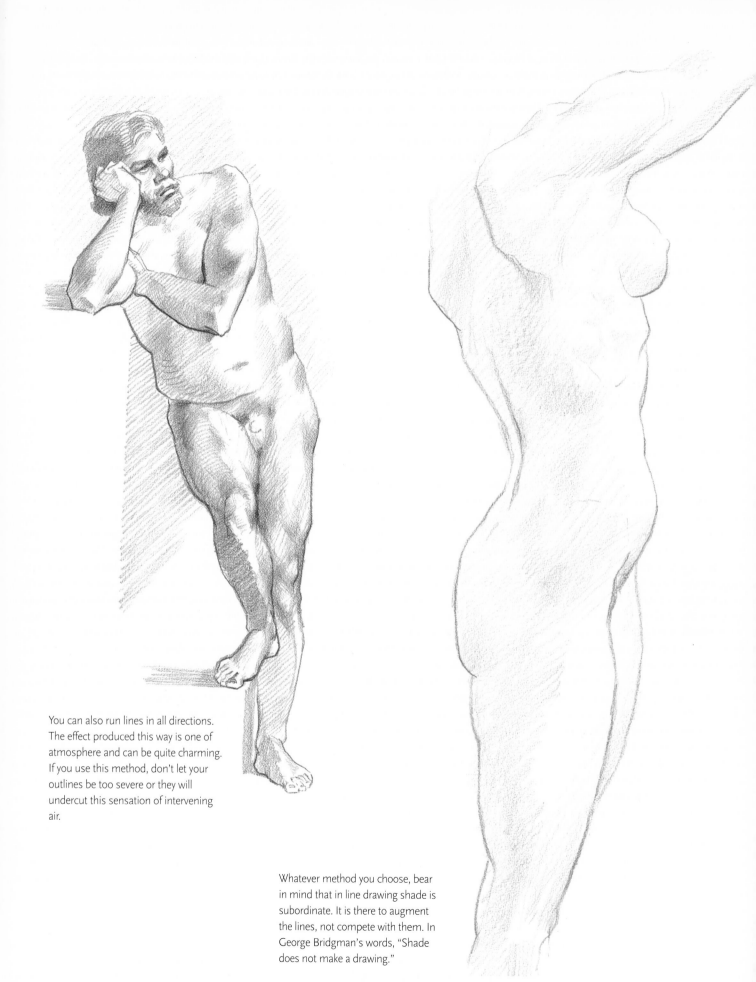

You can also run lines in all directions. The effect produced this way is one of atmosphere and can be quite charming. If you use this method, don't let your outlines be too severe or they will undercut this sensation of intervening air.

Whatever method you choose, bear in mind that in line drawing shade is subordinate. It is there to augment the lines, not compete with them. In George Bridgman's words, "Shade does not make a drawing."

Line Calligraphy

You've observed that lines don't really exist in nature but are an invention of artists to suggest what they see and touch. It is by definition impossible then to "copy" lines you see on the model: There are no lines to copy. Their sole purpose is to send the appropriate cues to the viewer, but there is still a lot of leeway in exactly how you draw lines. And since lines are something you invent, it stands to reason that you are in control of them. You can, and should, try to make them beautiful in and of themselves.

Calligraphy is defined as "the art of beautiful writing," and I believe that lines and strokes should be calligraphic in nature—unself-conscious, vested with a sense of playfulness and made to be attractive on their own terms. Drawing, on a good day anyway, is a joyous act. Line calligraphy can express that joy.

This model struck a simple pose, that showcased both her intelligence and her girlishness. It was a lot of fun to draw, and I believe the scribbled shade lines reflect this. (At the same time, it's worth noting the outline seen at the terminator along her back and the absence of an outline where planes break in the mass of her hair; even in the simplest of sketches, hard- and single-curved masses make their identities plain.)

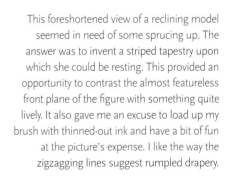

This foreshortened view of a reclining model seemed in need of some sprucing up. The answer was to invent a striped tapestry upon which she could be resting. This provided an opportunity to contrast the almost featureless front plane of the figure with something quite lively. It also gave me an excuse to load up my brush with thinned-out ink and have a bit of fun at the picture's expense. I like the way the zigzagging lines suggest rumpled drapery.

Line calligraphy is at its liveliest when you draw spontaneously. This often happens early in a session, during the shorter poses. You can suggest masses and contours with just a few lines thrown down casually and confidently. You can be more freewheeling still on backgrounds. Who really cares about the shapes of blocks and model stands? Sumi ink, a material designed for brush calligraphy in the first place, is great for that sort of thing. But freely scribbled backgrounds are not limited to quick studies; they have been used in some of the most finished drawings ever made. Pierre-Paul Prud'hon, whose figure studies took him dozens of hours and are far more interesting than his oil paintings, came up with some of the most crazy, abstract backgrounds in the history of drawing. Aside from leading the eye exactly where the master intended, they are a lot of fun to look at, as should be everything in a good picture.

Lines of different sorts, well placed with respect to each other, produce a sense of music in a drawing. Make a line thick or thin, or move from thin to thick in midstroke. Use lines to scribble shade by running them in a sine curve, placing them at right angles to each other or scribbling them every which way.

Settle on drawing tools that allow you to work freely. Producing the effect you want should be both easy and pleasant. If the materials you use don't respond to your touch, you may want to explore other tools. You'll find various mediums described and demonstrated in part two of this book.

A simple way to explain what the model's foot was doing two feet in the air, without pedantically drawing a block of wood, was to scribble in the block's side plane.

It is often helpful to darken the background of a picture. To an artist such darkening is never a mechanical act but an opportunity to play with the effects of different sorts of lines.

Perspective and Other Drawing Systems

When you draw, you are trying to record the three-dimensional world on a flat surface. You can be fairly truthful about lengths and widths; even if on your picture one inch (3cm) corresponds to one foot (30cm), at least you are consistent. But when it comes to depth, you can be neither truthful nor entirely consistent. The paper is flat; anything purporting to suggest depth is the result of some kind of chicanery on the artist's part.

The various methods by which artists try to communicate depth are referred to under the umbrella term DRAWING SYSTEMS.

There are a number of drawing systems to choose from or you can invent your own. In one system, called PARALLEL PROJECTION, you ignore the convergence of parallel lines as they recede into depth. Were you to draw a three-quarter view of a box using this method, its receding borders would remain parallel to each other.

There are quite a few varieties of parallel projection, but in every system, objects retain their true proportional sizes. You can best see this if you COMPARE THE SIZE OF THE MODEL'S FEET TO THAT OF HIS HEAD IN THE ART AT THE RIGHT. ▶

In real life, the closer you are to something, the sharper the size difference between the front and rear of the object. The farther back you stand, the closer in size the objects appear. Space is "flattened." If you use a true parallel projection system, your point of view seems to be an infinite distance from the motif. Parallel projection has an innate sense of omniscience. Space becomes infinitely flat.

The system has its benefits. If two receding lines are in fact parallel in real life, why not let them stay that way in your drawing?

And the system is so obviously different from what you see in real life, it calls attention to the fact that you are changing things in your drawing to suit your preference. Perhaps this is the system's undoing, as well; manipulations of reality may hold more charm if they're more discreet. Parallel projection, on the whole, is an eccentric solution to problems that can be solved with more subtlety.

If you allow receding lines to converge in the distance, you are using the drawing system known as LINEAR PERSPECTIVE. Lines

In this drawing the spectator is asked to pretend that things do not appear smaller as they recede into the distance. This drawing system, used extensively in Roman, Chinese, Japanese and Persian art, is referred to as parallel projection.

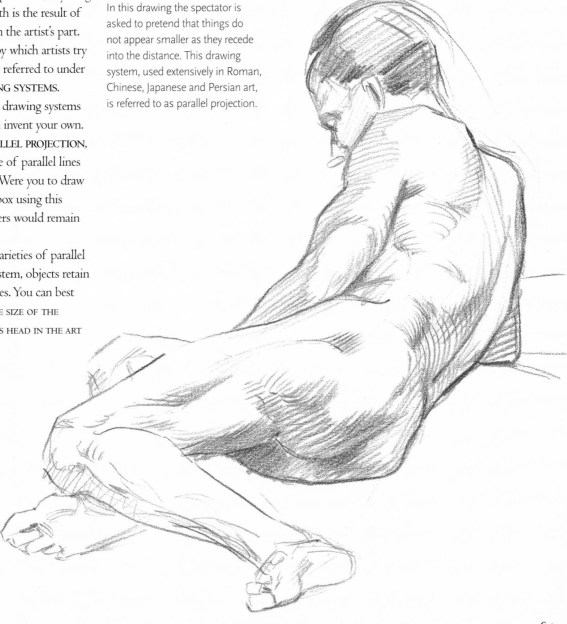

appear to converge as they move away from the viewer, farther into the background. The rules of linear perspective were figured out centuries ago and are easy enough to learn. This drawing system's greatest advantage is that it assigns the spectator a specific point of view. Additionally, within its rules, space can be handled with absolute consistency. This is not the place to go into a full explanation of how one-, two- and three-point perspective operates, but it is easily learned from books dedicated to the subject.

Problems come up in perspective when the visual cone is too wide—that is, when the view encompassed in the picture is too broad. It is in such cases that you find the huge feet and tiny heads that are the hallmark of beginning figure artist; the drawing resembles a snapshot taken with a fish-eye lens. Students are frequently crammed into small spaces in life drawing groups, and those closest to the model wind up with the most distorted views. You'd be better advised to stand at least three times as far from the

model as the model's height. This reduces distortion and produces a flatter, more elegant sensation of space.

Reclining poses are best drawn from above and as far back as possible. Students seldom take the trouble to do this. A seated artist right next to a reclining nude is bound to come up with results best left to the imagination, particularly if the model reclines on a model stand. (Model stands were designed

primarily for portrait work so that if the model is seated in a chair and the artist is standing, the two will be more or less on the same level.) If you're drawing a reclining pose, see if you can get the group's monitor to get rid of the model stand and let the model lie on a cushion on the studio floor. Sometimes still more drastic measures are called for in order to get a good view. When necessary, I have stood on stepladders.

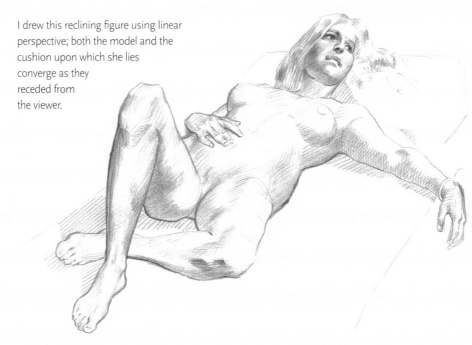

I drew this reclining figure using linear perspective; both the model and the cushion upon which she lies converge as they receded from the viewer.

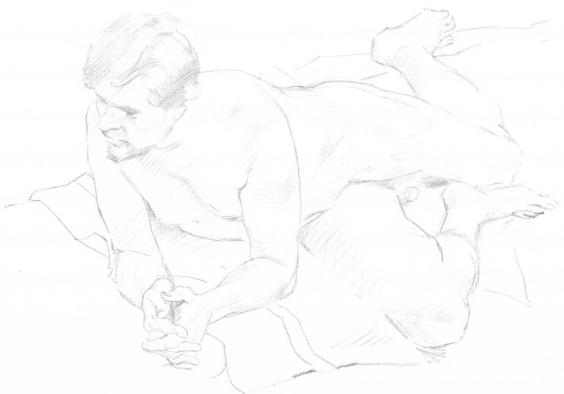

In this drawing, I had the model lie on the studio floor while I stood about sixteen feet (5m) away on the model stand. The view of the model from this point of view was quite good, and the closest parts of him are not grotesquely larger than the most distant parts.

Artistic Anatomy

Art students find the study of human anatomy intimidating until they commit themselves to it. Once they do, they quickly find that it is no big deal. While you can draw the figure without knowing the shapes, proportions and functions of the muscles and bones underneath, you should consider the other side of the story: It's easier if you come to the figure already knowing everything you possibly can. Figure drawing is tough enough under the best of circumstances. You might as well have every possible advantage going for you.

Without question, a knowledge of anatomy loosens you up, allows you to draw many things freely and authoritatively that otherwise would have to be painstakingly copied. It enables you to adjust what you see to better the effect. It heightens your ability to seize on the essentials of the pose.

I will not go into this subject in much detail in this volume, but there are many books you can consult. (You'll find some suggestions on page 69–70.) If there are art schools near you that offer courses in artistic anatomy, consider auditing one; it's much less intimidating to learn it from a teacher than from a book. There is a lot to learn, but it's nothing mysterious or particularly difficult. It is probably about the same challenge as acquiring basic fluency in a foreign language or learning to fix a car. In my classes at the Art Academy of Cincinnati, I cover the essentials of the subject in just fourteen lectures.

There are eleven major muscle groups that can be drawn as a whole, without bothering too much about the individual muscles. There are also a couple of dozen other indi-

vidual muscles you will want to learn. All told there are about thirty muscles or muscle masses to be considered. It's not too bad.

You can take anatomy as far as you care to for the sort of drawing you want to do. I do recommend you learn the names of things, because it will make any investigation you do of anatomy books a lot easier. On the other hand, many of my friends are comic book artists, who use anatomy extensively without knowing the names of the forms they draw. It's up to you.

One reason the subject can be learned so quickly is that artists need to concern themselves only with things that affect surface form. Artists do study the exact shapes of bones where they lie directly under the surface of the skin, but where their forms are hidden, very simple mass conceptions suffice. The rendering of muscles is simple, too. Where two or more muscles share the same basic function, you group them into a single mass, or muscle group. The anatomy books you can buy sometimes do not stress that point enough.

The artist uses anatomy two ways: First for information as to the detailed shapes of things on a figure already constructed; secondly to aid in constructing the figure itself, almost without thinking. Both approaches often come into play in the same drawing.

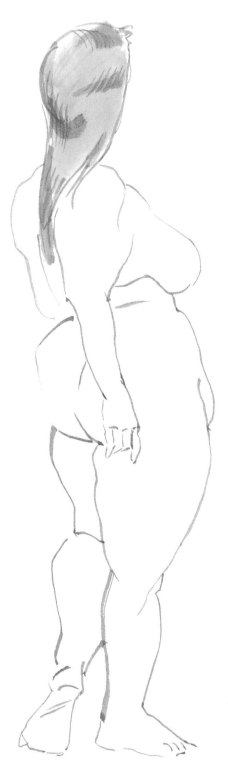

This drawing was made rapidly and quite spontaneously, but every turn of the brush is rooted in anatomical verities which are about the same on all human beings. For example, the Y-lines where the model's forearm overlaps her wrist and where her thigh overlaps her belly are universal in a view like this. Understanding anatomy permits you to respond accurately to what you see, by relating it to things which you have seen and drawn many times before. Incidentally, the model's large figure does not hide the muscular and skeletal forms inside; in fact, it magnifies them.

The contours of this muscular subject are entirely anatomical in origin. The information was pretty much there for me to copy. The understanding of the anatomy enabled me to anticipate the configuration of every line and where each one ought to begin and end. Some forms are essentially bony, such as the model's knees and the top of the hands and feet; others are muscular. Knowing in advance which is which enabled me to describe the bones with lines and tones suggesting hard edges, and to describe muscles with more supple lines.

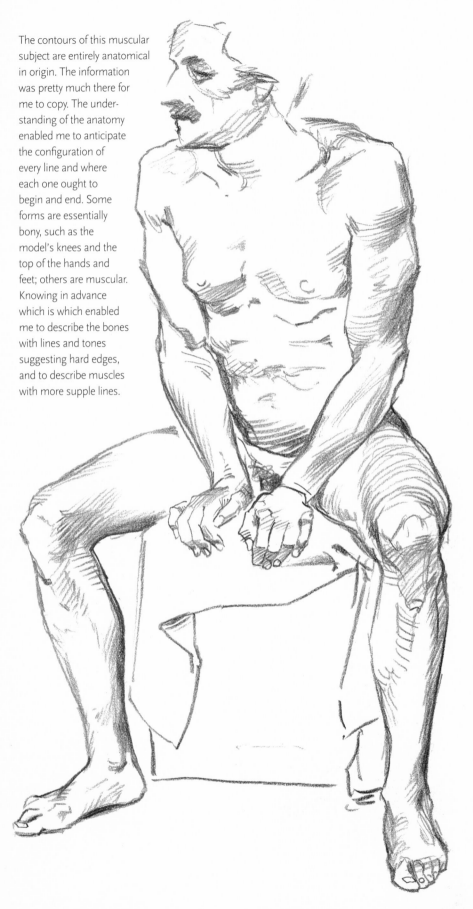

Muscle tissue comes in two basic varieties: CONTRACTILE TISSUE, or as artists sometimes call it, MUSCLE BELLIES and NON CONTRACTILE TISSUE, or more simply, TENDONS. Muscles start and end with tendons, which are fastened to bone or other tissue. The bellies are the part that actually contracts, and swells in the process.

Quite often the actual border of a muscle does not have as much effect on the surface of the body as does the place where muscle bellies turn into tendon. Such a border is referred to as a LINE OF INSERTION OF THE FIBERS. The back, in particular, is marked with swellings and depressions located along these lines.

You'll have to bite the bullet and memorize the origins and insertions of the important muscles and groups. Try to learn these points in as simple a fashion as possible, even if it's not dead-on accurate. For example, in school I learned to divide the humerus bone in half, then divide the top half into quarters. This helps you associate the lines of insertion of the arm muscles with the chest: one-eighth down is the insertion of latissimus dorsi; one-fourth down, the pectoralis major; three-eighths, the teres major; and one-half, the deltoid. With time you may find that some of these insertion points aren't to your liking. They are yours to adjust.

The same holds for human proportions. Everyone eventually settles on a system of one kind or another, and equally good artists throughout history have used wildly different proportional canons. A good deal of the recognized styles of Rubens, Michelangelo, Grosz and Thomas Hart Benton, lies in their choices of proportions. It's all pretty much up to you, although I highly recommend using some system, especially in the beginning. In your proportional scheme lies your idealized human figure, which you will probably vary quite a bit when actually drawing

from the model. Proportions vary not only according to your style but also according to the venue within which your drawing is to be used. For example, fashion artists have a very particular version of human proportions, from which they seldom deviate much. The great heroic styles of painting employed certain proportions, as did genre painting, romantic painting and so on. Comic book artists have their own systems. Normal human proportions would look vapid on a superhero.

I'm a believer in acquiring as many anatomy books as possible. The authors emphasize the things they really understand well and gloss over the things they don't. For example, Paul Richer's *Artistic Anatomy* is probably the best art anatomy book in print,

For what it's worth, the proportions shown in this diagram are what I generally think of as the norm. This system, popularized by Robert Beverly Hale, agrees with the common idea that the body is seven and one-half heads tall, but it uses a different unit of measurement, the height of the sternum bone. It is a good system for learning anatomy because almost all its landmarks are bones.

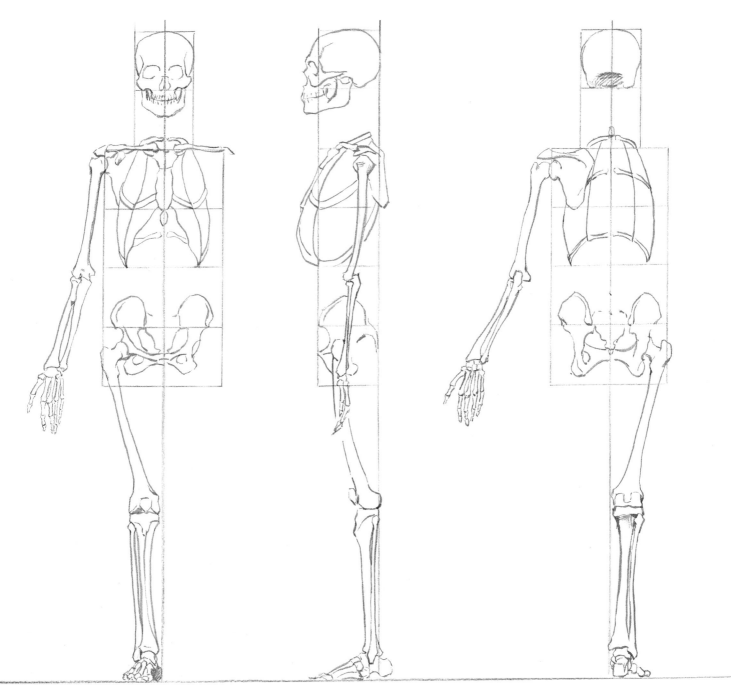

but its treatment of the feet and hands is rather skimpy compared to that of Jeno Barcsay's *Anatomy for the Artist* or George Bridgman's *Bridgman's Complete Guide to Drawing from Life*. The best plates of the neck and throat (to my knowledge) are in Eugene Wolff's *Anatomy for Artists*. Barcsay's book borrows extensively from Richer but also includes a marvelous series of cross-sectional diagrams not found in any other book.

Unless your model is a serious body-builder, anatomical lines on the figure will be quite subtle. Knowing what's what gives you the option of strengthening such lines, if that is what you want to do.

The lower outline of this model's left arm is her triceps muscle; the top outlines are produced by her biceps and deltoid. The front outlines of both her thighs are the quadriceps group; the back outlines, her hamstrings. Knowing the general shapes of these forms in advance enables you to respond freely to the individual shapes encountered on a particular model.

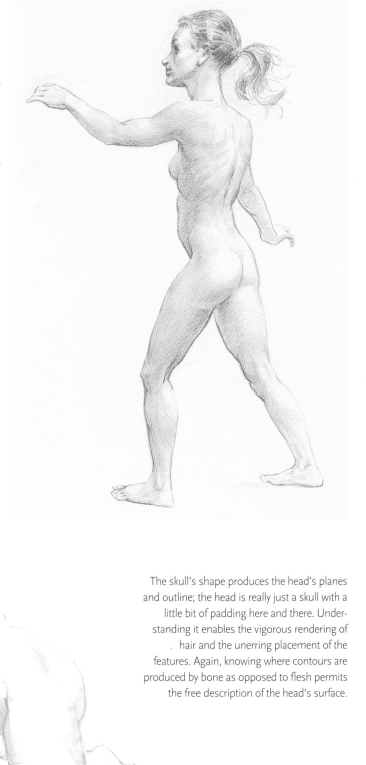

The skull's shape produces the head's planes and outline; the head is really just a skull with a little bit of padding here and there. Understanding it enables the vigorous rendering of hair and the unerring placement of the features. Again, knowing where contours are produced by bone as opposed to flesh permits the free description of the head's surface.

This image is little more than an outline clarified with a handful of interior lines, but each one of these lines is the result of anatomy.

A The two bumps on the model's right shoulder are the distal end of the clavicle and the acromion process of the scapula. The names may be unfamiliar to you, but the skeletal forms themselves are simple enough to learn. Once learned, they become old friends to you, appearing on the surface of every shoulder you will ever encounter.

B If you study the head of the femur bone from different angles, the shape of this knee will hold no mysteries for you. The two hard forms on either side of the knee are the condyles of the femur; the line between the two is the patella with a hint of the tendons that connect it to the quadriceps. The large bump on the outside of the knee is the head of the fibula. The interior line aiming for it describes the tendon of the biceps femoris muscle. This

terminology may be arcane, but its application is straightforward. The model's knee closely matched what I already knew about all knees, and this knowledge informed my description of this form.

C Feet are maddening to draw until you understand their anatomy. The top outline of the right foot is simply the metatarsal of the second toe; that of the left is the tendon of tibialis anticus, the muscle belly of the short extensor of the toes, and the tendon of the special extensor of the great toe. The nose-shaped form where the right foot joins the ankle is the distal end of the fibula and a hint of the distal end of the tibia. These bony forms are not difficult to learn, and they look about the same on every human being. Since you're going to draw the ankle anyway, why not come to it knowing why it looks as it does?

The back is the happy hunting ground of anatomy students. It doesn't much resemble the plates one sees in the books, unfortunately. Its muscles make their presence known on the surface of the body only when they contract. When they relax, they are quite thin. What you end up with is parts of some muscles becoming visible and other parts disappearing. All of this sounds more complicated than it really is.

Bones are more important to understand than muscles, particularly where they lie underneath the surface. Their shapes appear all over the body. They are not difficult to learn. Studying a human skeleton can help you learn the important bones in short order. Some art classes may have skeletal reproductions available for you to study; you can also purchase reproductions from some art supply stores or catalogs.

Drawing would be easier if muscles and bones were all there is to understand about anatomy, but the figure is not quite that simple. Fat deposits lie on top of muscle, and in certain places these are formidable enough to entirely change the shape of what lies underneath. The buttocks are a good example; these do not resemble the gluteus maximus muscle underneath. Some anatomy books discuss the location of the important fat deposits. (Wolff's book has the clearest plates of such deposits I know of.) Among other things, fat deposits are responsible for much of the difference between the body of a man and that of a woman.

As you learn the bones, muscles and fat deposits of some part of the body, try constructing figures out of your imagination, using anatomy as your guide. If you sketch the bones lightly, you can run your pencil from a muscle's origin to its insertion and come up with something that resembles the real human body. Then ask yourself how your picture is different from the real thing. Find out, and refine your conceptions. All the while, you should be drawing from life as much as possible,

observing and recording what you see as accurately as you can.

With time, the two approaches—drawing what you see and drawing what you know—will meet each other halfway. And time is the operative word here; it's going to take a while for you to learn the clinical facts of artistic anatomy, and a lot more time for this information to become so deeply ingrained in your hand that you require little thought to utilize it.

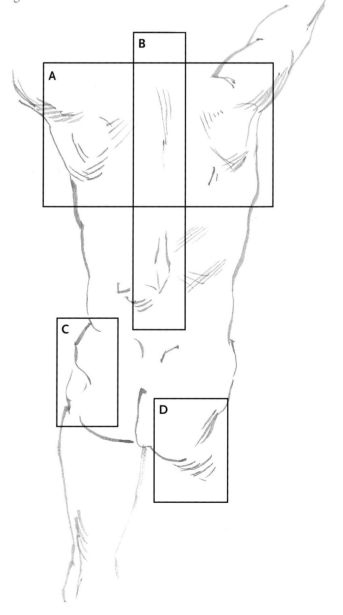

A When you draw the back, try to locate the shoulder blades. They slide freely over the rear surface of the rib cage, so their location is quite subject to change—particularly subject to whatever the arms happen to be doing. The model here has raised his arms. Whenever the arms are raised, so they are parallel to the ground or higher, the shoulder blades rotate. The two little lines just below the right shoulder blade are all you see of the trapezius muscle on this area of the back. That is interesting, since the trapezius covers almost half of the back. But you must remember that the muscles of the back signal their presence only where they contract, and this is about the only place on this view where the trapezius calls attention to itself.

B The muscle group called the erectors of the spine produces the furrow in the center of the back by bunching up on both sides of the dorsal spines of the vertebrae.

C Understanding anatomy is the key to getting Y-lines right. Here the overlapping mass is the external oblique muscle slopping over the pelvic crest. The mass it overlaps is the gluteus medius muscle, which in turn overlaps the tensor of the fascia lata muscle, which in turn overlaps the quadriceps group.

D To the doctor, the gluteus maximus muscle's insertion is rather complicated. To the artist, it is not. Treat it as a mass that plunges into the femur in between the quadriceps and the hamstrings, as illustrated here.

Composition

The language of image making is learned almost accidentally; you try your best on each picture and occasionally come up with ways of rendering that, looking back, seem to work well. A sense of composition is acquired in much the same way. Reviewing stacks of your pictures, you see that some seem to work better than others. I don't believe you can think much about composing under the severe time restraints of most figure drawing situations (although quite a few good artists would argue with that statement). You do the best you can and sort it out afterward. In this manner, you stumble on good ideas, and with time these become part of your way of approaching the nude. In a very real sense, the teacher from whom all artists learn composition is the model.

That said, there are a few things that can be said about composing a satisfying figure drawing.

We all begin with a blank piece of paper bound by four right angles. The right angle is about the most severe and unappealing form to be found, in pictures or in the three-dimensional world. Right angles hardly exist in nature. Most people when setting out furnishings in a room place chairs, plants or other things in the corners, instinctively seeking to relieve the monotony of the right angle. So it is with the composition of a picture: The figure you draw must compete successfully for attention against the powerful, ugly four corners of the page.

If you can draw well, you have an advantage in this contest. The viewer finds a well-drawn image more worthy of attention than the corners of a page, and will gravitate toward it. Study the following examples for devices that will serve you well.

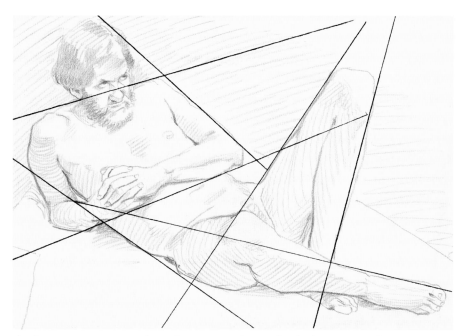

The four corners are countered, or at least sweetened somewhat, by the multitude of diagonal lines that bind the figure. Such lines are not deliberately contrived but seem to occur as I work. Single lines seldom cross the entire picture surface, as the diagram would seem to suggest, but pieces of separate picture elements—if connected as I have done—form large, sweeping lines. With time, you'll learn to strengthen lines that reinforce such movements and underplay those lines that do not.

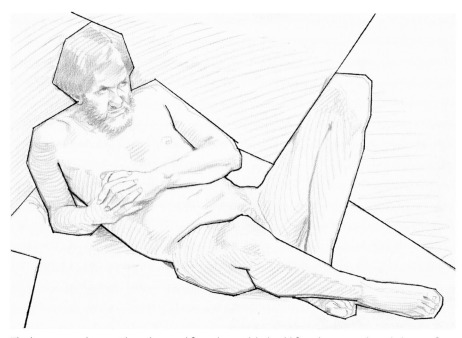

The lines, even when assiduously copied from the model, should form large, simple and pleasing flat shapes on the page, as suggested here. It may appear contradictory to demand that you strive for a satisfying design while at the same time learning to observe and map out the model before you, and yet this can and should be done. Such concerns for simple shapes are actually addressed when you pose the model and select a position from which to draw. Some poses and some points of view feel right; others do not. Such choices are compositional in nature.

You can think of your picture plane as a wall, but you can also treat it as a window. Composition is not solely a matter of the literal flat areas of your literally flat piece of paper; when you draw, you contrive an illusion of three-dimensional space, and you must deal with the aesthetics of the space you have hollowed out. In other words, within the context of your imaginary space, you should arrange your masses in a way that pleases the viewer. Again, you could liken it to setting up furnishings in a room.

Images must appear realistic. If your model is seated, provide some indication of the chair or block or the person will appear to be defying gravity. You don't need much; a few scribbled lines or a very descriptive cast shadow does the trick without distracting the viewer too much from your figure.

You must work awfully hard to get any image at all, but this dare not dull your

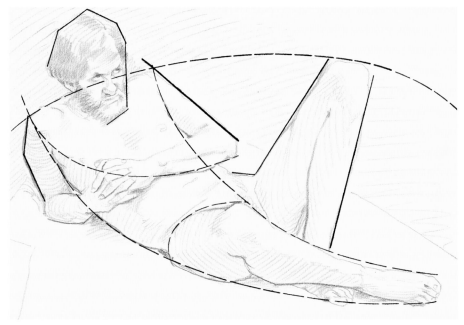

Another concern is a nice mixture of straight and curving lines. Again, such lines are not so much the actual lines you draw but implied lines that connect the various elements of your picture. Such sweeping lines can be curving or straight. I've drawn a few such lines here, using dotted lines for curving passages. In this respect, the picture is kind of weak; the broadly sweeping curves cry out to be relieved by more straight passages, of which there are too few.

One of the most helpful things to bear in mind is the presence of an implied vertical and horizontal grids within a well-designed picture. Various lines should align along the longitude and latitude of a drawing. You can see such fragmentary lines here. This grids of right-angled lines helps to stabilize the drawing. If your modeling is such that the sense of volume is too extreme, the presence of a grids cools down the effect a bit, paying homage to the literal flatness of the picture. As you proceed from a rough drawing to a finished one, you will find yourself emphasizing such lines. One way to train yourself in this regard is to occasionally do your figure drawings on graph paper.

If you use shading, look for broad, sweeping movements of tone that encompass the whole length of the figure, rather than choppy, little spots of gray scattered here and there. The shading treatment in this picture is quite restrained, but I have emphasized it to show that it is actually a simple set of broadly conceived shapes. It is this sort of broad treatment of shade, the picture's *shadow pattern*, that enables the viewer to clearly read the picture at a glance. If you use a medium more reliant on tone, such as black and white crayons on gray paper or red Conté crayon, this element of composition will take on an even greater importance. Let your viewer's eyes take a ride on the simple tone patterns you build. The eyes will go where you lead them.

When the model is being directed, it is common for the group's monitor to suggest "a little more twist." If the head is facing down and to the right, can the torso thrust up and to the left? Can the abdomen take a different thrust? Such concerns no doubt bring to mind the earlier discussions of action and equilibrium, but as much as they concern image making, action and equilibrium are also compositional in nature.

The thrusts of the model's abdomen, torso and head illustrated here tilt ever more toward the viewer. The forward thrust of the head in effect stops the eye. The whole effect could be likened to the letter **J** laid on its side and pointed to the right.

perception of what will make for a satisfying composition. Think of a drawing as a kind of simple melody.

A picture may be poorly drawn but compositionally interesting (REFER TO THE FIGURE BELOW ◄). This leads to the question: How much of composition is the artist's contribution? Some models seem nearly impossible to draw. Others somehow just lend themselves to beautiful drawings; their poses have a kind of inevitability. Composition, it may be said, lies in an effective partnership between artist and model.

When you find yourself having to choose between out-and-out fidelity to what you see and manipulating it to get a satisfying composition, the answer is clear. Your first loyalty as an artist is not to the model, but to the person who will view your drawing.

Of course, all of this presupposes your ability to control the image you are making. I strongly advise you to not place your model in the center of your paper—but to the right or the left. Yet, if you chronically cut off the model's extremities because you aren't able to accurately place the figure, this advice doesn't help much. You can't build a satisfactory shadow pattern if you have not learned to draw in two planes. The action formed by your model's great masses could be as stately as that of Daniel Chester French's statue of Lincoln, but this is of little use to you if you cannot credibly foreshorten each of these masses. And if your handling of equilibrium is not convincing, your viewer will be too distracted to enjoy the symphony of thrusts you have composed. Acquiring this degree of control over the figure takes some time and cannot be compromised. The best advice on composition for the figure artist is to train hard at the rudiments of illusory drawing. With the aid of a good model, composition will sneak in the back door as you are ready for it.

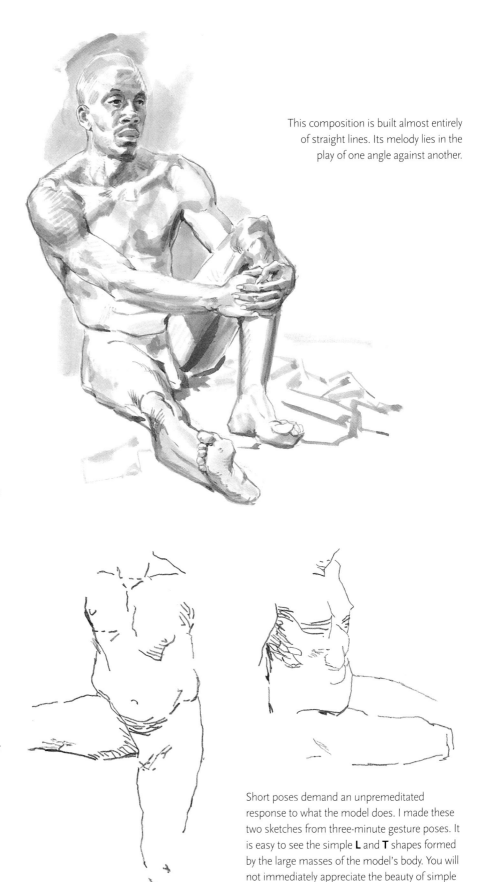

This composition is built almost entirely of straight lines. Its melody lies in the play of one angle against another.

Short poses demand an unpremeditated response to what the model does. I made these two sketches from three-minute gesture poses. It is easy to see the simple **L** and **T** shapes formed by the large masses of the model's body. You will not immediately appreciate the beauty of simple configurations like this, or of the drawings you record them with, but with time such simple ideas of composition will find their way into your repertoire.

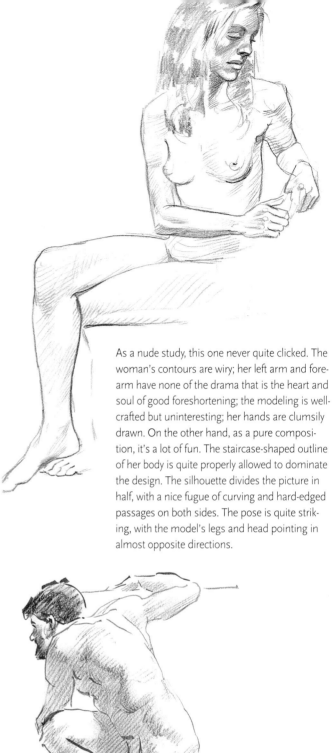

As a nude study, this one never quite clicked. The woman's contours are wiry; her left arm and forearm have none of the drama that is the heart and soul of good foreshortening; the modeling is well-crafted but uninteresting; her hands are clumsily drawn. On the other hand, as a pure composition, it's a lot of fun. The staircase-shaped outline of her body is quite properly allowed to dominate the design. The silhouette divides the picture in half, with a nice fugue of curving and hard-edged passages on both sides. The pose is quite striking, with the model's legs and head pointing in almost opposite directions.

The model handed me this simple backward **L** shape, which I then permitted to dominate the whole page. Her silhouette is characterized by a wonderful leapfrogging left to right of action and inaction sides. When the model offers you something like this, don't look a gift horse in the mouth.

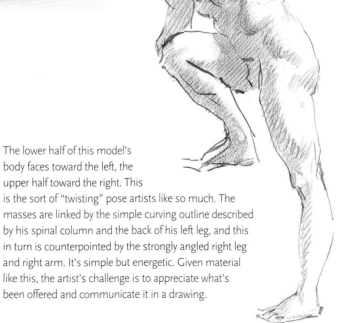

The lower half of this model's body faces toward the left, the upper half toward the right. This is the sort of "twisting" pose artists like so much. The masses are linked by the simple curving outline described by his spinal column and the back of his left leg, and this in turn is counterpointed by the strongly angled right leg and right arm. It's simple but energetic. Given material like this, the artist's challenge is to appreciate what's been offered and communicate it in a drawing.

The Technique of Figure Drawing

UP TO NOW YOU HAVE STUDIED ONLY COMPLETED DRAWINGS, WITHOUT GOING INTO THE PROCESS OF EXACTLY HOW THESE PICTURES WERE MADE. IN THIS SECTION WE WILL EXAMINE THAT PROCEDURE IN A DETAILED STEP-BY-STEP FASHION.

Everyone develops a personalized method, but there are some fairly common practices. First, GESTURE in the figure, that is, summarize it in a few quick lines. Then tighten the gesture into a ROUGH, in which the size, position and shape of each mass is sought. Loosely finalize the ideas with a MAP-IN, essentially the model's silhouette drawn quite carefully, but with a line so pale that it will be all but lost once further work is done. The map-in provides a kind of blueprint for the final drawing. Onto it you must RENDER, which is to apply just enough tone to make clear the masses you want to suggest. Finally, CONTOUR the rendering by assigning outlines of various weights.

There can be quite a bit of variation. Not all figure artists complete each of these steps. It depends on the person and, to a large extent, the medium selected. I will address some of these variations when I discuss the histories of several drawings.

The crucial thing to learn is how to translate the model's three-dimensional masses into a series of flat shapes on your paper, of the right size and shape. This demands accurate measuring and a willingness to look for and correct errors before moving on. In artistic drawing, you manipulate the information you see quite a bit, but before you can achieve such manipulations credibly, you must be fully capable of recording exactly the shapes of what you see.

You will study all of these things in this section, but first it would be helpful to go into some basic information and complete some exercises that will help you as you draw from life.

Handling Your Tools

There are many different marks you must make to get the illusion you seek—a flat, featureless gray tone or gradated one; crisp lines or an indistinct series of hatches; hard, soft or diffused edges or a combination thereof. To produce different effects, you must learn how best to use your tools and then consciously apply these methods as you draw. Consider the following: A pencil behaves differently if it has a pointed tip (from a rotary sharpener) versus a chisel-shaped point (from a razor blade). It behaves differently if it is eight-inches (20cm) long or three-inches (8cm) long. It certainly behaves differently depending on how it is held in the hand. I have illustrated two common grips right.

Later in the step-by-step demonstrations of this section, I will teach you additional specialized grips (pages 93-117).

Before drawing, you must choose a paper. Smooth or rough? White or tinted? Most commercially produced charcoal papers have a mechanical pattern to their fibers which is quite ugly. Find a paper that suits you. It is as personal as your choice of a mate, and the ramifications are as long-lasting. Don't be afraid to ask someone for help.

Having settled on a paper, consider how to cushion your drawing. Clipping or tapping a single sheet onto a Masonite board guarantees an unyielding surface for your pencil regardless of your paper type. Place a half-dozen sheets of paper under the top sheet to cushion the paper and enable a velvety touch. If you draw on bound pads or sketchbooks, the sheets underneath provide a similar cushion, but if you bear down hard when you draw, you'll emboss the sheets underneath, making them unusable. Prevent this by slipping a half-dozen sheets of paper underneath the one you are using.

A short, stubby pencil gripped in this fashion offers some degree of precision but favors a more sweeping line. This grip is useful for almost any figure-drawing task. Move the pencil using the thumb and forefinger or by flexing the wrist, elbow or the shoulder. The farther away from the point such articulations occur, the more graceful the line will be.This grip is particularly good for modeling with a Prismacolor pencil and for adjusting line weight with a lead pencil sharpened to a chisel-shape. With a Conté crayon, this grip is instinctive.

A new pencil is far too long to use with a grip like this, but if you break it in half and sharpen the two broken ends, you'll have a pair of very serviceable drawing tools.

To grip a long pencil far back from its point, hold the pencil between your thumb and forefinger and brace the pencil underneath with the middle and ring fingers. The little finger lightly touches the paper surface, helping to suspend your hand at a uniform height.

Exercises

The best practice for drawing is drawing, and you should do a lot of it. As often as you can and as well as you can. Slipshod work in a sketchbook teaches you very little. When you draw, even if it's just stealing an image of a fellow subway passenger, the act should muster every bit of your concentration. Hardbound sketchbooks are sturdy enough for you to carry constantly. I go through a dozen of them every year. Sketchbooks will change forever your attitude toward long airport layovers.

Settle on a tool that will work for quick sketching. I PREFER A BROAD-POINTED FOUNTAIN PEN. ▼ If you can find one with a nib flexible enough to give you a good range of line weight, you'll be able to sketch very rapidly. If you prefer sketching with a pencil, avoid mechanical pencils, especially the ones with very skinny leads. They will teach you very little about lines.

Less convenient but far more versatile is brush and ink. THE SUMI INK USED FOR JAPANESE CALLIGRAPHY ▼ is an excellent material, easy to control and capable of very descriptive drawing. You'll need a small jar of water, a small ink grinding stone and a stick of sumi

ink. Escoda manufactures a so-called traveling brush, a Kolinsky sable a bit smaller than the standard no. 3, whose handle also functions as a protective cap, somewhat like on an eye- or lip-liner pencil. You can carry the whole setup in a jacket pocket. Its ungainliness, as compared to a pen or pencil, is more than compensated for by the extreme rapidity with which you can draw.

All of us find ourselves with dead time—waiting for a bus, simmering a pot of stew or watching over a sleeping child. Why not spend some of your found moments drawing figures out of your imagination? Good drawing is a coalescence of what you see and

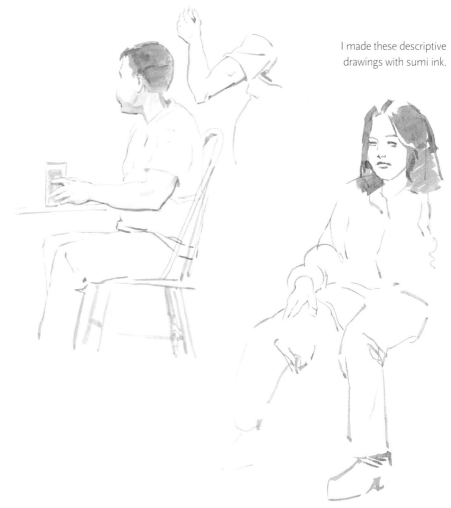

I made these descriptive drawings with sumi ink.

I was able to complete a fast sketch at a meeting using a simple fountain pen.

what you know. When you have time before a model, you develop the ability to observe and describe what you see. When you don't, you can take inventory of how well you've absorbed the information handed to you by all the models you have drawn. If the foot, neck or face intrigued you last time you drew a model, try drawing that body part again. You will find yourself learning that much more about what you want to draw and about the best way to draw it.

You should also become aware of what sort of lines and tones suggest certain effects of light. An extremely hard edge on the terminator is characteristic not only of hard-edged masses but also of intense direct light. A fuzzy outline on the near edge of a mass is also characteristic of intense direct light. Such ideas fall within the language of drawing, and they can be played with as well in the absence of a model as they can during a figure session. There are a lot of such effects with which you will want to acquaint yourself.

Beyond that, there are a number of exercises you ought to do to develop yourself as a figure artist. All of them pinpoint certain mechanical skills that are called upon practically every time you draw. Don't let these exercises intimidate you. If you keep a scratch pad handy, you can do any of them while talking on the phone. Don't limit yourself to these exercises. When you notice chronic problems in some area of your drawing, isolate where it is you're having trouble. Whatever skill it is you lack, devise an exercise that will enable you to develop it, then practice with it until it becomes second nature to you.

Very Pale Lines

Students tend to be heavy-handed with their pencil at first, but a great deal of illusory drawing requires drawing lines so pale that they are just barely visible. (Map-in lines are one example.) Practice just barely exerting pressure on your point. This will be most helpful when you must run shade on a front plane, where the slightest change in value signals a huge change in form.

One of the best ways to draw lightly is to hold your pencil loosely, gripping it far back from the point. It is surprising how much control you have when you draw this way.

Intervals

Practice dividing a line into exact intervals. Draw a line, and then divide it in half, in thirds, in sevenths, in fifteenths. Trained artists can do this in their sleep. It is an enormously practical skill to pick up, because so much of drawing the figure has to do with proportions. For example, a standing adult's height is seven and one-half times the height of the head. If it is second nature to you to place your point exactly one-seventh to one-half from the top of a vertical line, you'll never run out of paper when it comes time to draw the feet. (If fractional intervals are difficult for you to picture, as they are for me, then divide your line into fifteenths. Two-fifteenths equals one-seventh.)

Circles

Artists rarely draw circles; their perfectly symmetrical form is compositionally rather

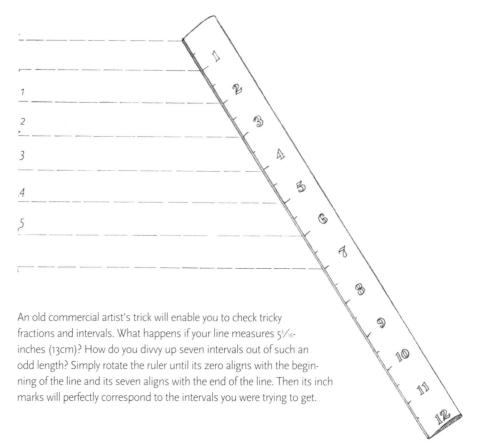

An old commercial artist's trick will enable you to check tricky fractions and intervals. What happens if your line measures 5³/₁₆-inches (13cm)? How do you divvy up seven intervals out of such an odd length? Simply rotate the ruler until its zero aligns with the beginning of the line and its seven aligns with the end of the line. Then its inch marks will perfectly correspond to the intervals you were trying to get.

dull. Still, they are used all the time in construction. Later, when I show you how to use The Rule of Tipped Cylinders to figure out shading problems, you'll need to draw a pretty good circle. I have no tips for you here, except the more the merrier.

RUNNING A CLEAN TONE

It is essential that the figure artist be capable of producing areas of shade of a single value. Such even gray tones are used to describe the entire side plane of a figure, then may be modified by darkening the edges at the terminator.

Practice running parallel lines, all equidistant, that the eye will fuse into a single gray tone. You won't get this uniform value by running your pencil back and forth; you need to pick it up at the end of every stroke. If you've done this well, there will be no patches of dark or light within the area

shaded—the shade is "clean." This needs to become a routine procedure for you, but it will take a little time and practice.

You should master this ability with whatever tool you use for line drawing—a pencil, pen, Prismacolor pencil, or whatever. (Mass-drawing tools—charcoal or soft Conté—give you a break here, because the tones they produce can be easily made uniform by rubbing them with a tissue.)

Once you're reasonably consistent at running a clean tone with straight parallel lines, try doing the same trick with curving lines.

RUNNING A GRADATED TONE

▼ HAVING MASTERED PRODUCING A FEATURELESS AREA OF GRAY, now try gradating that area. It can start out dark and grow lighter or vice versa. The value spread on these areas should be quite subtle, since side planes don't carry a whole lot of different tones. You'll

know you're getting a grip on this skill when the gradated area, at a distance, resembles a gently curving cylindrical surface.

Gradated tones are used extensively in figure drawing, with breathtaking variety. A tone may start dark, grow lighter and end up dark again. Or it may go from light to dark to light. Try varying the line weight in the course of each stroke. Another way to do this is to run a series of parallel lines, each one a bit lighter or darker than its neighbor. The transition from dark to light may be abrupt or almost imperceptible. Whatever the configuration, it must be utterly at your command.

If you can make a clean, featureless gray tone, there are shortcuts to producing a gradated tone. Lay down a patch of gray, and then gently darken it where you wish, laying a second set of parallel lines on top of the first. On this overlaid series of lines, each stroke of your pencil will have to start very light, grow darker and then lighten up again, in order to add gradation to a clean tone. Think of such a stroke like an airplane coming in for a landing, and then aborting the landing a second or two after touching onto the runway. Your pencil should move in an arc, gently touching the paper, moving across it a bit and then gently lifting back off into space.

My parallel lines run diagonally, upward from left to right, but you can choose whatever direction is most comfortable for you. Your lines should be very pale and thin.

Gradate your tone by varying your line weight.

Use curved lines to shade the side planes on a foreshortened mass, such as a leg pointing toward the viewer. You can use sectional contour lines to simultaneously indicate side planes and to reinforce the illusion of foreshortening.

Transition your parallel lines from light to dark to gradate your tone.

A third way to gradate your tone is to overlay parallel lines.

Diffused Edges

Hard edges come naturally; you learn to make them when you learn the alphabet. A diffused edge requires more thought and more practice, but it's worth the effort; very few tricks in your arsenal will go farther in helping you to craft a readable image. Diffused edges are the rule rather than the exception in good drawing, even on areas that you'll probably like to keep in sharp focus, such as the face. Default to fuzzy edges as you render, then sharpen them where you feel it would improve the effect. It is easy to sharpen a diffused edge but very difficult to diffuse a hard edge. For ink washes, pen and ink or Prismacolor pencil, it is impossible to diffuse a hard edge. If you're drawing in charcoal or soft Conté, you can diffuse edges by lightly rubbing them with a tissue. In a linear medium, the trick is more subtle.

It is difficult to overstate the importance of edge control. In realistic drawing, the artist selects three or four values: a light, a halftone, a dark and, sometimes, a darker dark. These values are used for the entire figure. The variations, which permit the rendering of small details, are entirely a matter of the edges. Learn to control them and you'll find yourself able to take your picture to any desired degree of finish.

Copy the Masters!

There is a treasure trove of instruction available from the great figure artists of history. If you don't have any of their drawing books, either buy them or borrow them from your local library. Every one of these people squared off against the same problems that face you. The ultimate way to see how they prevailed is to copy their drawings as carefully as you can.

Different artists offer different lessons. If heads are giving you a problem, try making studies from El Greco, perhaps the most facile painter of heads who ever drew a breath. He left us few drawings, but the heads in his paintings are easy to copy in charcoal or Conté. The few really finished studies Michelangelo left us have much to teach about rendering, action and equilibrium. Da Vinci's hands are the most perfectly drawn in all of Western art. Cecilia Beaux is quite possibly the greatest master of rendering that America has ever produced. Boucher's figure studies in white and black

chalk on toned paper epitomize what can be done with a short pose. Ingres practically invented drawing with a lead pencil. And if you plan to work for dozens of hours on your nude studies, Prud'hon's drawings will show you what can be done under such conditions. They have never been equaled.

If you own a computer and a laser printer, you can print a grid on acetate, which can be placed on top of the drawing you wish to copy. Rule a similar grid on your drawing paper, and you can map in your copy by the transfer method. Or you can avoid such things and use the act of copying as an exercise to train your eye.

If the masters' paintings are somewhat inscrutable, their drawings lie naked before us, revealing all their secrets. Even mediocre reproductions reveal clearly how these artists used their tools to get the effects they wanted. Try copying their drawings using the same materials they used, or get as close as you can. The natural chalks they used answer to the modern Conté crayon, more or less.

I go through cycles with copying, not bothering with it for months, then completely immersing myself in it. As in all drawing, it doesn't help you much if you don't pay attention to what you're doing. Find drawings that succeed in specific areas where yours have failed, and learn how your long-dead teachers solved the problems that have stymied you. The great drawings are exceedingly generous with such coaching.

Every figure artist ought to have a copy of *Bridgman's Complete Guide to Drawing from Life*. George Bridgman's sketches speak volumes, which is more than you can say for his text. If you copy them, the sketches will answer many questions for you, some of which you may not have thought of asking.

These fuzzy edges result from parallel strokes that don't start or end exactly in line with their neighbors. They can alternate in length at regular intervals, like spokes on a picket fence. This is a *uniformly diffused edge*.

More useful still is a *raggedly diffused edge*, in which there is no particular pattern to the length of each shade line. If you've gotten handy with clean and gradated tones, diffused edges will be no problem for you.

Gesturing In

The genesis of any well-drawn picture is an idea of what you want to communicate. These ideas are not literary or emotional but visual: "The model's abdomen and rib cage are almost at right angles to each other" or "He looks like he should fall forward, but he's somehow stable" or "Her hair falling over her back explains the shape of the shoulder blades underneath" or the like. Such ideas are quite fragmentary and may not even occur to you consciously. The point is that the pose should interest you, or you will find it difficult to retain the enthusiasm required to complete a drawing. I will be using the same pose throughout the step-by-step process to show you how each step will lead you to the finished drawing.

You've got to start somewhere, so throw down a few lines that establish the action of the whole figure. Don't concern yourself with the separate masses of the pose; capture the entire form in a few brisk lines. This is referred to as gesturing in the pose. Hold your pencil loosely, and use as faint a line as you can. (Some drawing tools are made to produce faint lines only, including 3H and harder lead pencils and hard carbon pencils. These are useful for gesturing in, if you don't press too hard.)

Speed and vigor are more important than accuracy in a gesture. Although the human body contains only three truly concave surfaces (the philtrum of the mouth, the lateral surfaces of the nasal bone and the achilles tendon), concave lines are very useful in the gesture stage of a picture, in which you are trying to describe as many masses as possible in as few strokes as possible.

The gesture establishes the placement of your figure on the paper, so there are considerations of design involved here, too. A gestured pose will take on a simple shape—say, a squiggle or an **L** or **J** shape. This shape will read differently if it is centered on the paper, placed to the left or right, or set above or below center. (If you're a beginner, you probably won't have much of an opinion either way on these things, so just concentrate on not cropping off any of the figure. With time, you'll become very opinionated about composition.)

The order in which you put down your marks should take you from the general to the specific, establishing the action of the pose quickly. The two most important decisions you will make in this regard are the tipping of the abdomen and that of the shoulders. I generally try to get the angle of the abdomen first, for it is the thrust of this mass that determines the characteristics of the whole figure. Be on the lookout for the abdomen tipping one way, the shoulders the other. This doesn't always happen, but when it does you should seize on it.

The gesture is the scaffolding upon which the final drawing will be built. Try to gesture in with a keen eye for the pose's rhythm. If the gesture looks dull, ask yourself why. The problem may lie in the pose itself. If so, try walking around the studio. The pose may be more interesting from another angle. If you think so, start it again.

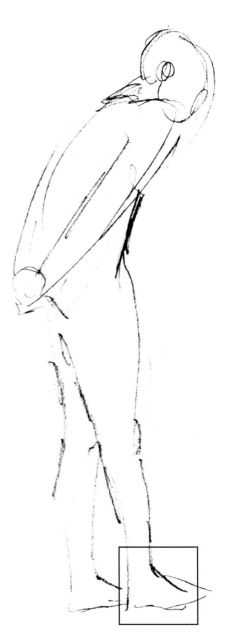

The first step is to quickly establish your figure on the paper. In this gesture, where the front of the model's foot joins his ankle, I drew concave lines. Later when the drawing is refined, I will replace these concaves with a series of smaller convex lines.

Roughing In

It's a challenge to develop a vigorously drawn gesture into a finished picture without losing the excitement of the first attack. In your gesture, one line may encompass several masses. There is a unifying quality when many masses are summarized in this fashion. Now you must examine these masses one by one and determine their sizes, shapes and directions. In so doing, you must work to

preserve that initial unity and build on it. This procedure is called ROUGHING IN.

Replace the sweeping lines of the gesture with smaller, more descriptive lines. On the gesture, the frontward silhouette of the model's right arm and forearm is described with a single line, while its rear silhouette is depicted with two lines. This indicates early on that the rear surface is the arm's action side, the front surface its inaction side. In tightening up the gesture into a rough, you introduce more variation to these surfaces but endeavor to retain the relationships of action and inaction sides.

Seek for Y-lines on the rough, but as much as possible, try not to let them interrupt the larger flow produced by the picture's main lines. Similarly, determine the placement and size of the face's features, the toes and the fingers, but strive to emphasize that these are small details of large masses.

Finally, place the terminator for the whole figure. Since the terminator functions as a kind of second outline placed inside the

silhouette of the figure, you must discover and record how this second outline augments the rhythms you put down in your gesture.

The lines indicating the terminator are the blueprint for how you intend to handle the edge. This terminator line may be lost in some places, and quite distinct in other places. FOR EXAMPLE, THE TERMINATOR LINE ON THE BACK, ▶ just above the model's right elbow, snakes back and forth, suggesting the gradualness of this terminator edge. At other places, such as the area of the left knee, a more sudden break is suggested. Think of such lines as notes made to yourself about where masses turn sharply or turn softly. You will base the shading scheme for the final drawing on these notes.

Your pencil should be held loosely and far back from the point at this stage. If you hold it as one does when writing, you will find yourself gravitating toward details instead of masses, and the time for that has not yet come.

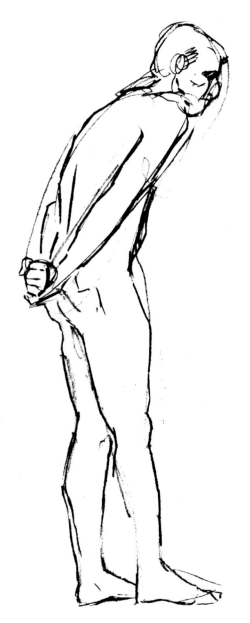

Retain the original rhythm and build on your gesture drawing as you begin to rough in individual forms.

Blocking In

I should stop here between discussions of the various stages and take a closer look at how these initial steps of your work can be done with greater accuracy. Once the picture has been gestured, you can begin taking some measurements to ensure that everything in the final drawing will be the right size, shape and location.

I use a thin 12-inch (30cm) knitting needle for measuring. It has some advantages over other tools students are likely to use, such as a pencil or a ruler, or no tool at all. The thin needle enables precise alignments. Its head makes a convenient starting point for measuring.

The work I am going to describe is very precise and assumes you will not alter the pose. Make certain you like what you see. If the pose looks dull from where you stand, move around the studio until a better view catches your eye.

First, measure the ratio between the model's height and width. These measurements have nothing to do with the actual body proportions, but rather the apparent lengths and widths you see from where you stand. For example, if the model is reclining and the body is aimed toward you, the severe foreshortening that results will alter the proportions radically. Measure height and width exactly. The "width" may be, for example, the horizontal distance from one fingertip to the edge of a foot. The "height" may be the vertical distance from the other foot to the top of the hair.

Hold the knitting needle at arm's length, horizontally or vertically. (Diagonal measurements are not dependable at this point.) Close one eye. Let the head of the needle align with one end of the model, and move your thumb up and down the shaft till it aligns with the other end.

Now divide the smaller measurement into the larger one. For example, a standing figure may be five times as tall as it is wide. Most often, the ratios involve fractions. The figure may be five and two-thirds as tall as it is wide. Ratios like this are difficult to measure and clumsy to handle, but there is no way around them. This ratio, often referred to as the figure's ENVELOPE, is the most important measurement you will perform, and the usefulness of all subsequent measurements hinges on this one's accuracy.

Now divide the figure in half, both vertically and horizontally, and take careful note of where these halfway points lie on the figure. Check this against your gesture. IN THE ILLUSTRATION BELOW, ▼ the vertical midpoint lies almost exactly at the base of his buttocks. The horizontal midpoint hits the man's elbow, pretty much cuts the knee in half and hits the little bump on the side of the ankle. The other dotted lines drawn over the gesture represent various landmarks used for comparison—here, the back of the man's head and the outline of his forearm. You do not need to actually draw such lines on the gesture; the dotted lines simply represent the sort of comparative measurements made by studying the model using your knitting needle as a guide.

Draw an envelope of the same ratio around the gesture drawing. You now have a means to verify or disprove the placement of the major lines.

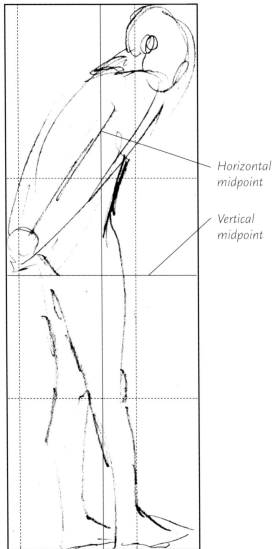

Horizontal midpoint

Vertical midpoint

Gesture checkpoints help you find the vertical and horizontal midpoints and take height measurements.

You can also take head measurements. This particular model's head, strangely enough, from top to chin, is a bit under one-sixth of his height (ILLUSTRATION BELOW ▼). This gives pause at first because we know that the average adult's height is seven and one-half times that of his head, yet I measured it and it was indeed so.

The answer to the anomaly is that the man's back is bent forward and the head is tilted. The bent back subtracts some of his height, while a tipped head is taller than a head viewed straight on.

As you move from gesture to rough, you must continually do this sort of checking and verifying. Don't try to cut corners here. Students often fail to notice the simplest relationships, such as what lies underneath what, and emerge with roughs over which no credible figure can be drawn. The few extra seconds it takes to verify things saves having

to start again from the beginning. Having taken the extra time with your measurements, you can move on with confidence.

In your rough drawing, your lines are more clearly and specifically set down. Here you are offered further checkpoints for accurate blocking in. What lies above what? What aligns horizontally with what? The more developed your image, the more chances you have for spotting errors. Don't skimp on this procedure; at the rough-in stage, it is still relatively easy to correct mistakes.

Perhaps the greatest checkpoint the rough offers is that of negative spaces. These are the areas of the drawing that are not obscured by the figure itself. The shapes of negative spaces are easier to identify than the shapes formed by the masses of the figure, perhaps because you come at them with no preconceived notions about what their

shapes must be. Look at the small flame-shaped negative area bounded by the model's left foot and foreleg. If everything up to now has been recorded accurately, the negative shapes on your drawing should look exactly like those on the model. If they do not, stop and locate where the discrepancy lies. A

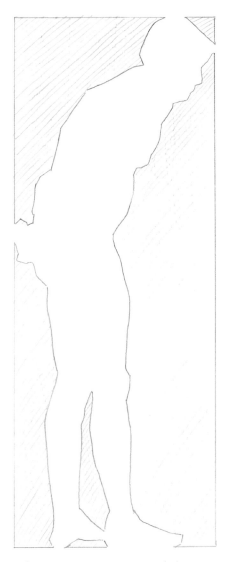

Use the negative spaces in your rough drawing as checkpoints.

Think of a head as a kind of modified box. You can clearly see the difference in height of the two heads. Such an apparent anomaly is best spotted early, at the gesture stage; had there really been a mistake, it would have been easy to correct.

wrong negative space means some body part has been made too large, too small or was drawn in the wrong place. Correct it while your picture is still in a state of flux.

There are larger negative areas in view here too, but they are harder to see because they are not created by lines on the model's body. Rather, they lie where the figure doesn't cover its envelope. You can see them more clearly if you use a framing device. Cut a piece of cardboard in an inverted **U** shape. Use a second piece to close up the open side of the **U**. Hold this at arm's length until the top and sides of the **U** touch the corners of the model's body, then slide the second piece upward until it touches the bottom limit of his body. (You can also use this device to help you arrive at the figure's envelope.) Using the frame as a reference, you can spot the other negative spaces around the model. Check them against what you have drawn.

This is the blocking in procedure. If it is done correctly, it will enable you to accurately draw even the most difficult pose. It requires discipline to do the checking and correcting required, but after a few months of it, you will find yourself making fewer mistakes. The aim is to learn to see these size and position relationships so well that a good rough can be produced in just a few minutes. This is more than a matter of expediency; a model cannot hold a pose for more than a few minutes without a weight shift, a cock of the head or the relaxing a taut muscle. The faster you can block in the pose accurately, the less dependent you will be on the absolute stillness of the model and the more responsive you will become to the subtleties of the pose. And as maddening as the whole procedure sometimes is, doing it properly rewards you tenfold when you move on to the final stages of your drawing.

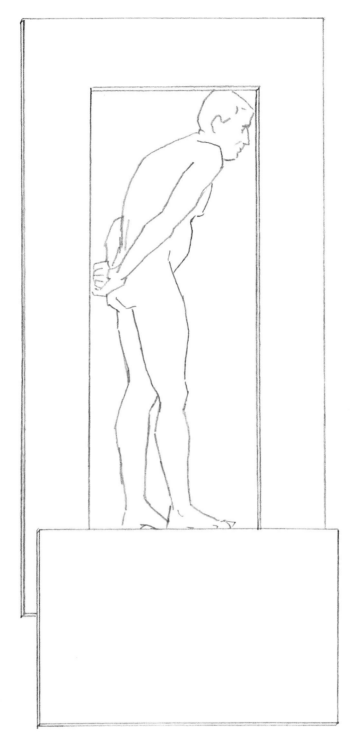

Use a framing device to help you view the negative spaces outside the body.

89

Mapping In

Once you have roughed in the figure to your satisfaction, it is time to commit yourself to its actual silhouette. Draw cleanly and lightly, letting your pencil go completely around the model's outline. At this stage, your view of the model is translated into a flat pattern on your paper, like the outline of an island upon a map. This procedure is referred to, in fact, as the MAP-IN. Your mapping lines should be bland and as faint as you can possibly make them.

You may be wondering at this point how a readable picture could ever be placed on top of this mare's nest of construction lines. There are several ways around this problem. One is to do your gesturing and roughing with a lead pencil and then map in with something that won't erase—a brush and very diluted ink, or a Prismacolor pencil, for example. Once the map-in is completed, you can erase the earlier work. Another approach is to do your final drawing on a fairly thin sheet of paper, just translucent enough so that an ink line underneath will faintly show through. This way, you can gesture and rough in your drawing on a separate sheet, finishing the rough in black ink, and then slip this construction sheet underneath the sheet for your finished drawing. The map-in can be executed directly this way, leaving no construction work in evidence. A third way is to just leave your construction lines there for all to see, trusting that the vigor of your finishing work will completely overpower what lies underneath. This is not an altogether a bad way to go. Page through the drawings of the masters and you'll often see their construction lines in plain sight. Quite often such lines will have their own charm. (They also provide some hints as to how these artists went about the process of drawing.)

However you go about it, when you map in your drawing, take your cues from the model, not from your rough. The rough's only function is to eliminate errors early on and help you put your mapping lines in the right places. Never trace your rough! Study the model, study your rough, study the model again and lay down your mapping lines as definitively as you can.

The mapping lines are not intended to be the final outlines of your figure. In fact, you will need to reserve the option of losing the mapping lines entirely against a toned background. So go very lightly as you map in, and don't worry about varying your line weight. There will be ample opportunity for such considerations later.

Not every kind of drawing demands a map-in. If you're working quickly, the step can be omitted. If you're using a mass-drawing medium, such as vine charcoal or black and white Conté on toned paper, this statement of the figure's contours would be counterproductive, as it finalizes early on something best reserved for the end. But if you're using linear media—a pencil, pen or brush—and particularly if you intend to do a very detailed treatment of tone and edge, the map-in is invaluable. The tentative lines of the rough are finalized, allowing you to complete the drawing with absolute confidence that every blocking decision has been made, and made well.

The map-in serves as a blueprint for your drawing, finalizing your translation of what you see into a flat pattern.

Rendering and Contouring

The final two steps are all that is meant for public consumption. The gesture and rough and map-in are either erased, put down so lightly that the viewer will hardly notice them or executed on a separate sheet. These three steps can be thought of as your rehearsal for the main event, the RENDERING and CONTOURING steps.

I will treat these together, because, at least in my own work, they are done at the same time. If a bit of shade will make a line unnecessary, you can leave out the line. If your lines are descriptive enough to suggest the mass, you needn't bother with shade. The aim is producing an image with the absolute least amount of things spelled out, and to accomplish this, you must hop back and forth between rendering and contouring.

Look again at the model and at your map-in. What is the gap between what you see before you and what you have drawn? Is rendering, that is the application of shade, even necessary? Can the desired effect be pulled off just by the use of variously weighted lines? Or conversely, can shade accomplish the job with very little line work? The answer depends not only upon the motif but on the paper and drawing materials you have chosen. A brush and ink can describe the human body so completely in line that they can be used without shade, if this is what you want. Black and white Conté on an appropriately toned paper require almost no lines to be readable, if you'd rather avoid lines. A terra cotta Prismacolor pencil works well with a smooth cream-colored stock. The paper is hard enough to permit precise line work but also allows many layers of tone to be applied, which leads to good rendering.

The basic idea in applying shade is to work from the edges in. This is really quite simple to understand, but to do so you must revisit the pattern of shade on your old friend the cylinder.

Under good lighting conditions, the cylinder is modeled in four shade movements. The first, dark to light, runs from the near edge to the highlight. The second, light to dark, extends from the highlight to the terminator. The third, dark to light, from the terminator to the side-plane highlight. The last, light to dark, from the side-plane highlight to the far edge. Shade on a cylinder can be less complex than this, but for a drawing to be readable, it will not be more complex.

Of the landmarks, three are areas of dark: the near edge, the terminator and the far edge. Each straddles a lighter area.

From this, you can derive the basic way of applying shade to curving masses: Shade from edge to edge, lightening up in between.

The rendering procedure is about the same for a human figure. The first thing you do is locate the terminator. The terminator placed, you need do little more than apply an

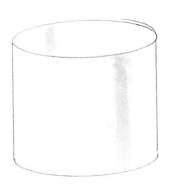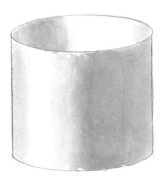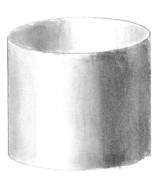

Your pale map-in lines already have begun to account for the near and far edges. Place a pale tone where you believe the terminator should be, gradating it somewhat on either side. From then on, simply begin darkening your edges, leaving a lighter area in between them for your highlight and side-plane highlight until the cylinder is modeled.

even tone to the side planes, and adjust it
here and there until you get the effect of
mass you want, always moving inward from
the edges.

This is called drawing from the outside
in, or rendering edge to edge. It can be
carried out to any desired degree of finish.
If a great deal of detail is required, ever
subtler movements of tone are required, but
the principle remains the same.

The demonstrations to follow show
various drawing mediums. Some permit
lights to be actually drawn in, instead of
having to darken things around them.
Some permit a back-and-forth procedure
of darkening and lightening. In any case, the
essence of the trick does not change. Bring
out your masses by darkening their edges
until you have the image that you seek.

Unlike on a cylinder, the terminator's edge here is
a dynamic one, changing in value and breadth as
you move down the body. This is because the
figure is actually made up of double-curving
masses, whose terminators are always changing
their configuration. The desired effect of the
masses results from the adjusted side-plane
tones.

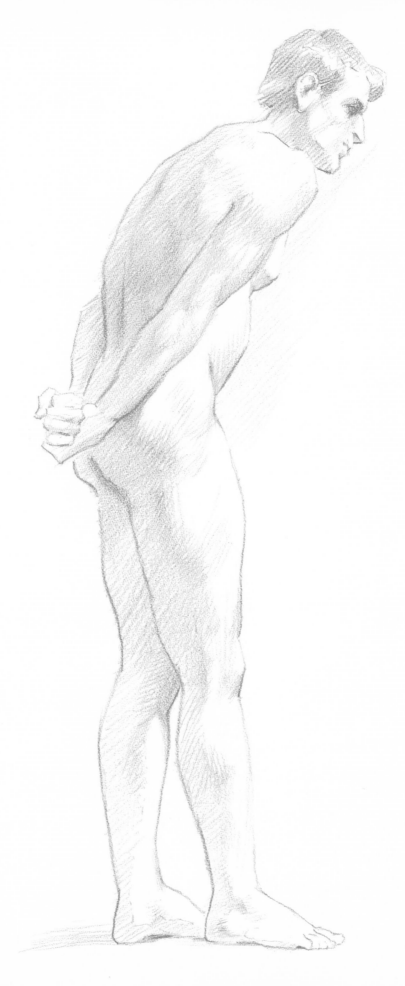

Prismacolor Step-by-Step Demonstrations

Figure drawing requires a good deal of underdrawing, as you have seen. It is often difficult to get students to construct their figures because, understandably, they don't want to clutter up their drawings with construction lines. One of the easiest ways to skirt that problem, as I have mentioned before, is to construct on a separate sheet of paper and do the final drawing on paper thin enough so that the construction is just barely visible underneath. Because this method permits freewheeling construction, it is quite useful for figure studies, particularly when you're limited to a couple of hours or so. I have used it successfully for poses that lasted only fifteen or twenty minutes. The under-drawing can be moved around underneath the final sheet until the figure is placed in a manner that pleases you.

Daler-Rowney manufactures a sketchbook containing thin paper of a pale yellow tint. The books only measure 8" × 12" (20cm × 30cm), unfortunately, so the material limits you to fairly small drawings, but it makes up for this in the wonderful control of edges it enables.

Prismacolor colored pencils made by Sanford work well on this paper, and come in a wide variety of colors. The earth tones are very pleasant to use, but you may want to experiment. (Choose just one color for your picture; later you may wish to explore the possibilities of drawing with two colors, a warm and a cool tone.)

Prismacolors are brittle, and their points wear down quickly. Consequently, they do not hold the chisel-shaped point that works so well for a lead pencil. As a result, a Prismacolor's line quality is poor. However, its ability to layer pale tones, one on top of the other, permits a range of effects not possible with graphite. It is particularly well suited to delicate adjustments of edges.

The underdrawing is done on whatever paper is handy, so long as it is white. Scrap paper is fine. Actually, the cheapest bond paper is just about perfect for this.

In this section are two step-by-step demon-strations using this method of drawing.

Draw from Life with Prismacolor

TOOLS

Daler-Rowney sketchbook, or any slightly translucent, smooth paper

Earth-toned Prismacolor pencils

Knitting needle, for measuring

Cheap bond paper

HB or 3H lead pencil

Fountain pen or black fine-point felt marker

TIME

Half hour to four hours

I Gesture in the pose in the manner previously described. Use a sheet of cheap paper and a hard pencil—an HB or even a 3H. Look for asymmetries, and determine action and inaction sides as you move up and down the figure.

I

2 You can use the same pencil for roughing in, but bear down a bit harder. You may want to use a slightly softer pencil as the rough is developed, to make clearer your final choices in line placement.

Use the techniques from the blocking-in section to spot any errors. Here, I detected a mistake on the placement of the model's left foot: It appears too high on the rough. I drew a diagonal line just below the foot as a note to shift that foot's position lower. Locate the terminator and scribble on tone on the side planes. This gives you a better idea of how the final drawing will look.

3 Using a fountain pen or a fine-point felt marker, have one more pass at the rough. Define the positions, directions, sizes and shapes of masses. The black ink line will overpower all of what you have roughed in up to this point.

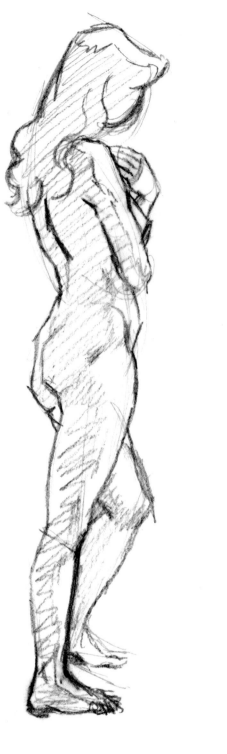

2

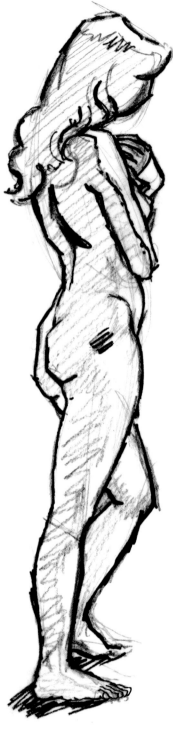

3

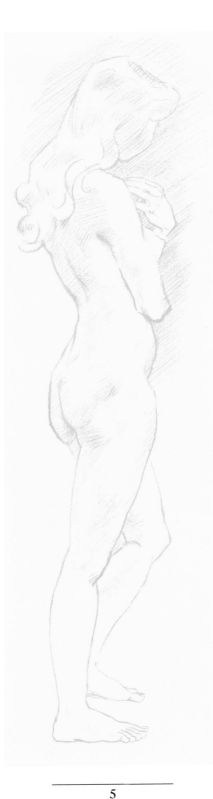

4

5

4 Make sure your ink lines are dry, then slip the rough underneath your drawing sheet. If your paper is thin enough, only the ink lines should be clearly visible.

Using a sharp Prismacolor pencil, begin your mapping in of the pose. Don't trace your ink lines, but use them as a guide as you study the model. Your mapping lines should be as faint as you can possibly make them.

The map-in is essentially a silhouette, but you can put in whatever interior lines you think you'll need in order to develop the drawing further. If you wish to place the terminator on your map-in, do so either with an erasable lead pencil or the Prismacolor, using a discrete series of dotted lines. Since terminators have a habit of appearing and disappearing and reappearing, you will need to reserve the option of making this edge invisible in places. So go easy with any mapping lines here.

5 When you're finished mapping in, remove the rough and set it aside. Cover the entire side plane with a pale, uniform tone, using parallel shading or whatever other application suits your purposes. I used a variation of parallel shading in which the lines change direction a bit as they travel over the side plane. The tone here is not absolutely uniform but darkens somewhat on the down-planes and lightens on the up-planes.

During the shading process, you can change gears at any point and define contours more boldly. Give the contours that describe the down-planes a heavier line than the up-planes, where the outline is often allowed to disappear against the ever-darkening tones being applied. I ran a pale outline around the highlights of the woman's hair. This is a good procedure on shiny-textured surfaces, but should never be done on flesh.

Run some background parallel shade outside the model's silhouette. Carefully keep it an essentially uniform tone at this point. Do not let the darkest values of the background tone actually touch her silhouette, because this would automatically produce a hard edge. You can harden any of these edges later if necessary, but for the moment everything should be kept as pale and as fuzzy as possible.

6 Keep going with the rendering and contouring until the image begins to take shape. Develop the front plane where, working from the edges inward, you are able to let front-plane details stand out abruptly against their surrounding halftones. As you move down the figure, lose and find and lose again the terminator. At the same time, make the tones on the side plane more uniform. The side plane of her hair is essentially one value. The side planes of her flesh still have a darker and a lighter tone, but these are made to be rather close to each other. This is in keeping with the rule that tonal detail must favor the front plane or the side plane but never both. Here, it is the front plane that gets the detailed tone, while the side plane is handled much more broadly.

Finally, examine the highlight on the model's hair. The outline that earlier encircled it is all but lost in the surrounding tone. Give that highlight a raggedly diffused edge, producing the sensation of thousands of hair shafts, each pointing in a different direction. That ragged edge also suggests very strong direct light. (This effect, called *halation*, simulates the glare of intense light.)

7 If you use your pencil lightly and remember to work from the edges inward, you can keep adding thin layers of tone until you have the image you want. I added a little more contouring to the hair, the hands and the feet. Darken the background tone in some places; leave it alone elsewhere. When the effect is as complete as you intend, stop. Prismacolor, used judiciously, still has room in its spectrum for further darkening of edges if you want to keep going, but you don't have to run the picture into the ground. The charm of good drawing lies in knowing when to stop.

Again, the merit of this method lies in doing your construction on an underdrawing, preserving a pristine sheet of drawing paper for the final effect. More delicate modeling and edge treatment are possible in this manner than when construction is done directly on the drawing paper.

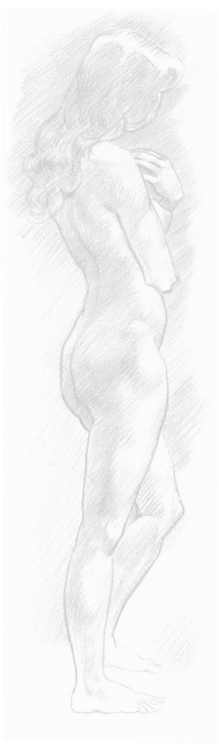

6

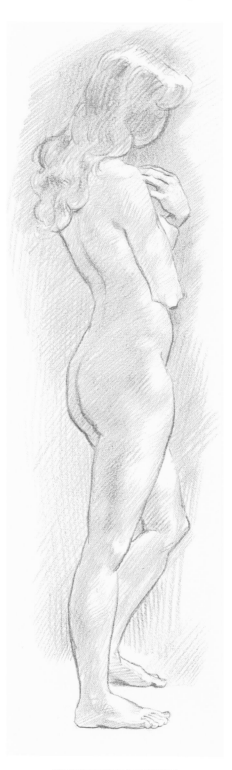

7

Rework a Quick Sketch with Prismacolor

Quite often the presence of a model is more distracting than helpful. If you can garner what facts you need in a quick study, reworking it in private often results in a more descriptive drawing. After all, what counts isn't what you see on the model but what the viewer of your drawing will see. Working alone, you can craft your image slowly and deliberately, including only what is necessary to communicate light and mass.

You can use Prismacolor to rework a picture done in another medium. Ink wash, as you will see shortly, is a method that enables you to accomplish a very full description of tone quite rapidly. However, getting delicate edges in this material is a slow and difficult process. The information the wash study provides is enough to guide you in making a fully rendered drawing with the Prismacolor pencil, which permits a finer control over edges than can be easily obtained with wash.

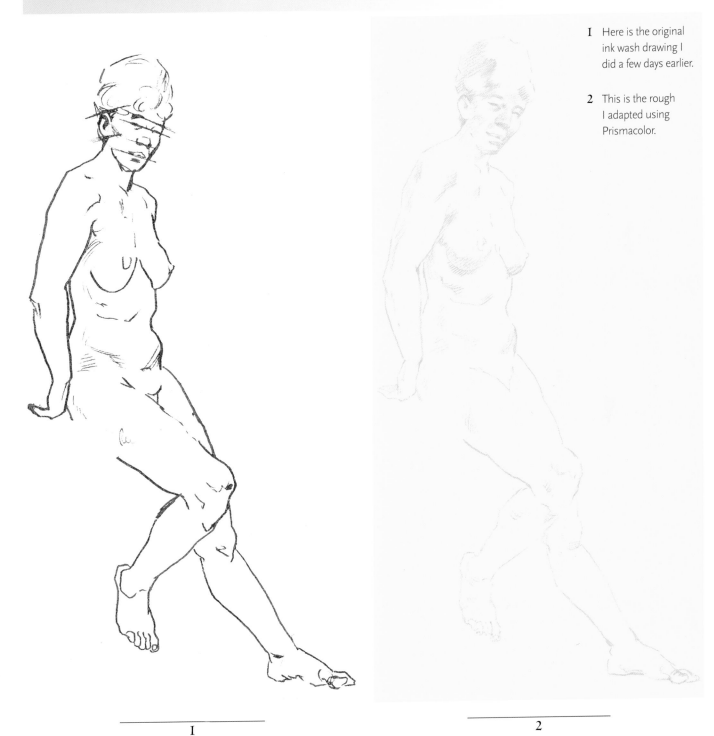

1 Here is the original ink wash drawing I did a few days earlier.

2 This is the rough I adapted using Prismacolor.

1

2

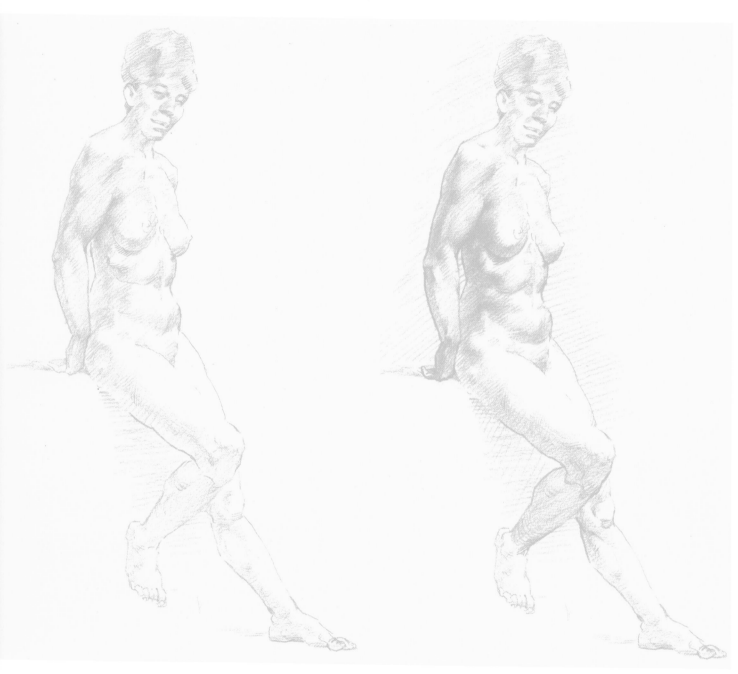

3 Use the rough and the original wash drawing to map in the figure and
to begin to spot dark areas, the terminators and the areas lying close to
them. At the same time, lose the top outline of the woman's right thigh,
which allows the up-planes of the two thighs to be massed together.
Throw an even, pale tone over the entire side plane of the figure, and
add some halftones to the front plane. Add a hint of cast shadow to
suggest the mass upon which the model leans.

4 As the whole picture grows darker and includes more contrast, run
some shade in the background to suggest depth. By this time, the whole
figure is covered with tone, except for strong up-planes, for which the
lightest values are held in reserve.

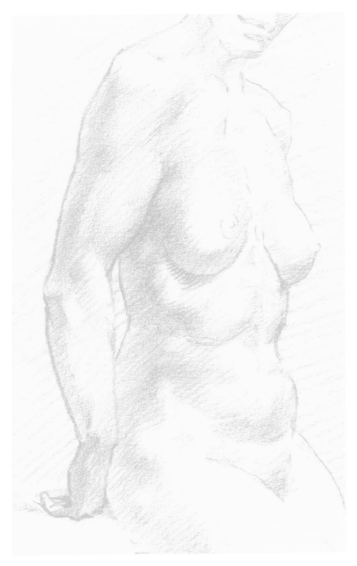

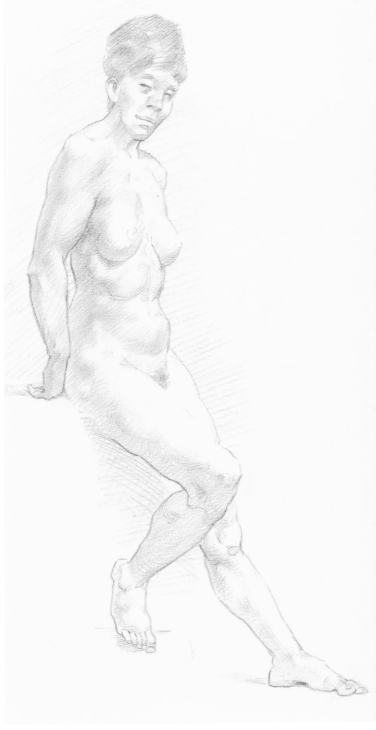

5 Tone is relative in a drawing. If you wish to light up the side planes with strong reflected light, you can darken the terminators, as I did here. Edges are relative, as well. All the edges you see here are quite soft, but some—those at the base of her rib cage, on her elbow and on her wrist, for example—are less soft than others, due to the presence of a distinct terminator line. Feel things out in your picture before rushing in with strong tones or hard edges. Once you put such things down, you can't take them back. The edges here are soft, but at the same time they are quite descriptive. Each mass retains its true shape. Make up- and down-planes clear with tone. You see few lines, except the scribbled layers of shade lines.

6 The final drawing contains as much information as I generally care to provide. The matte texture of the model's hair is made clear through its lack of distinct highlights. The sensation of a powerful light source coming from above is reinforced by the strongly lit up-planes and the absence of an outline on the right thigh.

Black and White Step-by-Step Demonstrations

The materials discussed so far are referred to as SUBTRACTIVE. They can darken a piece of paper—that is "subtract" from the light that paper reflects—but they cannot make it any lighter. This is why shade is applied from the edges inward with such tools. It is on the edges where darker tones lie. In between these edges, where lights or halftones may be found, you leave the paper alone or darken it only slightly. Under such conditions, the primary means of communication is line.

However, you can also use an ADDITIVE method. Instead of darkening a white piece of paper, start with a toned paper and use materials that will darken it in some places and lighten it in others. This sort of drawing relies less on lines and more on patches of tone for its effect. If you've never tried such tools, you may find it difficult to let go of lines and embrace the language of tone, but the effort will be worth it. Black and white on a toned ground gives you a lot for a little, yielding surprisingly good effects even on a quick sketch. On the other hand, if your paper is of good quality and you work carefully, you can develop a drawing over the course of dozens of hours—providing your model is willing to cooperate!

Working in this medium is a way of establishing your tonal palette by selecting a paper whose tone matches the halftones you anticipate for the drawing. The halftone is the darkest dark to be found on the front plane of your figure. If your paper corresponds to this value, you can make parts of the front plane lighter with white crayon or paint and parts of the side plane darker with a crayon, charcoal or brushed ink. You

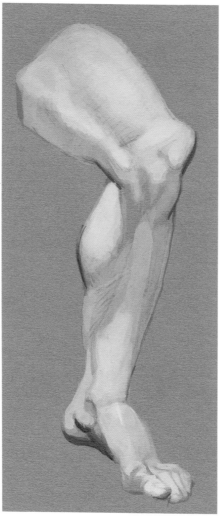

I loosely roughed in this leg study with pencil and then freely applied white gouache paint diluted with water to the front planes. Where lighter values were required, I added a subsequent layer of paint. The greater or lesser opacity of the paint, against the toned ground, gave me the range of values needed. To darken the side planes and contours, I added some touches of black sumi ink.

You can use white Conté crayon and ink with a more linear approach. The toned ground serves as the halftone, with touches of dark added to the side planes and touches of light to the front planes.

can very rapidly produce an effect of light and mass.

The effect any additive materials, including black and white crayon on a toned background, produce tends to be tonal rather than linear. Large masses are suggested not by way of a careful outline but by a suggestion of how they reflect light. The outlines of masses can be quite ragged, as long as you accurately draw the edges of the lights.

Using black and white on a toned ground is about as close a method to painting in oil as you're going to find in drawing.

Your choice of paper will depend largely on the materials you use. Using white paint and ink wash for your tones, requires heavy paper or board to prevent buckling. Should you stick to crayons or charcoal, lighter material works nicely. The tone of paper, as I have said, depends on the value of the

halftones you expect for your drawing, and this is not an easy decision to make unless you've used these materials quite a bit already. A rule of thumb is that halftones are generally quite dark, their value much closer to your darks than to your lights. A dark blue or brown paper is a good first approximation for studio work. If the paper is too light, your white passages will not stand out.

For drawing in charcoal or pastel, the paper requires an uneven surface, replete with hollows to trap the minute particles of charcoal, kind of like a thick net spread over the surface. This quality is referred to as the paper's TOOTH. Conté crayons have a binding material in their pigment, and you can use them with a smoother paper if you wish. With paint and wash, a smoother surface works.

The cheaper grades of charcoal paper have a very mechanical tooth to them that I find offensive; the crayon stroke produces a series of dots not unlike those in a newspaper photograph. (Seurat used this quality to his advantage in the Conté studies he made for his paintings; the dots simulated the pointillist brushwork with which he would execute the final picture.)

When you come across a toned paper you like, buy as much of it as you can afford. I like pads; the paper surface is nicely cushioned by the sheets underneath, inviting a velvety touch of the crayon. Pads also have a sense of cheapness to them, inviting a less self-conscious approach. If you prefer paper that doesn't come in pad form, a print shop will cut it and bind it into pads for you at nominal cost.

The following demonstrations examine the process of using black and white on a toned ground using a couple of different materials.

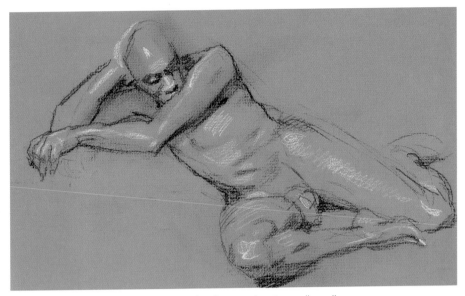

This study, executed in a few minutes, implies far more than it actually spells out but is really as "finished" as any pure line drawing in this book.

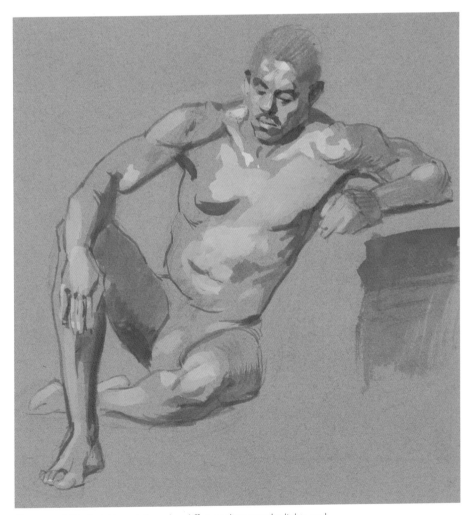

If your model is darkskinned, the value difference between the lights and halftones is far more pronounced than that between the halftones and darks. A model can be drawn very rapidly if you make this characteristic work for you. A few hints about terminator and side plane are all that is required, if you handle lights and highlights convincingly.

Black and White Conté on Toned Paper

Conté crayons are a synthetic form of the natural chalks used by artists since the Renaissance. They come in a variety of hues and hardnesses, and are available in both stick and pencil form.

The question of sticks versus pencils is largely a matter of personal preference. In general, sticks make it easier to apply broad areas of tone, while pencils favor lines. Both sticks and pencils may come into play in the same drawing, as was the case in the example.

TOOLS

Toned charcoal or pastel paper

White Conté crayon

White Conté pencil

Hard black Conté pencil, sharpened

Soft black Conté crayon

Vine charcoal

Kneaded eraser

Tissue or cotton swabs (for smaller areas)

TIME

Twenty minutes to several hours

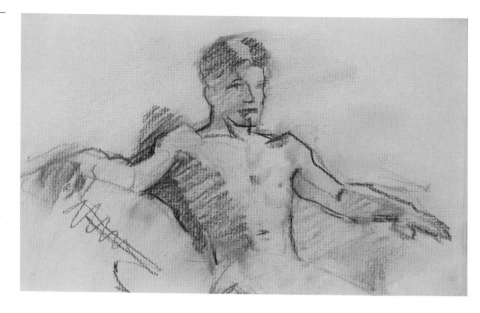

I

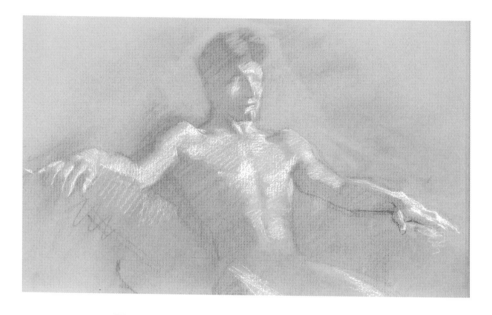

2

1 Gesture and rough in your drawing using a piece of soft vine charcoal. The cheaper grades, which are increasingly all that you'll find in art stores, are best for this. They erase very easily, leaving no trace, so you can work briskly without any worry that your crude strokes will interfere with the final drawing. Follow the blocking-in procedures, taking care that the sizes, shapes and placement of large masses are the way you want them.

Scribble a pale tone over the side planes and wherever else you anticipate large patches of dark. (Here, the halftones of the model's hair and the background have been so darkened.) Your vine charcoal will make only the crudest sort of lines, but that's exactly the kind of line you want right now.

2 When you have developed the rough to your satisfaction, rub the whole thing lightly with a wad of tissue. The lines and tones will mist out to a pale gray but should remain clear enough to orient you.

Using a piece of kneaded eraser, remove patches of the misted tone where you anticipate lighter values. Use the eraser, or your finger, to blur the edges of your front plane as needed. As you pick up the charcoal dust in the right places, an image will begin to emerge.

With a stick of soft white Conté, lighten areas of the front plane. Make sure all charcoal dust has been removed from any areas over which you want to use the Conté. The cardinal rule of these materials is that your black and your white pigments should never touch each other; they should always have some of the toned ground separating them.

This work should be quite broad, suggesting only the starkest contrasts in value. At the same time, hold back on using the full power of the white crayon. Only a pale scribble of the material is needed to produce an enormous effect. Wait until the finishing of your picture to unleash your starkest values.

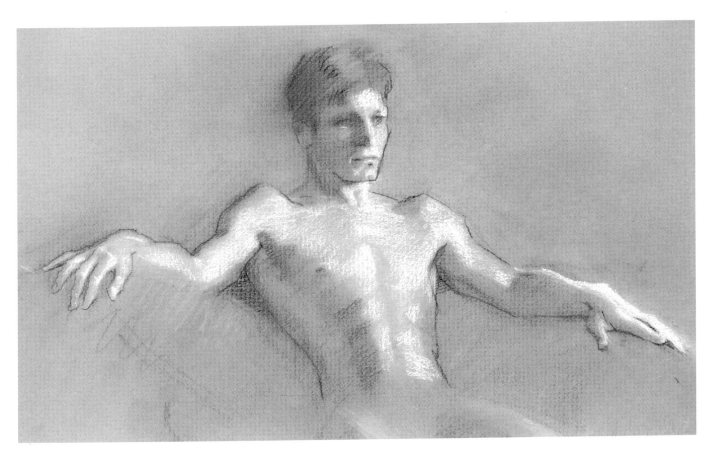

3 Rub the drawing again with a wadded tissue, but take care not to bring the white chalk dust in contact with the charcoal dust. The aim here is to provide a misty "bed" upon which to draw further refinements of value. Use your kneaded eraser to clean up any areas of the drawing that have unwanted charcoal or Conté dust on them.

Now draw right on top of this. On the side planes, use your soft black Conté crayon on its side to darken values as needed. Be careful about darkening the side plane too much, however; since there is little or no black pigment on the front plane, the slightest darkening of the side plane will suffice. Too much will destroy the effect of transparency that is characteristic of side planes and shadows. Reserve your darkest values for the terminator.

On the front plane, you can darken areas by pressing down with your kneaded eraser. This removes a bit of the white Conté mist, revealing more of the paper's halftone. The harder you press, the darker the tone you will produce. Try to cultivate a light touch with the eraser. With a little practice, you will become quite sensitive to how hard you need to press to get the effect you want.

The kneaded eraser shares some of the characteristics of a brush, or rather a variety of different brushes. It can be molded to any size and shape. Shape the eraser for the stroke you want to make, and try to describe as much with one stroke as you can. You can also lighten areas by stroking them with your white Conté crayon.

Reinforce the outlines of your figure as needed with your black or white Conté, but don't go overboard with it. With these materials, your effect is garnered almost entirely through properly placed tones; outlined contours are incidental to the process. Take care not to place your lightest white Conté strokes on the outline of the figure. The lightest values on a mass are *never* located on the outline but are always inside it. This is true even in strongly backlit poses.

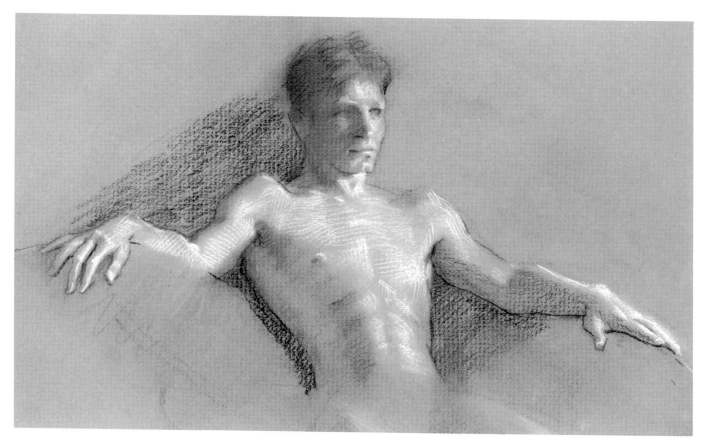

4 Go back and forth in this manner, lightening and darkening your image, bringing it into sharper focus.

Unify the effect, soften the edges and mix the tones slightly by rubbing the picture with a wad of tissue. Do not let the black and white dust mix.

You may want to darken (or lighten) the background to strengthen the composition. Note that the gray tones placed behind the figure make his side planes appear brighter and more transparent.

Once you are satisfied with the basic effect, switch to harder grades of black and white Conté. Here, I switched from crayons to hard Conté pencils. The white crayon strokes on the front plane are more sharply defined now, due to the harder tool and the increased leverage of the pencil over the crayon. Reinforce some of the contours with the harder black pencil.

If your small details overwhelm the all-important larger masses, simply mist out your drawing again with a tissue and try again.

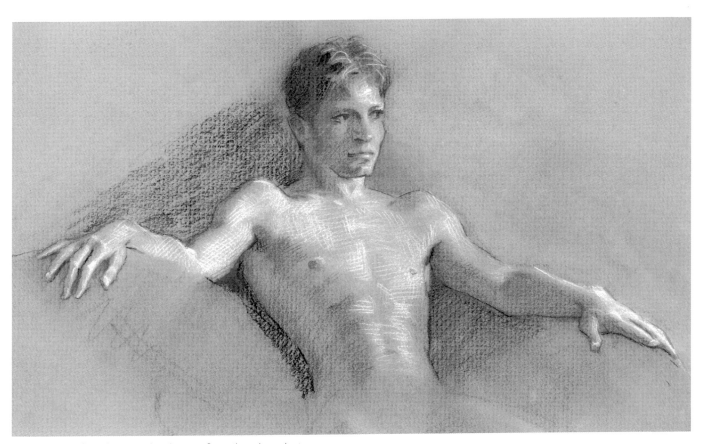

5 Keep going from the general to the specific until you have the image you want. You can adjust values using your kneaded eraser and your black and white Conté pencils. You can refine edges using your tissue, or rubbing with other tools—a cotton swab, a powder puff or even the edge of a razor blade. (Be judicious with the blade: It tears the fibers of your paper to shreds. Make it your last step if you use it.)

If you want finer lines than your Conté, in either stick or pencil form, will give you, you can mix your mediums further. A carbon pencil gives great lines, somewhat more controlled than the Conté pencils. A sable brush and sumi ink gives you still more control and permit flat washes of tone.

Broadly set down your final touches, of both the black and the white pigments, and leave them alone afterward. This is particularly important when you draw highlights with the white Conté. Create a hard edge on one side and a soft edge on the other side by pressing your crayon down and then flicking it away in the direction you intend for your softer edge.

Charcoal and White Conté on Toned Paper

You can work similarly to the previous demonstration with white Conté and charcoal alone, without bothering with black Conté. The effect is somewhat broader and less refined, but it has its own charm.

TOOLS

Toned charcoal or pastel paper

White Conté crayon

White Conté pencil

Hard charcoal pencil

Vine charcoal

Kneaded eraser

Tissue or cotton swabs (for smaller areas)

TIME

Twenty minutes to several hours

1 Rough in your drawing with vine charcoal as before. Don't fuss over details, but put down enough information to clarify the positions and sizes of masses. The diagonal line that connects the model's eyes indicates the tipping of her head. I used a broad line to place the terminator.

2 Mist out your rough by rubbing it lightly with a wad of tissue, and then pick out the light areas with a kneaded eraser.

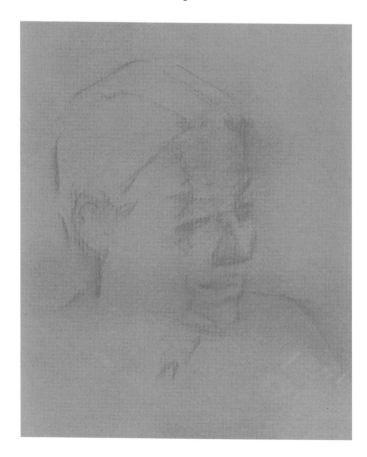

1

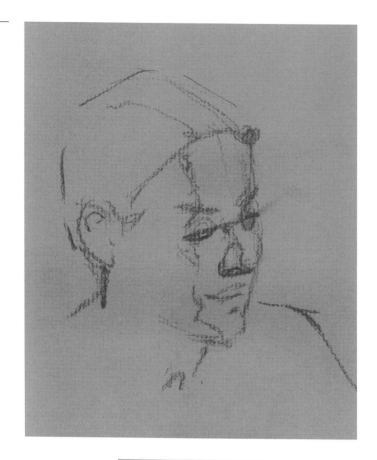

2

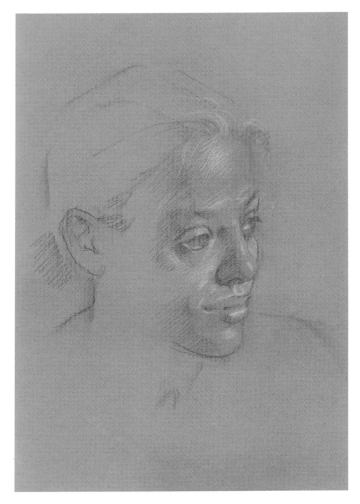

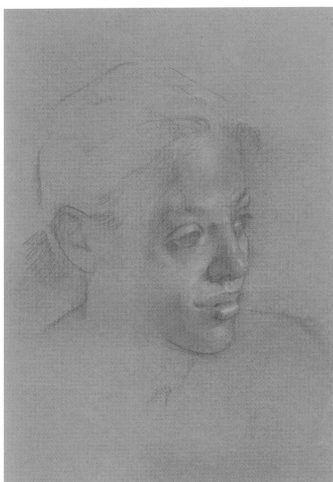

3 Begin to draw your lights with white Conté, either with sticks or crayons, your darks with a charcoal pencil. Parallel strokes will produce an effect of unity and transparency. Go easy with the charcoal; your toned paper should be dark enough so that the side planes don't require much additional darkening.

4 Mist out again, taking care not to bring your charcoal and Conté dust into contact.

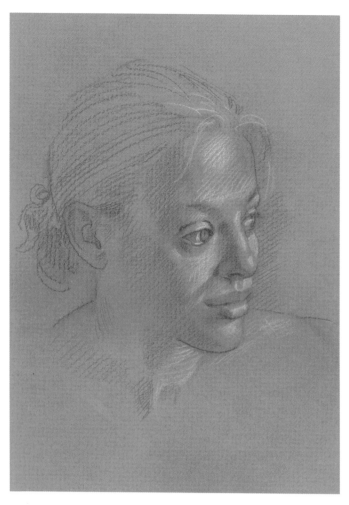

5 Restate your lights and darks. The image
 becomes clearer each time you mist out and
 reinforce your values.

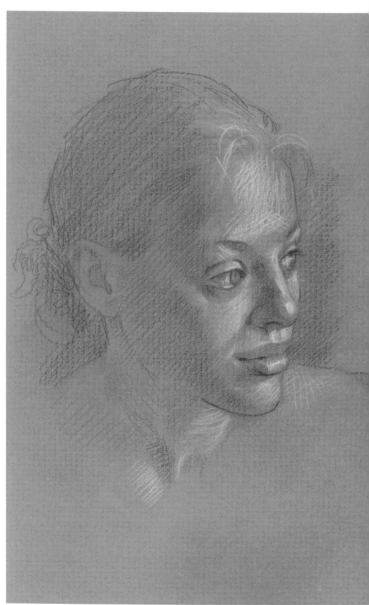

6 Stop misting once you are satisfied with
 your values and edges. Let your top layer of
 charcoal and Conté be calligraphic, not an
 amorphous patch of tone.

Ink Wash Step-by-Step Demonstrations

A WASH DRAWING is made with ink freely diluted in water; the less the concentration of ink, the paler the tones. The technique is similar to that used for watercolor, except that only one color is used—here, the black sumi ink sticks used for Japanese calligraphy. Figure artists are freer also than water-colorists to define contours with a line if desired.

Sumi ink is also sold prediluted in jars, but this material is much harder to control. I recommend the sticks.

To use them, you need a suzuri stone, which can be purchased along with sumi ink sticks at any well-stocked art store. It is a kind of palette with a basin at one end. Brush a puddle of clean water into the basin, and then scrape the sumi stick back and forth inside the puddle. The friction causes a small amount of the ink to dissolve into the water. The more you rub the stick, the stronger the solution of ink. You can then dip your brush in this ink solution, removing excess liquid as necessary on the flat area of the stone.

You can apply washes very rapidly over large areas of a drawing, which has made this method a favorite among painters for compositional sketches. At the same time, washes permit very detailed rendering.

The downside of a wash drawing is that it is difficult to control edges unless you work very slowly and methodically. If you intend to make rapid figure studies with this material, be prepared for a lower batting average, but be grateful for happy accidents.

Because you use a great deal of water, ordinary drawing paper will buckle. It is better to use either stretched watercolor paper or paper mounted on cardboard. Two versions of the latter material, illustration board and watercolor board, are commonly available. Watercolor board is much easier to use because tone washes don't set into its fibers quite so quickly. It gives you a few extra crucial seconds to soften your edges. Watercolor board is available in a smooth grade, called hot-pressed paper and a rougher one, cold-pressed paper. I prefer cold-pressed paper for my own work, but you ought to try them both to see what suits you better.

Before you begin rendering with this medium, first examine how it can be used to make more casual sketches on ordinary drawing paper.

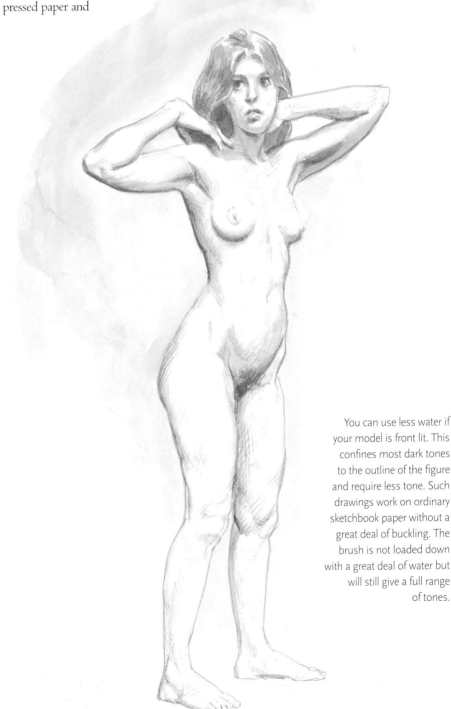

You can use less water if your model is front lit. This confines most dark tones to the outline of the figure and require less tone. Such drawings work on ordinary sketchbook paper without a great deal of buckling. The brush is not loaded down with a great deal of water but will still give a full range of tones.

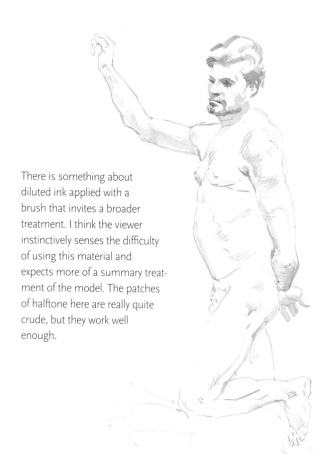

There is something about diluted ink applied with a brush that invites a broader treatment. I think the viewer instinctively senses the difficulty of using this material and expects more of a summary treatment of the model. The patches of halftone here are really quite crude, but they work well enough.

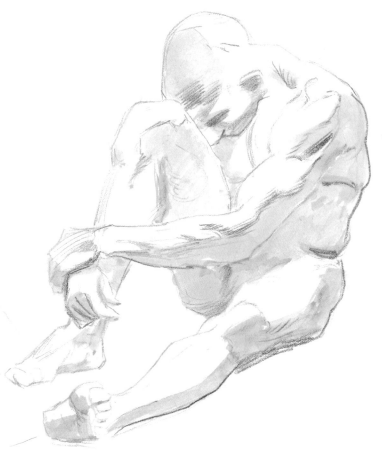

You can practice drawing in two planes—that is, defining mass by assigning just one value to the front plane and one to side plane—using a single wash of ink applied over the entire side plane of your model. Almost nothing else is needed for a clear effect of mass.

This sketch contains no patches of wash but relies on line alone for its effect. You can produce a lovely, descriptive, line with a no. 2 sable brush and an appropriate solution of ink. With some practice, you will become familiar with how much ink to dissolve in your water and how heavily you need to load your brush to get the kind of line you want. You can apply sumi ink with a nearly dry brush, producing lines that resemble those of a lead pencil but having all the suppleness of a brush line.

Render with a Brush and Sumi Ink

Like live television and tightrope walking, wash drawing allows exactly zero mistakes on your part. Washes can't be erased, and can only be lightened in the first few seconds after they have been applied. A hard edge, once set down, can never be softened. This means that wash can really only be used in one of two ways: With complete spontaneity, or with a clear idea in advance of precisely the effect one seeks. The preceding examples fall into that first category; all of them were done with a lot of enthusiasm but very little planning. Unfortunately, for every such success there are likely to be three failures.

However, washed-in ink can be a reasonably cooperative tool for more elaborate rendering, if you're deliberate about it. Over the next few pages you will notice that the technique you will use is similar to the approach you used with Prismacolor, another medium which can't be erased. In both cases the trick is to state your darks with pale, almost ghostly patches of tone, then begin darkening things from the edges inward until the image you want emerges. As with Prismacolor, impatience is the enemy. That dark value, or that hard edge which might fascinate you, cannot be drawn until the end. In this sense, wash is the opposite of oil paint, which demands that one's accents be set down as quickly as possible. Wash provides no such instant gratification; in fact, wash drawings generally look awful until they are nearly complete. You have to force yourself to keep going.

TOOLS

Cold-pressed watercolor board

3H and HB pencils

Sumi ink stick

Suzuri stone

No. 2 and no. 8 pointed Kolinsky sable brushes

A jar of clean water

A good eraser (Beware of cheap erasers. Erasers on the end of a pencil are useless, and have been known to leave a red smear in their wake which, ironically enough, cannot be erased. Those white, block erasers sold under the trade name Magic Rub are excellent and won't damage your watercolor board. A piece of kneaded eraser is safe enough if its surface is clean.)

TIME

Two hours

I As usual, the gesture must summarize the pose in a few quick strokes. Use a hard pencil, such as a 3H grade, whose lines will be nearly invisible, and take care not to bear down too hard with it.

 It's useful to ask yourself why you chose the pose at all. What about it interests you? The gesture, in large part, is your answer to that question. Here, the model's dangling foreleg, her thigh and her back formed a staircase-shaped zigzag that appeared worth building a picture around.

2

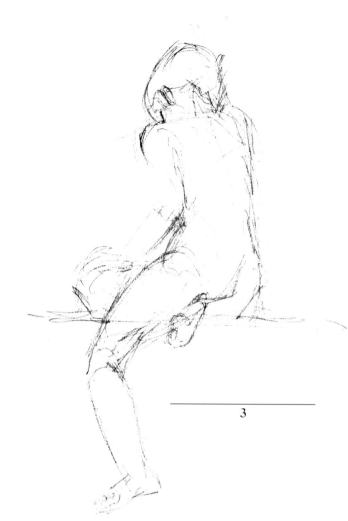

3

2 The foreshortening on this pose was not extreme, but it took me several tries to unscramble it to my satisfaction. It began to take better shape for me once I simplified its masses into simple mannequin forms on scrap paper, as described in the section on foreshortening. I seldom bother with that, but on this drawing, the rough made no sense to me until I did so. It's a good trick when a quirky pose gives you trouble.

3 The staircase shape is essentially lost once the roughing-in procedure begins in earnest using a softer HB pencil. This is because once the individual masses and their thrusts are described, the simpler conception of the pose is diminished. The completion of the drawing will be an attempt to get back to where you started.

4 Mapping in was done with the same HB pencil, with the scribbles erased. This map-in is not quite so neat or pristine as the Prismacolor map-in we examined previously. Since all of it is destined to be erased completely as soon as possible, it is unnecessary to be quite so finicky.

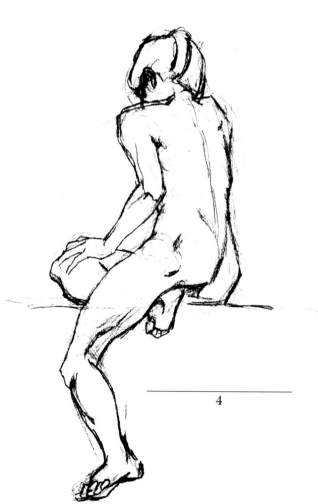

4

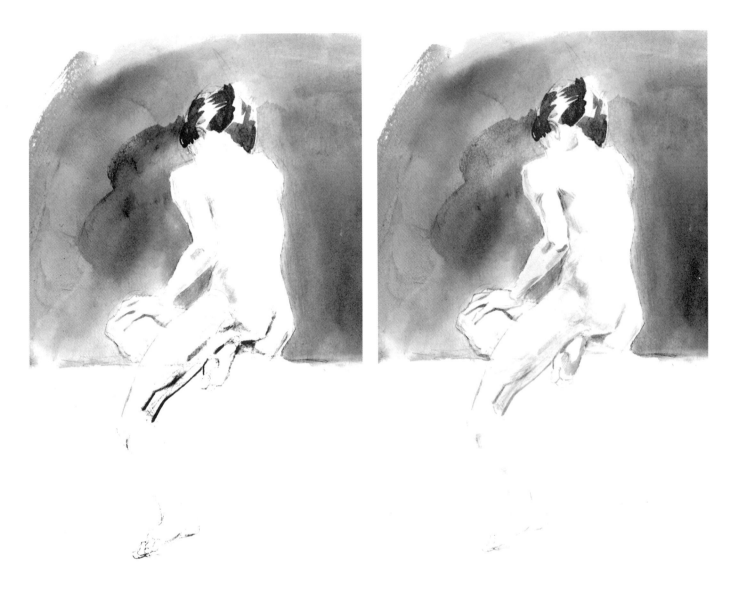

5 The model is illuminated from above and from her right in a strong three-quarter light. Anticipate a dark background and dark hair for the drawing. With these things in mind, begin to apply some darks to the map-in and see how they work.

 Deal with the background first. Wet this area with clean water, then brush a dark solution of ink and water into it, being careful to keep the brush away from the figure's contours. In this way, hard edges are avoided. The edges can always be put in later on, but right now the figure must appear somewhat out of focus. If this is done properly, the model's silhouette will appear haloed.

 Place dark accents where terminators are anticipated, such as on the model's left thigh and the soles of her feet. Also hint at the shadows her left hand throws on her right knee. All of these darks are actually fairly light at this stage, but they appear dark compared to the white of the board. Scribble in her hair, reserving white areas for its highlights.

 At this stage, the pencil lines are no longer needed. Let the board dry, and then thoroughly erase them.

6 With the four edges of the figure established, begin to darken the figure from the edges inward. First, throw a pale, even tone over the side plane of the figure. The procedure is similar to that used for the background: Wet the area you want to darken with clean water, then brush a solution of ink and water into it. Stay away from the front plane for the moment; it is important to see and evaluate the simple two-plane effect before moving on.

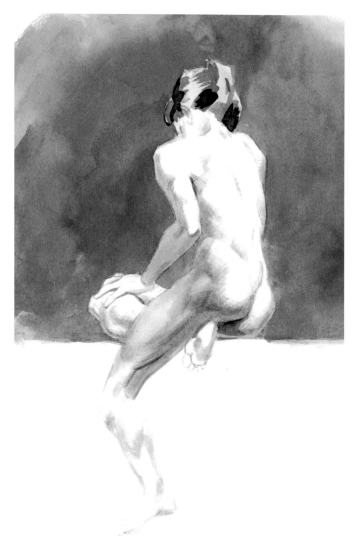

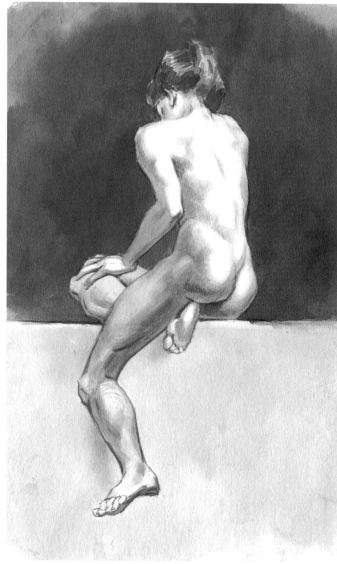

7 Begin introducing some pale tone into the front plane now. Look for areas which are turning away from the light, and throw some dark into these places. This is done on the underside of the model's rib cage, on both sides, in the small of her back, along the edges of her buttocks, and so on. The upper two-thirds of her left thigh is not a side plane, but an area of the front plane pointing almost directly at the light source. Under these conditions, it is completely covered with a halftone.

Work slowly, using weak solutions of your sumi ink, reserving the white of your board for the light areas of the front plane. As you darken things around these areas, they will begin to take on a sense of dimension.

Darken the background with a second layer of ink wash, bringing the darks right up to the figure's silhouette in some places, while leaving a blurred edge in others. This darkening of the background has a curious side effect, one well-known to painters: The model's side planes suddenly appear lighter; her flesh becomes almost luminescent. The lesson is that if you want to lighten an area, you can do so by darkening the area which surrounds it.

8 Cool down that luminescence somewhat by darkening the side planes a bit more, particularly on the model's thighs and forelegs. Introduce still more pale tone into the front plane, all the while reserving the white of the board for lights. Attend to the edges of the hair's highlights. Harden edges along her silhouette here and there, but still retain a diffused edge over most of this contour.

Stop when the image seems almost complete. Leave a little to the viewer's imagination. If the cues you have supplied are credible, your viewer will happily fill in the blanks for you.

Discover How to Gradually Tone Your Drawing with Ink Wash

I Lightly use the 3H pencil to accurately rough in the figure's position and proportions on your board. Next, restate the lines with the softer HB pencil; as always, take your cues from the model instead of tracing your rough. The map-in shown here is sufficient for our purposes. Make sure you don't bear down too hard with your pencil, or you'll produce gouges on the paper surface which will impede the flow of your washes.

2 Select the areas where you will have large patches of tone—the darks of the model's hair, the blanket and the side planes of her body. Note that the background tone does not meet the contours of her body. Produce soft-edged passages like these by applying touches of thinned-out ink to the wet board, but at the same time keeping the touches well away from the edges. The ink spreads out on its own but loses intensity the farther it goes from the original ink spot, creating the blurred edge. You can always make the edges harder and darker later on, but keep your tones very pale and soft in the beginning.

If necessary, you can manipulate the tones while the board is wet using your brush to move them closer to the edge. You can also gently lift away some of the ink by touching a clean, dry brush to an area. I used this technique where the model's thigh joins her buttock.

Working wet-into-wet like this is difficult to describe and requires some practice. Familiarize yourself with how diluted ink will react to different kinds of manipulation. Working with ink wash can be discouraging at first. You must force yourself to believe that a readable image can emerge out of it. This is the best encouragement I can offer: Play it safe and don't rush in too early with your darker values. They can ruin your initial drawing.

I

2

3 Begin refining the image, darkening your side planes and applying pale washes where you will need halftones. The white of the board must be preserved for the light areas, so try to anticipate where these areas will be and keep your ink away from them. Remember to apply shade from the edges inward. Apply pale tones to down-planes until they turn convincingly.

4 Brush a darker value into most of the woman's hair, reserving some areas for the highlights. Darken the side planes more. Apply thin washes of tone to slightly sharpen the diffused edge of background tone against the model's outline. Improve your composition by adding a dark patch, running diagonally, beside her right hand.

3

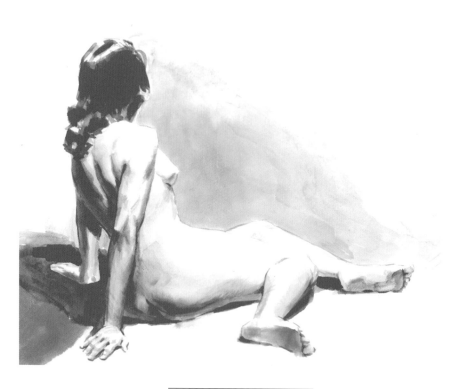

4

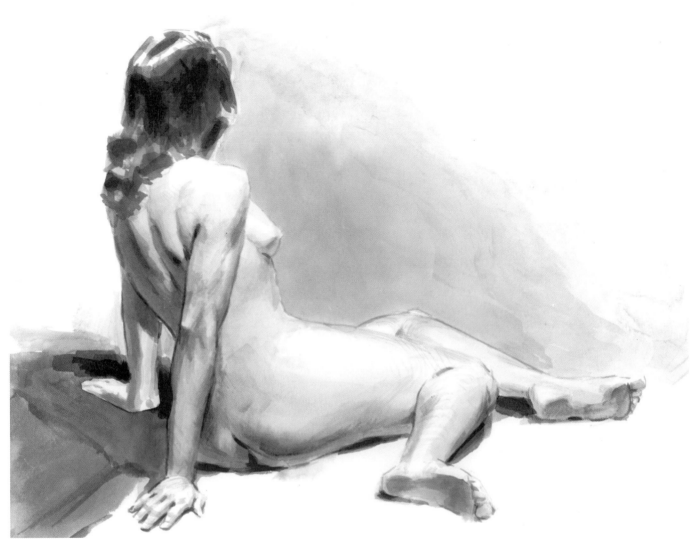

5 Tweak your picture until you reach a satisfying
 image. You may be tempted to use outlines,
 but try to avoid this. Let the washes of tone
 carry your illusion.

Problem Solving

EVERYTHING ON THE HUMAN BODY IS HARD
TO DRAW, BUT SOME AREAS PRESENT UNIQUE
CHALLENGES THAT NEED TO BE ADDRESSED.

The head is difficult to draw, not only because of its complexity, but because all its details must be made to point in the same direction as the whole mass. Place the eyes poorly and the model becomes cockeyed; an error in constructing the nose results in a broken nose. The construction of the head must be second nature to the artist.

The hand presents the opposite problem: Each hand contains a large number of moving parts, and you must determine the direction of each part. I will offer a few hints for tackling this problem along with some basic information about the hand's anatomy.

Students have agonized over the foot for centuries, but it's not too difficult to learn if you consider its springlike function and give some attention to its print and skeleton.

Hair is a lot of fun to draw. Many of the elements of figure drawing discussed in part one—edges, the tonal palette, line calligraphy, The Etcetera Principle and especially texture—come up to the plate every time one draws hair. In this section, I will clarify how they can be used to your advantage.

Finally, the question of how to use tone to express thrust is hardly ever taught or written about, but this is a wonderful tool for capturing the action of a pose. The Rule of Tipped Cylinders, which I describe and demonstrate, will enable you to pull this off with great authority.

Head

Remember a few basic truths about the head and face: The head is bilaterally symmetrical. You must draw the left sides of the nose, mouth and eye so that they appear essentially as mirror images of their counterparts on the right. At the same time, the head is a curving surface, and all its features must be conceived and drawn as details lying on that curved surface.

The subtle details of the face are difficult to replicate, especially the eyes and nose, but breaking the head and face into individual shapes helps.

First, I should address the head in general terms. Measure the head in eye widths—the width from one corner to another of the eye. The typical proportions of height to depth to width, 7:6:5, are not set in stone, but they are useful and easy to remember. There are also some reference lines that will help you place the facial features.

The head's VERTICAL MIDPOINT LINE is particularly useful, as it runs through the corners of the eyes. On the side view, the HORIZONTAL MIDPOINT line gives the frontmost border of the ear.

The TRACE LINE separates the two great planes of the head. When the model is placed in three-quarter light, this line invariably forms the terminator. Regardless of the direction of light, however, this trace line forms the basis for the application of shade. It's to the head what the meeting of two facets is to a box. Its shape varies considerably from model to model. Study this line yourself with a friend's help. Hold a piece of soft charcoal at a 45° angle to your friend's face. Skim the person's head with the side of the charcoal, moving down from forehead to

chin. The soot marks you leave will be the trace line of the face.

THE IDEALIZED HEAD IN THIS ILLUSTRATION ▼ has a few more lessons to teach. Notice it has been enclosed in a box, corresponding to the 7:6:5 ratio. You can draw such a box from any angle and in any drawing system. Draw the head in the box by locating certain points. In this manner, you can tip or cock, that is THROW, the head this way or that.

One eye width from the top of the box is the widow's peak, generally the lowest point of the hair. Divide the distance from the widow's peak to the bottom of the chin into thirds. The first third takes you to the eyebrows and, more importantly, to the top of the eye cavity. Go down another third to the top of the ear. The final third is the bottom of the nose, also the bottom of the ear.

This method is known as THE RULE OF THREE. It's a more useful proportional canon than most for the face. It holds for a large percentage of American and Western European faces.

The mouth lies about four-ninths the distance from the bottom of the nose to the bottom of the chin. I know of no really trustworthy trick for placing it, other than just looking hard.

To learn the head, take your sketchbook everywhere, and draw it from multiple angles, carefully noting the features' heights and widths. Also, learn the skull by heart. Plastic model skulls sold in toy and hobby stores aren't perfect, but they're close enough to the real thing to generally teach you the topography of the human head.

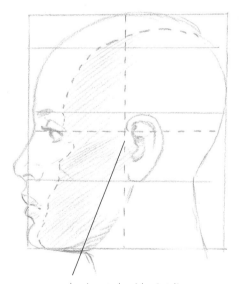

trace line vertical midpoint line *horizontal midpoint line*

Here, a female head viewed from the front and from the side. The head's proportions are seven eye-widths tall, six eye-widths deep and five eye-widths wide. On the front view, there is an eye-width's distance between the two eyes, and an eye-width's distance from the corner of each eye to the widest point of the head.

The dotted lines that bisect the construction box are the horizontal and vertical midpoint lines. The trace line rides down the side of the forehead, travels over the superorbital eminences above the eyebrows, runs over the flesh above the eye and down the side of the eye itself. Then it jumps backward to the protrusion of the cheekbone and runs down the cheek, around the muzzle of the mouth and ends at the chin.

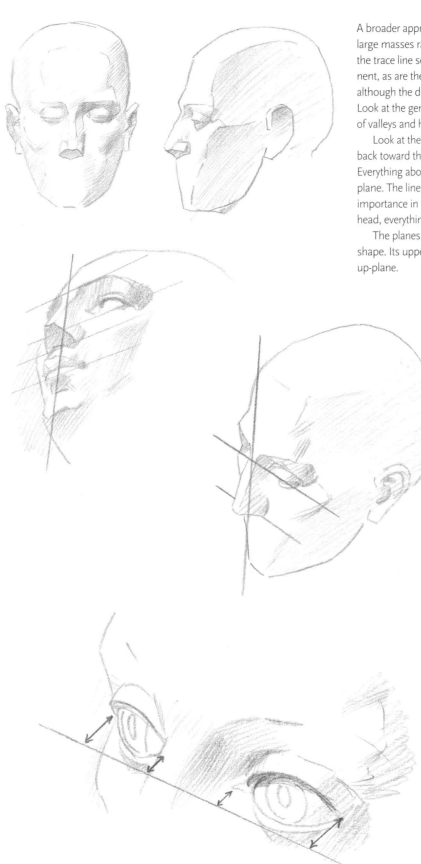

A broader approach can teach other things about the head. Concentrate on large masses rather than details in these drawings of a male head. Visualize the trace line separating the two great planes of the head. It is quite prominent, as are the ears, eyes and nose. The mouth is absent altogether, although the drawing hints at the muzzle-shape mass where it would lie. Look at the general topography of the head, and imagine it more as a series of valleys and hills.

Look at the profile view. Examine the line extending from below the eye back toward the ear. This corresponds to the zygomatic arch of the skull. Everything above this arch is an up-plane, and everything below is a down-plane. The line appears far subtler on a model than in this drawing, but its importance in modeling is profound. If your light shines from above the head, everything below this line will be darker than everything above the line.

The planes of the ear are also prominent. Think of the ear as a bowl shape. Its upper region is a down-plane, and its lower area is a pronounced up-plane.

The horizontal midpoint line is important for any view of the head, but it is indispensable when the head is thrown. Run your horizontal midpoint line from the center of the base of the nose through the top of its bridge. To help you place the features, use the Rule of Three. You may also wish to draw the horizontal midpoint line which divides the two halves of the head. Refer again to the boxed-up head on page 120, and examine the lines on these thrown heads.

Placing the eyes has its own special problems. They lie buried in the orbital cavity of the head, and if you ignore this fact, your model will appear bug-eyed. The inside corner of the eye lies farther forward than the outer corner. If you draw a construction line across the vertical midpoint line of your box, you can run depth lines backward to place the corners of each eye.

I mentioned earlier that every detail on the head lies on a cylindrical surface. Actually, they lie on one of two cylinders. Think of the top cylinder as the size of a large can of coffee grounds and the bottom can as the size of a 12 oz (355ml) beverage can. The former functions as the contour of the skull, the latter the muzzle of the mouth. The eyebrows and nose run along the front of the larger cylinder. The area associated with the teeth runs around the front of the mouth cylinder. The eyeballs are buried deep in the orbital cavities of the skull. The parts of the eyes that you see and draw are the contour lines that run over the surface of the eyeball indicating the eyelids, pupil and iris of the eye. All of these are contour lines.

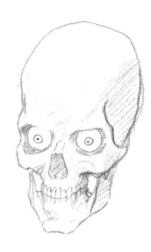

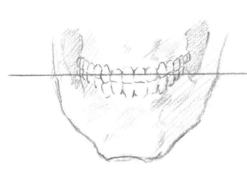

Usually, faces are drawn with closed mouths. Still, understanding teeth and their relationship to the mouth is important. An adult has thirty-two teeth, each with its own particular function. The front teeth cut, the canines tear and the molars, which run along the side, grind. These functions determine each tooth's form. Teeth emerge from the jaw separate from each other, but they fill out toward the ends to merge into a single mass. When drawing individual teeth, make your line heavier near the jaw, and then let it fade toward the end of the tooth. The line between the lips gradually appears at the height corresponding to the middle of the upper teeth.

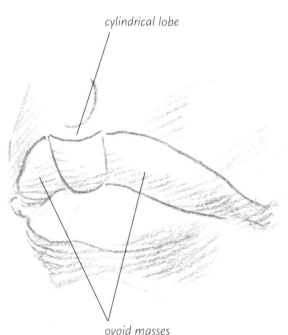

cylindrical lobe

ovoid masses

The upper lip juts forward while the lower hangs back. The upper lip is a down-plane and the lower lip an up-plane. Remember that up-planes are light and down-planes dark so draw the lower lip lighter than the upper lip. However, the upper lip rarely is hidden entirely from the direct light. Its edge is quite fascinating and ought to be studied closely as you draw the mouth.

Three lobes make up the upper lip. The center of the upper lip is a cylindrical lobe. Two lateral lobes made of ovoid masses complete the upper lip. Two ovoid masses also make up the lower lip.

Hands

Drawing the hand well is a problem of ACTION. You have to handle a large number of separate masses each pointing in its own direction. The hand has sixteen moving parts—precisely the same number of moving masses on the rest of the body. Drawing a hand is like drawing an entire figure.

The component masses of the hand are not particularly complicated. The body of the hand and the fingers—each is composed of three joints, or phalanges—and the thumb, which has two phalanges. The body of the hand takes up half the length of the hand. The other half is taken up by the fingers. All the masses of the hand are skeletal in nature, so carefully study the skeleton of the hand.

The five bones extending from the wrist, which are the metacarpals, resemble finger bones, but all of them are completely buried in the body of the hand.

Most of the muscles that animate the hand and fingers lie on the forearm, but three muscular masses located on the hand itself have an important effect on its surface. On the anterior side lie two of these. The first,

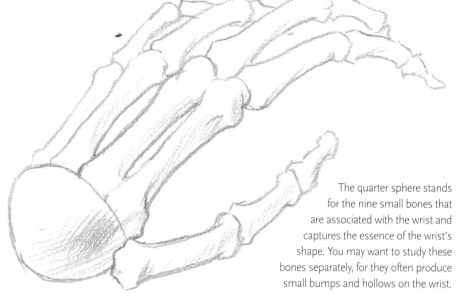

The quarter sphere stands for the nine small bones that are associated with the wrist and captures the essence of the wrist's shape. You may want to study these bones separately, for they often produce small bumps and hollows on the wrist.

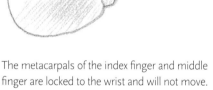

The metacarpals of the index finger and middle finger are locked to the wrist and will not move.

Extend your fingers back as far as you can and the body of the hand also curves slightly backward.

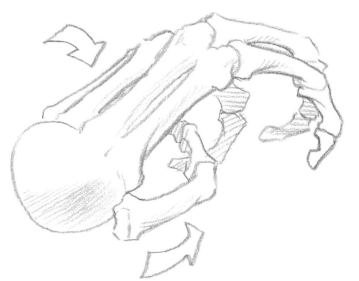

The metacarpals of the ring finger and little finger can move a bit, especially the latter. The metacarpal of the thumb is extremely moveable. Cup your hand sharply, as if to cradle a marble, and you can see the body of the hand's shape take on a curve, due to the movement of these three metacarpals.

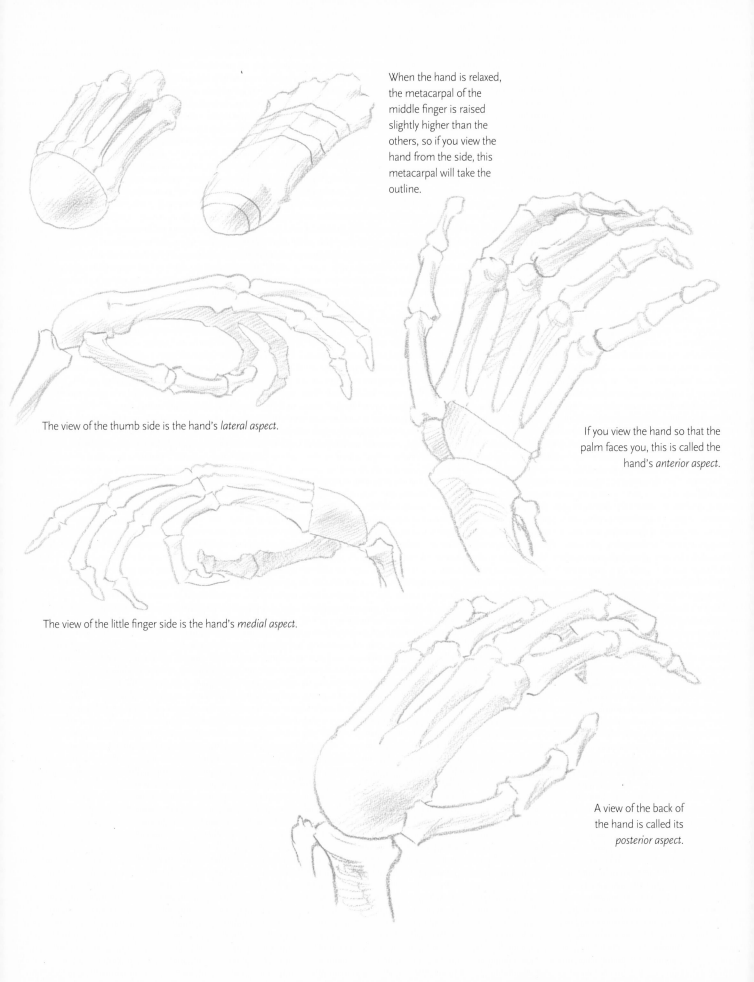

When the hand is relaxed, the metacarpal of the middle finger is raised slightly higher than the others, so if you view the hand from the side, this metacarpal will take the outline.

The view of the thumb side is the hand's *lateral aspect*.

If you view the hand so that the palm faces you, this is called the hand's *anterior aspect*.

The view of the little finger side is the hand's *medial aspect*.

A view of the back of the hand is called its *posterior aspect*.

the thenar eminence, is a collection of four muscles that form a very thick bulge on the thumb side of the palm. It is shaped somewhat like a chicken drumstick, with its small end converging on the base of the thumb. Think of it as emerging from the wrist and from the metacarpal of the long finger. A smaller mass, the transverse abductor of the thumb, extends from a bit higher on the thumb and aims for the top of that same metacarpal.

Another group of muscles is associated with the little finger. Known as the hypothenar eminence, it is smaller and more angular than the thenar eminence. It resembles a section cut out of a very skinny pyramid shape. The muscle which really dominates this view is the abductor of the index finger.

The abductor of the index finger or more properly, the first dorsal interosseus, is the muscle that originates on the shaft of the thumb's metacarpal and inserts into the base of the index finger. This muscle's egg-like form is most clearly seen if you force your thumb sharply upward, pressing it also in the direction of the other fingers.

These are all of the muscles that play a significant role in the hand's shape. The rest

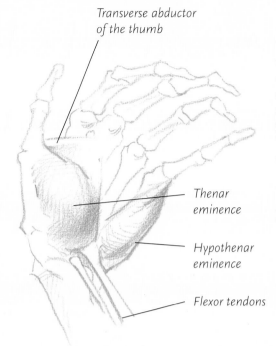

Transverse abductor of the thumb

Thenar eminence

Hypothenar eminence

Flexor tendons

The thenar eminence dominates the thumb side of the palm, but it does not cover the metacarpal of the thumb. As a result, when you look at the thumb side contour of the body of the hand, you're looking at bone, not muscle. When you draw it, try to express the rigid bone you know lies underneath.

Two flexor tendons are visible on the anterior view, where the forearm joins the wrist. It is fun to draw them with a few faint lines.

On the lateral view of the hand, you can see a bit of the thenar eminence behind the metacarpal of the thumb. A pair of thick tendons converge on the base of the thumb and form a **V**-shaped depression between them called the *snuff box*.

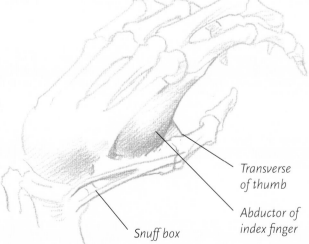

Snuff box *Thenar eminence* *Abductor of index finger*

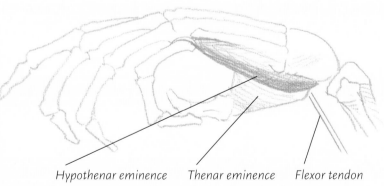

Hypothenar eminence *Thenar eminence* *Flexor tendon*

The medial view showcases the hypothenar eminence, which can be thought of as including the abductor of the little finger muscle, running alongside the metacarpal of the little finger. Behind it the thenar eminence is visible. Unlike the thenar eminence, the hypothenar eminence takes the outline on its side of the hand. When you look at the little finger side contour of the body of the hand, you're looking at muscle, not bone. Your outline should express the tautness of muscle here.

Transverse of thumb

Abductor of index finger

Snuff box

The posterior aspect displays the abductor of the index finger, the snuff box and a little bit of the transverse abductor of the thumb.

of the hand and fingers are composed of bones, tendons, fingernails and various forms of padding.

The tendons are flat and tapelike, designed to slide freely over the back surface of the hand. They become quite prominent when you extend your fingers sharply backward, but their influence is also evident on your knuckles. Your knuckles—really, the ends of your metacarpals—are shaped like small spheres buried in the mass of the hand.

The phalanges of the fingers are numerous, and if you draw them too carefully on the figure, you risk dominating the picture with this one small area. It is better to group many finger joints than to draw each one. Actually, implied contour lines connecting the joints of the finger are something the artist thinks about quite a lot. There are four

The fully fleshed hand is a good deal broader than its bones.

I think of a railroad trestle cresting a hill when I draw the extensor tendons running over the knuckles.

The tendons also run over the knuckles. Subtle as this form is, it is characteristic of the back of the hand, and you should find a way to draw it. Like all small details, it should be clear, yet it dare not compete with the larger mass upon which it lies.

I should mention the extensor tendons that lie on the posterior surface of the hand. One muscle, located on the forearm, sends out a tendon that branches into four separate tendons, aiming to run up the back surfaces of the fingers. This branching takes place a bit forward of the carpus, but the tendons are held down tightly by ligaments for the first quarter of the metacarpal surface. From that point, they begin to be clearly visible. If you can't see them on the back of your own hand, try raising your hand above the level of your heart. After a few seconds the outlines of your veins will disappear and the tendons should then be quite obvious.

such lines: the arc of the knuckles, the arc of the first phalanx, the arc of the second phalanx and the arc of the third phalanx. When the hand is laid flat, these four lines are simple **U** shapes, increasing in their curvature as you move outward from the knuckles to the fingertips. But when the hand interacts with another mass—to hold a baseball, drink from a cup or gently grip the top of the thigh—these arcs act as surface contour lines, and their shape is largely determined by the overall shape of the surface with which they are in contact. Using these particular contour lines takes some practice, but it's part of the fun of drawing hands.

In this pose, I sparingly assigned outlines to portions of fingers but did the main work with flat washes of tone applied along the knuckles and joints of all the fingers at once. This effectively masses twelve separate forms into just three planes.

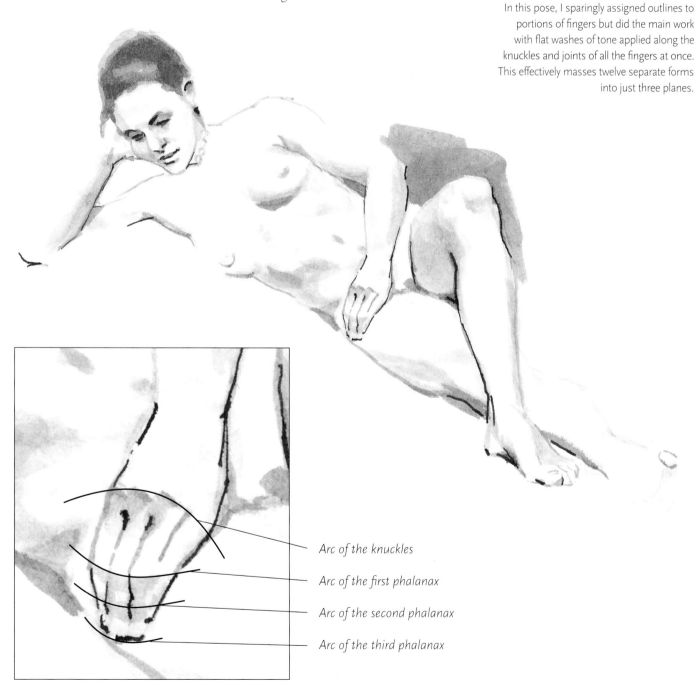

Arc of the knuckles

Arc of the first phalanax

Arc of the second phalanax

Arc of the third phalanax

Four implied contour lines connect the fingers' joints.

127

the foot, blocked only by some tendons and one small muscle, so if you have a sense of the sizes and shapes of the bones and how they are arranged, it will help you draw the foot more confidently.

There are two systems of bones, the ANKLE SYSTEM and the HEEL SYSTEM. The ankle system is where the foot articulates with the ankle. To this system belongs the first three toes. The heel system contains, appropriately enough, the heel bone and the bones associated with the fourth and fifth toes. The ankle system begins high, at the ankle, and ends low, at the balls of the foot and the toes. The heel system lies more or less on the ground all the way through, as can be seen clearly on the footprint.

In this arrangement of bones lies the great rhythm of the foot. There is a sense of the ankle system sloping over the heel

The foot has twenty-five or twenty-six bones which dictate movement and appearance.

The ankle system.

The heel system.

The overlapping systems that make up the foot.

This overlapping ankle system also produces one of the most famous Y-lines on the figure.

system in any view of the foot, which you ought to get a feel for.

The long bones are called metatarsals. Their influence produces the center third of the upper surface of the foot, so it is important to understand how they are arranged. If you sketch a tombstone, distorted so that one side is nearly vertical while the other gently slopes, and add also a similar shape lying on the ground, you can get a sense of the upper surface of the foot. The metatarsals connect these two forms.

You can add the bones of the toes to this conception. They are so small compared to the actual size of the toes that their forms have little visible influence on the toes' shapes, but their thrust determines that of the toes.

The first phalanx of the big toe makes a marked change of direction from that of its metatarsal The outline of the foot always takes a sharp turn when it hits this point. Because of that, the end of the big toe's metatarsal is one of the great landmarks you should watch for when you draw the foot. Emphasize it. It is as important to the foot as the nose is to a profile head.

As mentioned earlier, the big toe and the little toe are very dissimilar to their companions. The big toe is huge, more than half again as wide and as thick as any of the other toes. You can suggest all of the toes simply by drawing the big toe and treating the others as a single mass. The little toe tends to curl in on itself. It seems to be more a part of the foot's outline than a separate mass.

The bony masses on either side of the ankle are referred to as the external malleolus and the internal malleolus. The external malleolus is always lower and more pronounced than the internal. Both are there to help lock the foot in position, preventing lateral displacement.

Sketch a tombstone, distorted so that one side is nearly vertical while the other gently slopes, and add a similar shape, lying on the ground, you can get a sense of the upper surface of the foot.

Draw in the metatarsals, which connect these two forms. You can also add toes to this conception.

The first phalanax of the big toe makes a marked change of direction from that of its metarsal.

These are just a few points worth considering as you address the foot. Drawing the foot takes a lot of practice, but there is one shortcut worth recommending: Find a dozen or so good drawings of the foot from different points of view, and copy them until you know them by heart. This will not only help you understand the foot but will also give you a repertoire you can fall back on. It may sound like cheating, but it's how most people have learned to make sense of this very complicated mass. George Bridgman's *Complete Guide to Drawing from Life* contains a great assortment of drawings worth this sort of work.

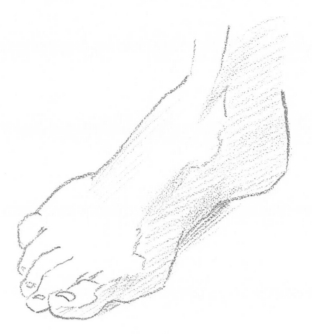

If you imagine three-quarter light illuminating the foot, the terminator shown here is pretty characteristic. It runs around the big toe and the head of its metatarsal, jumps forward to ride the metatarsal of the second toe, then jumps backward to where the big toe's metatarsal joins the ankle. The **V**-shaped line above this is where a very thick tendon, that of the tibialis anticus muscle, comes into view.

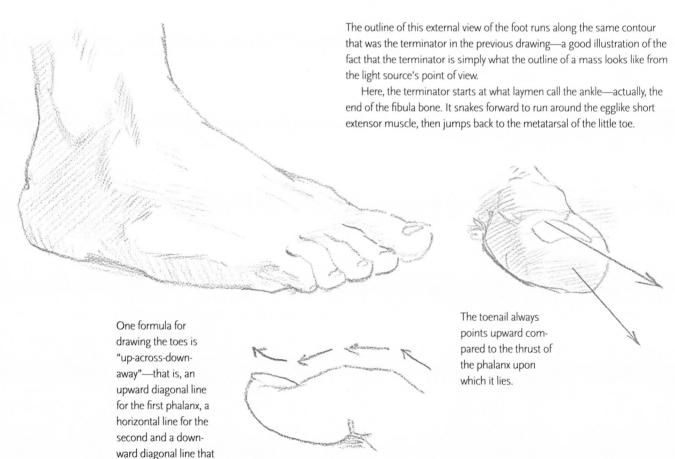

The outline of this external view of the foot runs along the same contour that was the terminator in the previous drawing—a good illustration of the fact that the terminator is simply what the outline of a mass looks like from the light source's point of view.

Here, the terminator starts at what laymen call the ankle—actually, the end of the fibula bone. It snakes forward to run around the egglike short extensor muscle, then jumps back to the metatarsal of the little toe.

One formula for drawing the toes is "up-across-down-away"—that is, an upward diagonal line for the first phalanx, a horizontal line for the second and a downward diagonal line that suddenly flies off onto space for the third phalanx and its nail.

The toenail always points upward compared to the thrust of the phalanx upon which it lies.

Hair

The essence of hair is its texture: The stuff is smoother and shinier than any other large mass on the figure. When hair is styled, this smoothness and shininess is multiplied, because thousands of individual shafts merge into locks, which in turn carry a bright highlight. Highlights are secondary to the rendering of human flesh; you can tell the whole story of skin using a light, a halftone and a dark. But with hair, the halftones and darks are almost equal in value, and the primary effect is brought about by the use of a bright highlight. Highlights on hair are seldom the brightest value in a picture, but they are always much lighter than the other values assigned to hair.

The shapes of hair highlights are worth noting. Highlights on most masses are modified oval shapes, but hair highlights are almost always bands, which wave back and forth along their course. These bands tend to lie over prominences of the mass upon which they lie—be that mass the skull, the shoulder or other layers of hair.

Remember also that hair cannot be perfectly styled or combed. Individual strands here and there will deviate from their neighbors and interrupt the evenness of your highlights. Pay homage to this effect; it will add a lot to the sensation of real hair.

In this gesture sketch, the model's side planes are assigned a fairly uniform dark, while her front planes are not modeled at all; no suggestion whatever is made of highlights on her flesh. Her hair, on the other hand, is just a blob of black with a strong highlight. The actual value of that highlight is about the same as the darks on the model's skin, but this makes no difference.

Here, the highlight lies where the side of the skull turns suddenly downward. This plane break is quite subtle on the skull itself, but the presence of shiny hair magnifies and exaggerates it.

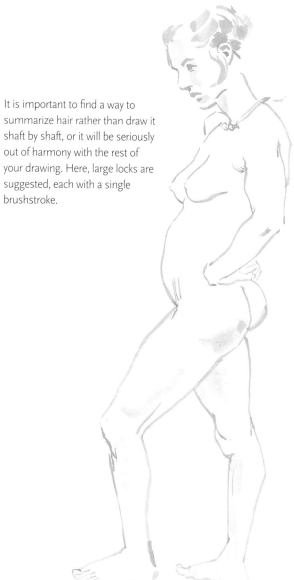

It is important to find a way to summarize hair rather than draw it shaft by shaft, or it will be seriously out of harmony with the rest of your drawing. Here, large locks are suggested, each with a single brushstroke.

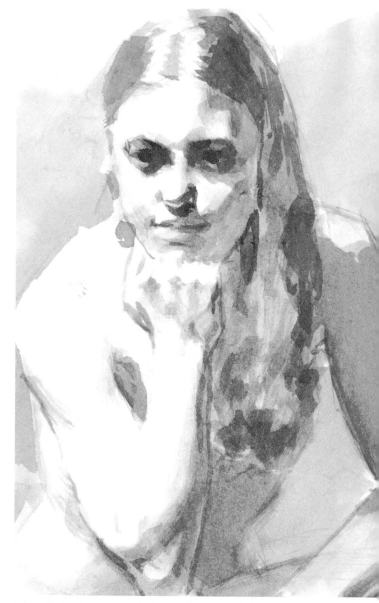

The model has pinned her hair back with clips, producing locks that resemble flattened cylinders. The dark to light to dark of the two brushstrokes here is meant to suggest this form. When you draw hair, search for ways to communicate things like this, or you'll be forever lost in minutia.

Where the hair is neatly combed, its shafts move in lock step, producing a crisp and bright highlight. This is the case where the model has parted her hair. As the hair falls, it loses this orderliness unless it has been carefully styled, and highlights become less orderly, as on the hair that falls to the model's chest level.

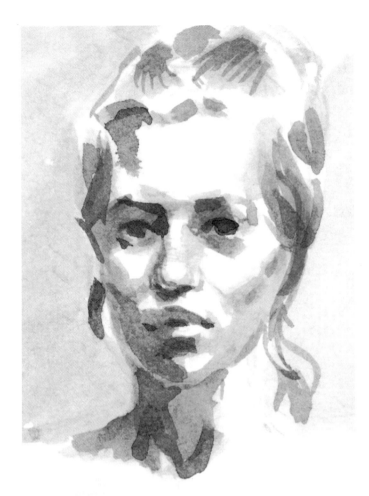

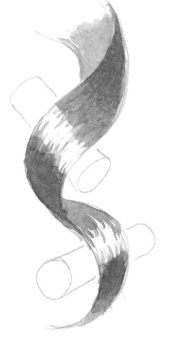

Hair locks spiral in three dimensions, like ribbons or like one-half of a DNA molecule. At one point in its spiral, the lock catches a highlight; everywhere else, it is dark. If you imagine cylinders placed underneath the locks as they turn, the shape and direction of these highlights is simpler to understand.

Don't try to indicate each strand of hair, even if you're using a tool that is sympathetic to such an attempt, such as a brush.

When bangs of hair fall over the forehead, the break between skin and hair is clear enough. The situation is different in places such as the widow's peak or the sideburns, where hair gradually begins to grow out of the skin. There is no clearly defined edge separating hair and scalp; they merge one into the other. Similarly, a highlight in hair might be close in value to the skin over which it lies. You must lose the edge in such places. Passages like these should be seized upon and emphasized, as was done here, or the hair will resemble a wig. Wash is a good medium for describing such things. If you use pencil, be prepared to freely scribble, bearing down where there is a clear edge between flesh and hair and losing your line entirely where the edge is not distinct.

Work broadly, and allow your viewer to complete the effect, or you'll be committing yourself to give overly detailed treatment to every other surface of your model's body. Don't open that can of worms.

The Rule of Tipped Cylinders

The cylinder is a good approximation for many forms of the body. You have already examined the four shade movements that most clearly suggest a cylinder, but there is a problem. This pattern of shade occurs only when the light source is at right angles to the cylinder's long axis. When such masses point toward or away from the light source, shade movements change radically. The cylindrical forms of the body—the limbs and neck—are also those most given to wild changes in thrust, so the effect of light on cylinders is of some importance in figure drawing.

There is no substitute for studying the figure itself, but there is a way to grasp how and why the pattern of shade changes on cylindrical masses. The method is referred to as THE RULE OF TIPPED CYLINDERS. To use it, you must first determine the thrust of each of these masses.

Wherever the cylinder's rim strikes the sphere, the values it encounters can then be transferred down the whole cylinder for this or any other cylinder. This is The Rule of Tipped Cylinders: The modeling of any cylinder, regardless of its thrust, is determined by the modeling of the sphere. Because the sphere acts as the template for all shade values, it is the CONTROLLING SPHERE. You need not actually shade your controlling sphere. If you understand the theory behind how tone runs on spheres,

you can make a diagram showing its tonal landmarks.

The rule's biggest limitation is that it presumes that the lamp or window has been placed quite far from the model; light rays strike each mass at the same angle. If your light source is close to the figure, you will have to draw a separate controlling sphere for each mass.

The rule is unnecessary when the pattern of light and shade is clear to you. Still, in situations where a limb is pointed toward or away from the light source, The Rule of Tipped Cylinders does much to explain how light will reflect and why.

We are reviewing the sphere because the shade pattern on cylinders is always derived from that found on spheres, as we will see.

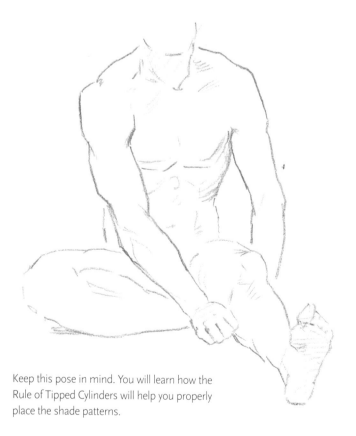

Keep this pose in mind. You will learn how the Rule of Tipped Cylinders will help you properly place the shade patterns.

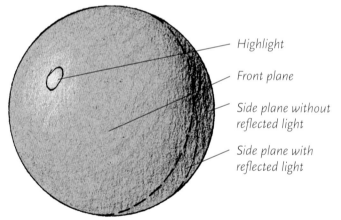

Highlight

Front plane

Side plane without reflected light

Side plane with reflected light

Draw a sphere, and construct it as if it were lit by the same source illuminating your model. It is important here to determine the placement of shading landmarks on the sphere, as described on page 16. The crucial landmarks are the highlight, the terminator produced by direct light and the terminator produced by reflected light. You may recall that these two terminators almost invariably overlap to some degree and that where neither of the two light sources can reach is where there are all the darkest darks. Where the side plane is lit by reflected light, values are not quite so dark. The front plane should be quite a bit lighter still, and grows lighter and lighter as you move from the terminator to the highlight. Reflected light strikes part of the front plane, but it is not strong enough to produce any effect on values. This gives four distinct areas on the sphere: its highlight, the rest of its front plane, the portion of its side plane lit by reflected light, and the portion of its side plane that receives no light at all.

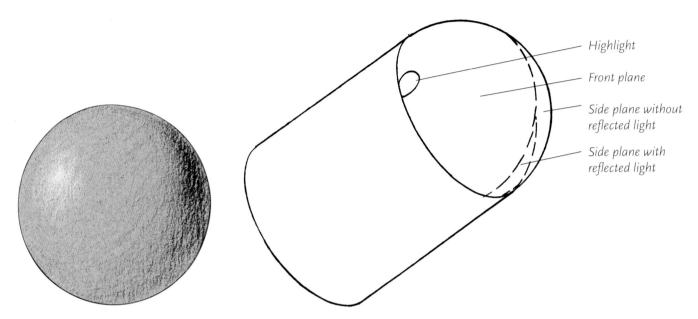

Labels (top diagram): Highlight, Front plane, Side plane without reflected light, Side plane with reflected light

Now take the rim of one of the cylinders you sketched, and run it around the surface of your sphere. You'll probably have to enlarge or reduce the size of your cylinder. The cylinder and the sphere must be precisely the same diameter. However you enlarge or reduce your cylinder, make certain that the shape of its rim and the angle of the cylinder remain the same. What you will come up with is a picture of a cylinder just large enough to swallow half of your sphere. In the discussion of contour lines (pages 16–18), this line that halves the sphere is classified as a hemispheric contour line.

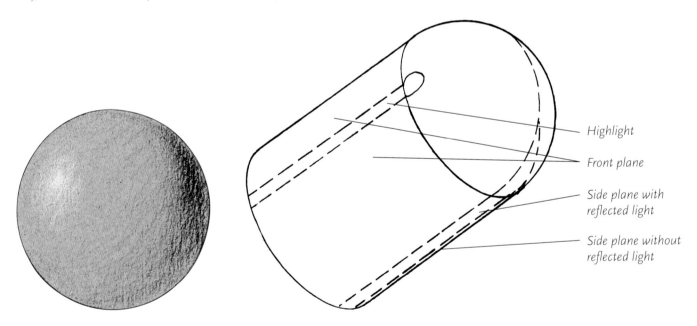

Labels (bottom diagram): Highlight, Front plane, Side plane with reflected light, Side plane without reflected light

Wherever the cylinder's rim strikes the sphere, the values it encounters can then be transferred down the whole cylinder for this or any other cylinder. This is The Rule of Tipped Cylinders: That the modeling of any cylinder, regardless of its thrust, is determined by the modeling of the sphere. Because the sphere acts as the template for all shade values, it is the *controlling sphere*. You need not actually shade your controlling sphere. If you understand the theory behind how tone runs on spheres, you can make a diagram showing its tonal landmarks.

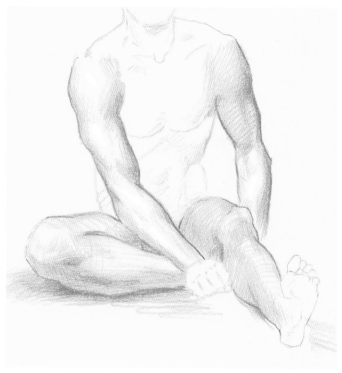

You may need to play with the rule a couple of times to get the hang of it. For this drawing, imagine the light striking the controlling sphere from the left, and reflected light coming from a source placed somewhat lower. Transfer the cylinders you drew on the previous page with a controlling sphere of the same diameter, and the shade landmarks to the cylinders' shafts. Use the tonal patterns as guides in conceiving shade on the figure. Obviously, arms and legs are more complicated than simple cylinders, and the pattern must be adjusted to suit the depressions and bulges of the human body.

Notice also that the foreshortened left thigh and foreleg encounter no tonal landmarks. The rims of the cylinders that describe their thrusts miss the sphere's highlight and its terminators. The result is a rather flat effect without much difference in tone. On the other hand, the right arm contains both a strong highlight and a dark side plane. The rule enables you to alter the pattern of shade as you move from one mass to the next, without losing the sense that all of these masses are lit by the same source.

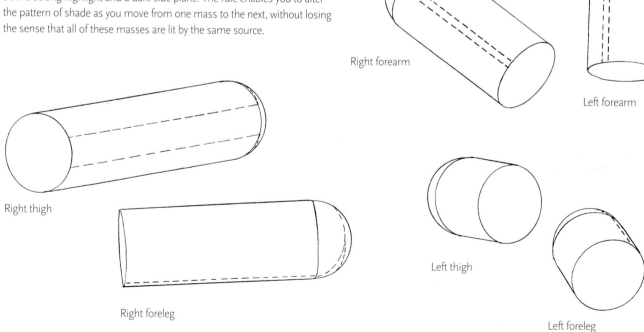

Left arm

Right arm

Right forearm

Left forearm

Right thigh

Right foreleg

Left thigh

Left foreleg

138

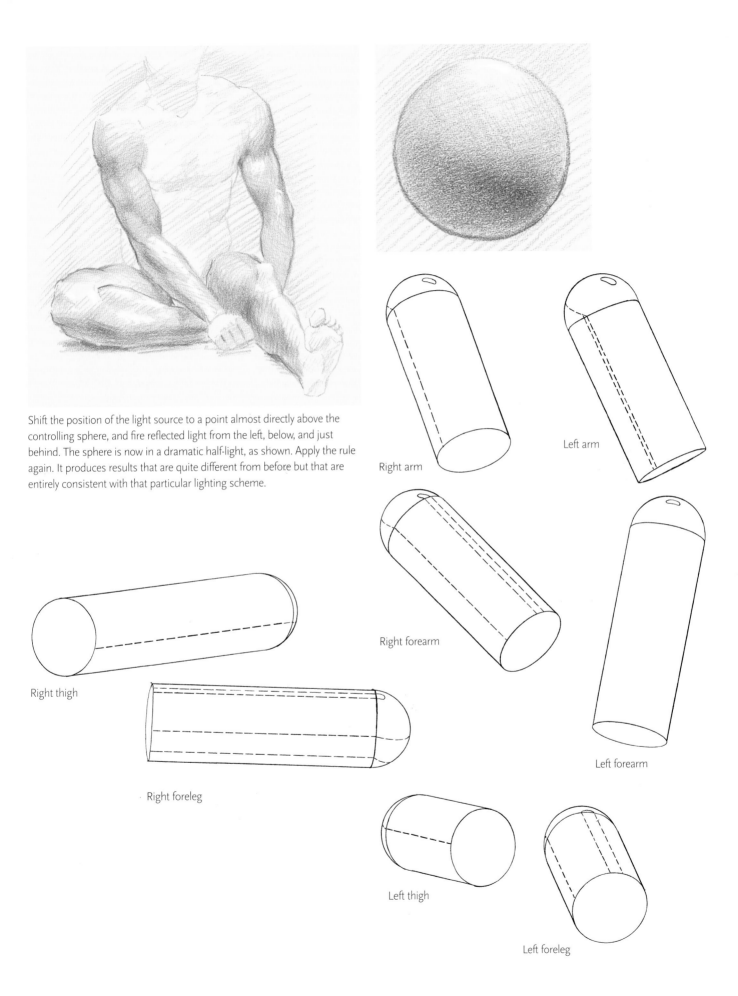

Shift the position of the light source to a point almost directly above the controlling sphere, and fire reflected light from the left, below, and just behind. The sphere is now in a dramatic half-light, as shown. Apply the rule again. It produces results that are quite different from before but that are entirely consistent with that particular lighting scheme.

Right arm

Left arm

Right forearm

Left forearm

Right thigh

Right foreleg

Left thigh

Left foreleg

The preceding material is a distillation of ideas that have helped me in my own work. Most of this was picked up in art school and represents a heritage handed down from teacher to student over the course of centuries. I have also added my own ideas that have helped me over time. All of it is offered in the hope that it will help you, regardless of where you intend to take your work as an artist.

Drawing well requires a passionate desire to learn in the face of repeated frustration. If you really mean business, you will have no

Conclusion

trouble supplying that passion. It just takes some time and some commitment.

If representational drawing is your aim, choose your friends wisely, particularly if you're in art school. Today's academies are crammed with students (and, too often, teachers) who, never having learned to draw well, learned to talk instead. It is easy to minimize drawing's relevance; it is very hard to learn how to draw. If naturalism is your aim, fight for it and surround yourself with others who share your inclinations. Learning to draw even passably well is hard enough, without having to apologize to your friends for your choices. Learn all you can, from anyone who can do things you cannot. Your teacher need not be a great artist to have good things to offer you. If an instructor knows how to throw the head or shade a sphere or make thrust obvious, that's enough; one good trick is worth a thousand theories. Every good art school has a few instructors written off as technicians rather than artists. I suggest you give these "technicians" the benefit of the doubt. They may have skills to offer that would otherwise take you decades to figure out, and their own work might be more significant than what their classes suggest. Good teachers serve up only what they know their students are ready to digest. The fundamentals of any field are not sexy, but competence comes only after those fundamentals are absolutely conquered.

The same holds true of books you may wish to consult. I have cited a couple of books that have helped me in spite of the fact that the drawings themselves don't thrill me. If someone knows a craft and can communicate it, why pass up the chance to learn?

As your skills improve, consider merchandising them. When others are willing to pay you for your work, you'll find yourself making pictures that justify their faith in you. It is no surprise to me that some of the most interesting drawings and paintings being done today are executed by commercial artists. They are not dilettantes: They must communicate or starve. This is a good discipline for an artist. It is easy to say that the public is too coarse to understand what you have to say. What if Shakespeare believed that, or Cole Porter, or Thomas Jefferson? The folks back home may not be on the cutting edge, but they are your audience, and they're as sophisticated as any audience in the world in the ways that really count.

It is risky to make categorical statements about art, but I'll be dogmatic on one point: The human body is a beautiful thing, to be treated by the draughtsman with love and respect. Any approach which trivializes the figure is a wrongheaded one. Learning to draw the figure as a beautiful mechanism requires years of practice; ugliness is easy. If your figures are ugly, you're not being true to your subject matter, and you're thumbing your nose at the body's designer. Of course, there is ugliness and there is stylistic intent; they are not the same. Daumier, Rembrandt and Goya drew their models honestly, making no apparent effort to idealize them. Yet the body always retained its dignity, particularly in Rembrandt's work, where the artist's respect for the body governed his treatment of even the humblest subjects.

This book has concentrated on drawing, but please remember that drawing is not the whole story. Drawing is generally done as a dress rehearsal for something more significant—painting, sculpture, architecture or what have you. If you intend to be a painter, don't put it off forever; *paint*. The demands of drawing will not suffer for it; the one will help the other. There is no magical crossing-over point when your skills as a figure artist qualify you to paint well; they are two entirely different disciplines, each of which complements the other. Drawing's charm lies in its informality; painting demands commitment. Take both roads.

The prevailing view in art school seems to be that each new artist must somehow redefine what art is. This is a rather tall order for most people. Very few picture makers have ever redefined what pictures are. Giotto did. Masaccio did. Michelangelo did. Pollock did, for what it's worth. So did Picasso. Rubens did *not*, nor Gainsborough, nor Raphael, nor Vermeer, nor Sargent, nor a host of others. Each just made some pretty impressive images for us to enjoy. Perhaps this is enough. Make the best pictures you possibly can. The society you live in could use them.

Index

The best in drawing instruction comes from North Light Books!

These books and other fine North Light titles are available from your local art & craft retailer, bookstore and online supplier or by calling 1-800-448-0915.

Bert Dodson's successful method of "teaching anyone who can hold a pencil" how to draw has made this tome one of the most popular, best-selling art books in history-an essential reference for every artist's library. Inside you'll find a complete system for developing drawing skills, including 48 practice exercises, reviews, and self-evaluations.

ISBN 0-89134-337-7, PAPERBACK, 224 PAGES, #30220-K

You can render strikingly realistic faces and self-portraits! Instructor and FBI forensic artist **Carrie Stuart Parks** makes it easy with foolproof, step-by-step instructions for mastering proportions, facial features, and other tricky details, including eyes, noses, mouths and hair. Special tips on value, light and shading will help add life and depth to any portrait.

ISBN 1-58180-216-1, PAPERBACK, 144 PAGES, #31995-K

A sketchbook journal allows you to indulge your imagination and exercise your artistic creativity. Let **Claudia Nice** provide you with invaluable advice and encouragement for keeping your own. She reviews types of journals along with basic techniques for using pencils, pens, brushes, inks and watercolors to capture your thoughts and impressions.

ISBN 1-58180-044-4, HARDCOVER, 128 PAGES, #31912-K

Walt Reed's classic, proven instruction has been refined and tested through years of use in the classroom. The principles and step-by-step techniques he stresses uniquely illuminate the art of drawing the human form. You'll also find detailed anatomy studies examining bone and muscle structure, plus special guidelines for drawing the head, hands and feet.

ISBN 0-89134-097-1, PAPERBACK, 144 PAGES, #7571-K